Digital Creativity

Digital Creativity

Something from Nothing

Gregory Sporton
University of Greenwich, UK

First published 2015 by
PALGRAVE MACMILLAN

Palgrave Macmillan in the UK is an imprint of Macmillan Publishers Limited, registered in England, company number 785998, of Houndmills, Basingstoke, Hampshire RG21 6XS.

Palgrave Macmillan in the US is a division of St Martin's Press LLC, 175 Fifth Avenue, New York, NY 10010.

Palgrave Macmillan is the global academic imprint of the above companies and has companies and representatives throughout the world.

Palgrave® and Macmillan® are registered trademarks in the United States, the United Kingdom, Europe and other countries.

ISBN 978–1–137–48640–0

This book is printed on paper suitable for recycling and made from fully managed and sustained forest sources. Logging, pulping and manufacturing processes are expected to conform to the environmental regulations of the country of origin.

A catalogue record for this book is available from the British Library.

Library of Congress Cataloging-in-Publication Data
Sporton, Gregory, 1964–
 Digital creativity : something from nothing / Gregory Sporton.
 pages cm
 Summary: "Digital Creativity examines the impact of technology on the creative practitioner, how it influences, and sometimes determines, the way they work and what they produce. It questions the claims to creativity of the technology industry, and at the same time argues for seeing computing as a craft practice. Artists and craftspeople have always been drawn to new technologies for inspiration, and the book seeks to contextualize the frenzy of claims about the impact of digital technology against the reality of what it is to be creative. The different motivations for creativity are tested, making much-needed distinctions between the practices of the arts and the models of innovation in engineering and elsewhere in the technology industries. Finally, the book warns of the problems ahead if technology comes to dominate creative practice, either by defining it or imitating it. Ultimately, artists must engage with it if it is to retain a human form and scale."—Provided by publisher.
 ISBN 978–1–137–48640–0 (hardback)
 1. Technology and the arts. 2. Creation (Literary, Artistic, etc.)
 3. Creative ability. I. Title.
NX180.T4S66 2015
700.1′05—dc23 2015003631

For Fred Inglis, my great mentor and friend

Contents

Figures

Acknowledgements

The idea for this book originated in the frustrations of the complicated technological tangle I found myself in when Director of the Visualisation Research Unit in Birmingham. Accompanying me on these travails was a series of intrepid assistants and research students who regularly showed greater patience and insight when dealing with the vagaries of our tech than I could. I am accordingly grateful to Mike Priddy, the late Daniel Hunt, Keir Williams, Carla Perkins, Nicola Plant, Julia Chidley, Tychonas Michailidis, Bland Mahdi, Antonio Roberts, Wang Shuang, Iona Makiola, Lee Scott, Katerina Pushkin, Lamberto Coccioli and Jo Vi for their contribution to my understanding of what was going on. However frustrating our work often proved, it was also inspiring to see what could be achieved with the exercise of the imagination. Jonathan Green, my main colleague throughout this period and co-inventor of MotivePro, should be gratified to see I found a use for his syllogism in the final chapter, and I remain in awe of his ability to turn ideas into working propositions. David Durling offered support and challenged me to get an account of this period written down, and Andrew Kulman stopped and stared at what we were doing often enough for me to think it might be interesting to others. At the University of Greenwich, colleagues left me alone long enough to get the work done, and then gave me the responsibility of founding a new department in its image once it was finished. This is a rare privilege. I am obliged to them for their continued forbearance, especially for the faith shown in me by David Maguire, the vice chancellor and no mean technologist himself, in appointing me in the first place. Stephen Kennedy and Nick Lancaster gave me copious notes on early drafts, as did Fred Inglis on later ones, and the book is much better for their interventions.

Introduction: The Conference

We assemble in the conference hall and snap open our laptops or fold over our iPads and check the wireless connection is live. The speaker sorts out his computer's VGA connection to the projector or inserts his USB drive into the one provided to ensure the smooth running of the programme. We know we are about to be assaulted because the presenter promises not to inflict on us 'Death by PowerPoint', before proceeding to do exactly that. Invariably at this delicate moment these sessions develop a problem with the technology. This is greeted with knowing, sardonic laughter by the assembled tech-heads, with a further edge of cynicism sharpening the reaction if I am attending a conference *about* technology (as they often are). Either someone has the wrong adapter, has ignored the warnings given in advance about the system's limitations or is testing those limits by using flashy but unusual software that is by no means certain to work. They might be playing video and can't work out why it is clearly visible and working on the monitor but not showing up on the big screen, or can't manage the extended desktop that puts their notes in front of them whilst we see only the slides. Sometimes they have foolishly made themselves dependent on an Internet connection that doesn't work, and the only person surprised by this is the presenter. Despite the universities of the UK having one of the most advanced networks in the world, SuperJANET5, punctilious IT managers at university level are so paranoid about security that they invariably choke off most of its functionality before it gets to an individual academic. Wars of attrition between computer science departments and central IT managers are a fact of life in most universities. This isn't

entirely without foundation: the university network *is* under permanent attack from hackers. The practical result is that the institutional firewall inevitably blocks whatever complexity the speaker is seeking to drag into the room from its server so far away and so big that it couldn't have been loaded onto a memory stick, so a world-leading network operates like a cut-price start-up ISP.

The wetware (that is, the people) can sometimes turn out to be far less clever than the technology at their disposal, or worse, so unreliably human that they make nervous mistakes. They press the wrong button or leave some crucial bit of tech at home, like the mini DVI adapter that Mac users never seem to have on them in such situations, or forget to check if the battery in their laser pointer still has some charge in it. Having settled the set-up issues, they then proceed to lecture me on the wonders of digital technology.

Supported by slides that have too much text displayed at too small a font to be legible, and habitually devoid of pictures, a man (and it is invariably a male who does this) often begins by explaining a notion about technological progress. This fixes on crucial 'game-changing' or 'disruptive' technologies. These are technologies that are lauded for their capacity to 'change the way we see the world' (or given the antiquity of some, how we once saw it). They are name-checked as having 'redefined' communication in some way. You already know what most of these technologies are, but there are sometimes surprises. Whether it is the invention of writing, the three-masted sailing ship, the off-set printer or the telephone, it turns out that these specific technologies, most of which we now think of as redundant, decorative or passively waiting their turn for a rare, useful moment in the background of our lives, happen to have changed civilisation. We now take them for granted or have consigned them to technological oblivion with the advent of something new. Their replacements, usually assumed to deliver a similar experience with an ever-greater efficiency, are the evolutionary successors of the original idea. They are responses to the demands unleashed by the clever new way of doing things they are displacing, derivatives of an organising principle enabled by the technology, not innovations in themselves. We are then treated to a tour of their virtues, their transcendent qualities, in preparation for the real point of the discussion. This is the conflation and comparison of these things of the steam-powered, clockwork past and their favourable impact on

civilisation with the new world of 'bits', binary code that is busy virtualising and visualising a world whose threshold we have only just crossed.

The enthusiasm for the engineering is always immense: machines that design machines across many generations are at the point where no single human could now know how it is that they operate or what it is exactly that they even do; ever-expanding computing capacities require the regular citing of Moore's Law,[1] together with exhortations that if people are to keep up, they need to double their own productive speeds; and chilling warnings that the world's computing power will multiply by any arbitrary number of factors within five years, leaving behind those who do not bend to accommodate such power. Any amount of other assertions about the astonishing feats of the computer industry could be added, including its credentials as the great democratising force of our time or the place where 'ordinary people' can have their say and develop their fan base in the Blogosphere or on a YouTube channel. But this is where I begin to shift in my seat and my concerns bubble up as I sit silently scanning the conference's Twitter hashtag to see if anyone else is feeling quite as uncomfortable. I have just seen a demonstration of their counter-productivity after all, and I am used to being disappointed by their shortcomings in everyday practice where they rarely live up to their billing.

Then, for someone who comes to technology through the world of the creative arts, there is the final indignity. The technologies about which the presenters have been gushing so uncritically turn out to have an even more serious aspect to them that will affect my own area of expertise. The technologies that so fail us on a regular basis, so enslave us to their demands to remain connected, that distract us from more important tasks at hand and force us to adapt to their limitations are proposed as releasing and challenging human creativity, the end to which they have apparently been devised. They recommend themselves in this way via a series of morally superior principles like democracy or freedom of speech or the distribution of creative expression that users can assert by utilising the technology. Technology itself is presented as merely a neutral conduit for the flourishing of these qualities through the space they create for the imagination via their systems. It is human agency that is the apparent driver of the technological framework, though the

inconsistency with this idea and the notion of neutrality always goes unremarked.

The marvels that are presented before me bear little resemblance to the technology I deal with. I want to begin by acknowledging the challenges and complexities of my research with technology as a creative purpose, whilst noting it is rare to experience anything like these gilded promises of technological engagement with which I am confronted. My episodes in experimentation can be very frustrating, but there are always incremental improvements in the design of a prototype or the need to understand why a line of code is creating system crashes. Even better, sometimes my research group discovers opportunities and solutions of no interest to the technology industries that dwarf us and determine what we have at our disposal. They inadvertently give us creative alternatives, undermining the didactic engineering under whose thumb we often feel ourselves to be. When they churn out beta-tested products to pay for the next round of their R&D, we find ourselves hacking it. When they present locked-down finished products, we work around them. We have understood that their technology is simply science with a business plan, but resent their wild claims as enablers of creativity. Our interest, admittedly, is different: we want to know the potential for creative outcomes, not financial ones. Our approach to their technology (and we are acutely aware that it does not belong to us) is to link it to an expressive purpose, to ask ourselves questions about what might be proposed as art work through an exploration of its functionality, the application of the gauze of cultural experience drawing out properties and possibilities prioritised by our aesthetic judgements. We often tease the results of botched engineering processes into doing something that we alone would want, or twist the will of the most deterministic engineering process, perverting it into producing results that would horrify the original designer. It is an engaging, creative process which sometimes leads to a better understanding or a new way of interpreting results or processes, and sometimes 'new' art work. The newness of this material is sometimes questionable: it is perfectly possible to work on processes that have analogue precedents that were significantly better.

The terms of this encounter are not solely set out by the technology. More frequently, we see its disappointments and regularly work with them: the random checksum errors; the strange system crashes;

the inability to load software despite having all the system require-
ments; or the long stretches of Internet searching to discover known
issues that the manufacturer has decided to omit from the release
details, often finding ourselves dragged into an unwanted engage-
ment with the complexity of technology as we seek ways around it.
What we end up understanding the most about is a certain model of
creativity itself, our human capacity to overcome limitations and the
necessity to innovate to realise a vision invoked but not delivered by
the promises of technology. Our imaginations are used to triumph
over technological limitations in the pursuit of the cultural, and this
is our real line of work.

The conferences I attend are rarely as specific, effective or engag-
ing as these sessions in the lab. Often, the *idea* of technology is really
the main subject of these gatherings, with a few specifics thrown in
as exemplars. There is a touching faith expressed in the potential
of technology to resolve and repair all things; the cities, the econ-
omy, the education system or democracy itself. There is a forthrightly
expressed belief that we have yet to even glimpse the limitations of
zeroes and ones. It is rare to hear a critical account of their inadequa-
cies, though on more than one occasion I have challenged colleagues
to tell me whether the all-singing and dancing results were achieved
as painlessly as they claim, especially in the face of a live failure of
the demo.[2] In the process, digital technology is abstracted into an
unstoppable force of history, a 'transformative' or 'disruptive' process
of change, somehow demanding a completely different approach to
all that has come before it. A fetishistic desire for the technology to
redefine what it is to be human, to extend or refine the concept, is
regularly expressed, or substituted for a pretentious argument about
how our existence is altered towards a course laid down by a French
cultural theorist from the 1970s who knew nothing of the World
Wide Web (pick one as you please). At the same time, this process
is imbued with the comforting historical assurance of the certain
triumph that comes from citing the innovations of the Industrial Rev-
olution or the introduction of the printing press as metaphors for the
Bit's forthcoming impact on civilisation. Without really being aware
of it, these presentations are about culture, and fail miserably to
understand its lack of impact on the corporate technology industries.
As Williams (1974: 9) said more than 40 years ago, in discussing sim-
ilar debates on the impact of television, such statements mask more

serious philosophical and historical questions, especially 'whether it is reasonable to describe any technology as a cause', given the relationship between technology and culture.

In some instances, a more significant and attenuated argument is made. This moves to much more serious ground, the symbolism of technology twisted to substitute for the condition of humanity. The premise is rarely challenged, the veracity of the evidence or the implications for understanding our historical relationship to technology or culture seldom questioned, but in this opening gambit, the claim that technology itself is the progressive force of civilisation, the bringer of peace and the creator of understanding is offered as a commonplace. This is the moment when the argument for those earlier technologies turns into a broader one, claiming they changed the very disposition of humanity. The speakers then move enthusiastically to tie specific technologies to cultural change only of the most positive kind. Moveable type magically becomes the transformer of the medieval world and, via complex byways, the logical ancestor of Twitter, which in turn liberates the Arabs in the 21st century (there is no mention of British riots or social media rape threats). The telephone increased the possibilities of personal communication across distance in real time. Because it could do this, it facilitated the creation of complex organisations, extended their geographical coverage and gave rise to the corporation. By the same process, the steam engine released the power of coal that in turn created cities as we know them today. The internal combustion engine changed the arrangements of these cities. The jet engine brought the cities closer together. From the engine, whether steam, jet propulsion, electrical or internal combustion, to the vacuum cleaner, the impacts of these technologies are grasped in an attempt to thrust evidence of their ushering in of new social and economic paradigms, new ways of living or their role in forcing change in society upon us. This change is always for the best, inexorable and beneficial, or at least this is how it is argued in the technophile version of events. The technologies themselves, often referred to as if they are independent actors in the saga of civilisation, have determined historical periods or ushered in profound changes in how we live, and especially about how we perceive the world. The speakers I have listened to attentively, whilst checking my Facebook page or making a smart remark on the conference Twitter hashtag via the free wireless provided (if it works: and

woe betide the conference whose organisers haven't ensured enough bandwidth for the assembled delegates), often look to the drama of maritime discovery in 1492 or the symbolism of the atomic bomb to create a story, a sense of the birth of a new world made for us to live in through technology, whether in its shadow or through its liberating force. By using ancient technology as metaphors from the past, they seek to induce a sense of both historical context *and* the immediacy of engagement in a technological revolution that somehow feels lacking to us as we turn our mobile phones to silent or look up from our laptops to see what the presenter is up to. Before googling them to check out whether what they have to say is going to be of further interest, we have already taken for granted this connected world where we assume bits can be retrieved from its most far flung corner. We are urged to assume the evolution from the spinning jenny to the networked computer as logical or that the jacquard loom is the place to look for the nascent zeroes and ones whose properties we have so cleverly harnessed.

The implications for our own times are clear. Whether it is the technological framework, the hardware or the user interface that is that subject of the claims, what makes our culture, these proposers offer, are the technologies we invent and deploy. By extension, invention, deployment and adoption of technology make *us*, and shape our personalities and our bodies. The examples are given in the spirit of the moment, despite the shortcomings and inadequacies of the evidence put forward for them. They are the tenuous claims of technology in the abstract and spurious ones about digital technology in particular, made in order to tell us that this is the moment of the digital machine. A broad range of people, many of whom ought to know better having had the frustrations and disappointments that come with working with the stuff, want to disguise the deterministic processes of engineering that have delivered it to celebrate the fact. This is not to say there is no credence in this claim, but to observe the culture that bad technology creates when foisted on us as a response to fulfilling someone else's business plan.

It is at this point I begin to think about the way my own working environment has been transformed by technology. Email, for example, has become the sclerotic artery of the university in which I work, used as a mechanism for pushing problems onto others, expressing displeasure about something without the discomfort of a face-to-face

encounter, as a tool for public humiliation or as a safety mechanism to avoid liability in the absence of trust. This is partly to counter the avalanche of documents that computers have made possible. The administration of everything has become more complicated and distributed given that we are all typists now, and publishers as well. The potential of the word processor has been realised in the generation of countless documents to provide evidence of something that has been raised as an issue to someone somewhere at some time. It is now simply and permanently appended to the bureaucratic process, Baudrillard's simulacrum reified in documents whose provenance is impossible to ascertain, generated as they have been by people without training in technology, but plenty in institutionalised behaviours. The documents are given a further twist by being updated on some semi-regular basis that invalidates proposals presented in the wrong format, though discovering the correct one in such an environment is a tricky task. Authorless yet authoritative, these documents dominate institutional processes, as reports, policy statements, official forms of all types and meeting agendas. Locating a definitive policy is filled with comic results. PowerPoint is considerably more insidious. That ubiquitous tool of the visually talentless allows the amateurish ideas of managers to look so professional that they seem almost credible. The technology lends them an authority they have not earned and can rarely defend, reflecting the superficiality of the modern workplace as one where presentation is, quite literally, everything. The principle that our culture is determined and now directed by the technology we deploy makes me shudder when the manifestations are so poor.

Disrupting the technophile monologue

In a discourse of ever-increasing gambles in the absence of opposition, we see new assertions that we are being altered significantly by technological impact *as a species*. History and anthropology, it seems, is all over the technology that is redefining the Age of Information, but not so much (or so importantly, or so radically) as biology. This new level of techno-theism goes beyond determining and reshaping the modes of living and communicating that we are currently experiencing at ever so rapid a rate. That experience enables us to accept there is substance in acknowledging the ways in which the

historical adoption of technology has determined our collective view of the world. It also encourages a level of wilder speculation about the teleology of technology. In these scenarios, the proposition goes further: technology demands autonomy of action and application.[3] In the event that they were imaginable or possible, impediments to the fulfilment of technological destiny should not be tolerated, lest they distort our progress to our destiny. It would simply be perverse and would fly in the face of the long history of technology as the beneficent provider of economic fulfilment and social cohesion. The literature of new technology is redolent with attempts to make precisely this claim, to muster the growing power and pervasion of digital technology and present it as a monolithic argument of science fiction-like compulsion and imagination. Books seeking to deal with the substance of technological impact invariably start with an historical account not dissimilar to the one I have just described, as we will discuss in Chapter 1. There is, at bottom, a very sound and serious cultural reason for this. The transformative technology of our times showed up on the computers of early adopters less than 20 years ago. Could it be possible that something so young could produce so much apparent change in so short a time? Isn't it possible and desirable to understand its impact by looking at models of technological change from past times and to extrapolate answers for its meaning in our own? Being beguiled and inspired by technology stimulates a demand to understand it better. By examining other moments of immense and profound change in our world, we sense that we can find some sort of pattern or blueprint for a future that is arriving in ever-more rapid manifestations, affecting our daily activities. Without any preparation or training for what comes at us, we are swept away by its ability to take over our lives. It is for this reason an account needs to be made of the ways in which we evaluate the historical progress of a technology, and the answer is not always supplied by the evidence of the ageing or redundant infrastructure around us, as is lazily assumed by technophiles who look in awe at Victorian sewerage systems or Roman roads as if they emerged entirely unproblematically from the past, and we will attempt in our own way to redress this omission in the first chapter.

An equally important task is to address the two inconsistencies here that prompt questions about the validity of historical models based on the transforming power of technology in guiding us towards an

understanding of their force. The first is that whatever claims might be made for individual inventions or their applications (not at all the same thing, it should be observed), it is the social change they have engendered that has properly made a mark on the world. The measurement of a successful technology and its application is in its capacity to change society. The second is the flawed notion that technology is an end in itself, one that we will touch on initially, but explore more fully in Chapter 2.

Amongst the other themes in this book, I want to examine how digital technology became ubiquitous without us noticing. I will do so in Chapter 3. Further, I want to ask why the definitions of concepts like imagination, creativity, intelligence or humanity, concepts that had previously been seated in the domain of culture, have been colonised by technologists and sold back to us in the form of hardware and software. They have been redefined to meet some very different needs and to resolve very different questions as they emerge in the minds of the technology industry's engineers. The virtues of technology are everywhere celebrated, especially by those who revel in pointing out it is no longer driven by human agency. Yet the foundation of this age of technology is, as Mumford pointed out decades ago, that 'the thought was father to the wish' (Mumford, 1934: 218), and that without ideas and their generation, technology becomes an autonomous process whose claims to improvement or progress are based more on myth than fact. One of the dangers of this is that discussion about technology has become a one-sided conversation, without the participation of most of society. Their compliance is assumed given their enthusiasm for some of the products of the Digital Age. They are patronised for their lack of understanding of the underlying technologies, and therefore not qualified to join in the dialogue or offer a critique should they turn out to be less than perfect in their understanding of what drives the technology with which they are engaged and by which they are often frustrated. The workaday products of technology, as my examples suggest, are not actually very productive. Social media platforms seem increasingly colonised as another method of marketing, if not for the product then the self, when they are not being abused as a mechanism to hurl vilification at public figures or to reduce complex issues to 140 characters or less. What is missing is a wider debate about what we want from technology in our lives. Technophiles of all backgrounds

simplify the social questions in Manichean terms: give us complete freedom in the technology sphere or you will confront complete tyranny in the forms of Internet censorship, electronic surveillance or governmental secrecy. You will face increasing and inescapable costs in health care, impoverishment in old age, isolation and social ostracism in early life, suffer a creative deficit that will make you unemployable, and more broadly, watch your society die from the absence of economic opportunity. This case is essentially false: we are only now coming to understand how much of our privacy we are sacrificing in the trade-off for unlimited Internet usage and the extent to which our online behaviours leave us bombarded with messages we may not want to hear. But it seems especially urgent a case to engage given the turn of the ambitions of technologists to change us not only as a culture, but as a species. With ever-more speculative assertions about how it is changing how we think and its impact on our lived experience, we are being increasingly formed by it with a very incomplete understanding of the implications of such a thing.

My further mission, to explain where creativity fits into this and how it is affected, is not possible without this background to the aspirations for technology more broadly. Given the need to raise the stakes in order to grab our attention in the conference hall or the technology journal, there has been a dramatic shift towards making claims about technological emancipation that transcend or transform our cultural development. The persistent iterations of this argument about the cultural impact of technology, how VCRs then or mobile phones now are a guarantee of both our democratic rights and the inalienable freedom to be creative, take an ambitious step forward. The new frontier of creativity in the digital space is crossed because the making of music itself can now be done by those who formerly only consumed it, part of a process that reinforces the case for technology as a creative force. As analogue forms of creative practice, like music, film or image-making see their long-standing craft practices simulated by digital technology, the notion of creativity as a specifically human activity begins to change. I want to argue that creative applications of technology are the exception, rather than the rule. Some of this depends on how a concept like creativity is interpreted, and in the Arts we have all noted its recent colonisation by the forces of technological determinism producing new variants. The character of this definition will be discussed at length in Chapter 4, but it is

worth noting here that we should be less concerned about how and what the tech is made of than what it will do to us.

Essentially, this manifests in two ways that are ultimately not reconcilable, and this will be discussed more fully in Chapter 5. But here, we should note that the first of these builds on the opportunity for those who previously admired and enjoyed cultural practice like music or literature to begin to create their own, away from the domination of an elite set of tastemakers that dominate cultural discourse. They are regularly cited as the heroes of the digital revolution in creativity, the means by which cultures and economies will be transformed, and represent the bleeding edge of that transformation through the predicted demand for creativity in advanced economies as the competitive advantage required for survival. The validity of this proposition needs to be set against the counter-force of the much-vaunted computing power that is coming our way, and this is the second proposition. Artists and creative people of all sorts may be insistent that there are tasks computers cannot perform, but this looks increasingly uncertain when the delivery system itself is digitised. As we will see, the effort to identify, replicate and define creative practice is not driven by an idealistic desire to release waves of human creativity, but by the business models of the technology sector, and the potential of the technology to imitate qualities we have taken to be uniquely human does not require replication, only simulation.

Finally, I would like to point out that it has seemed impossible for me to write about matters to do with creativity and digital technology without referring to the wider cultural and economic factors that determine the technology we play with in our lab. The idea for this book emerged from such encounters, and for me at least, it is not possible to formulate propositions about this from the perspective of creative practice alone. This is partly because of the processes I will later describe. The subversion by powerful forces of the notion of creativity itself, invoked as a shield of legitimacy given its moral association with goodness, supports some rather sly practice. At least as pressing is that some account needs to be made for distinguishing one sort of creative activity from another rather than lumping incommensurate approaches together because they might be configured jointly as a coalition. Technology's record of creativity is nothing much, especially compared to some of its enormous achievements

in other spheres, so where it newly marks out creativity as its own ground, it ought to be joined. This is to say that technology and creativity are systems of understanding in their own right, and thus reducing either to a subset of the other would do both a disservice. In creative practice emerging technologies certainly feel disruptive, but I am less enthusiastic than my colleagues I encounter at conferences, who light upon the supposed creative opportunities and new possibilities they sense lurk beneath the user interface. They are playing their part in the game of technology, so fair enough, but the argument feels partial and they seem dazzled by the shiny properties of digital technology. For myself, I would like to see its workings in more detail rather than be blinded by its effects.

1
The Social Narrative of Technology

I want to begin by asking some questions of the technology that seeks to define the age in which I live, and examine some of the claims made about it as a force within our culture and economy. Firstly, it is worth explaining my objections to the models we are presented with that are noted above from the perspective of technological progress, and then to question the loose application of a notion like creativity to some of their more baleful results. There is a typical assumption on the part of those citing older technologies as the conduits of progress that they are autonomous and, once released into the world, develop according to an agenda driven by the glory of market dynamics. This is a popular approach amongst pop technophiles like Kevin Kelly and is connected to the ideology of free markets and deregulation, neo-liberalism in the technological space, whose ideas have been simultaneous with the period of powerful growth in the presence of digital technology in the lives of all of us. Kelly, for example, has anachronistically applied this idea to pre-historic models of technological development, suggesting that the need for humans to improve nutrition, longevity and the ability to fight has provided the impetus for technology as the natural response to deprivations of any kind. Brian Arthur similarly conflates technological advances with our experience of nature. He sees the initiation of technological process as our logical response to the sluggish speed of evolution in resolving our practical needs. Indeed, for Arthur, the slow processes of biological development are the very foundation of creativity and innovation, with the formation of hope and possibility through technology in long-standing tension with the frustrating relative stasis of

the natural world. Sometimes these narratives are balanced with the countervailing influence of humanity, the construction of a culture that informs how we live and, consequently, the technology required to support it. Often the people are left out altogether, in clear preference for the machines that evidently made, make or will make our civilisation. These histories of humankind as the story of technological innovation provide an alternative narrative to that of, say, great events, great men or great ideas. The picture that emerges from this approach is one where, as Williams (1974: 14) would have it, 'research and development have been assumed as self-generating' when there may be alternative imperatives in play. For Williams, technology is more likely to be driven by intention, with 'certain purposes and practices already in mind', linked 'to known social needs'.

It has begun to seem routine to us that we should always be switched on and connected, and that this is the proper progress from our dependency on a biological evolution that is too slow to equip us with those special features we can now no longer do without. It is how our presence in the world can now be counted, given that so much of our lives will now be recorded and stored, accessed by anyone who can spell our name correctly, or even misspell it the right way. If they retain the slightest interest in us, it can take them to our Flickr images or to watch our YouTube video that we uploaded to share our wonder at opening the box of the latest product of the Apple engineers. The truth is that beyond the metaphysical claims made for the properties of technology, and these often assume heroic proportions, it is the business plan that determines the effectiveness of the science, a process we will discuss in Chapter 2. But this argument for the historical determinism of the culture of technology is frequently repeated and needs some attention here. Given it can include anything from Babylonic cuneiform to the CD as evidence of a logical, inevitable progression of technology dragging humanity along in its wake, it stakes a claim that the satisfaction of all human desires is located in these systems and that they represent the solutions demanded by a whole culture. This teleology is significant in confirming the ambition of technologists, even where it finds no support in the history of technology itself or in the history of culture and ideas. In most of these arguments, the simplistic technological history of what Jenkins (2008) refers to as 'delivery systems' turns out to be the configuring feature of human enterprise. The development of

delivery systems, usually assumed as neutral in their impact on the practice concerned, might be something like the progress of music from, say, Guido d'Arezzo's handwritten musical notation to the published score, to the gramophone record, the Philips' cassette, the CD to the MP3 download. In the technological domain, this is only part of the story. The rationale for change and innovation that is offered about the past focuses on a justification about transmitting to others a sufficiently faithful version of the original work. This definition is regularly on the march, with the implication that as the logical extension of existing practice, such-and-such a thing would be invented and naturally adopted until it dominated its part of the field, thus standing up to make its contribution to history and society. As will be evident, this is one of the myths of technology, that 'the prestige of improvement and of success and power was with the machine', as Mumford (1934: 27) put it so long ago. As the demand created through its various properties begins an arc of manifestation and exploitation, pressure builds for the new and improved as an end in its own right. The progress from one form to another is assumed to be simply a question of how to deliver essentially the same material, in itself an unchanging and sacrosanct part of a creative tradition of human experience. The moment of inspiration is reconstructed as a series of iterative forms supported by a technological narrative. These present themselves in this process as objective and disinterested carriers of human intention, despite prioritising certain features over others. By presenting each system as a contingent mode of communication and transmission, where content is preserved and regurgitated by ever more efficient and faithful means, the historical dimension is retained whilst leaving an open question about how we might encounter it through delivery systems of the future. As part of this inevitable process, new models are adopted and tolerated until 'something better' comes along (Jenkins, 2008: 13). This 'something better' forges its link in the historical chain through universal adoption and the construction of a social framework around it: access to free music downloads becomes a political entitlement, the subject of legal and cultural dispute, but certainly proof of the efficacy of the technology at establishing ubiquity amongst the computer literate music 'consumers', if nothing else. What this consumption consists of, and how enjoyment has been altered by the systems themselves, is regularly elided in a wider argument about the ability to do something and the

stimulation of demand to turn ability into desire, desire into need and need eventually into a right. The question of who profits from this state of affairs is cloaked in the sanctity of an argument about such a right, though such calls are regular homilies from the founders of technology companies.[1]

As suggested above, the really important claim for these inventions and processes is less the implied technological progress (and this ought not to be quite so taken for granted, given that vinyl is making a comeback), than whether and how their advent really possessed the capacity to shape us as a civilisation. More searchingly and riskily, the gambit cites their impact upon us because they fashion our culture at the same time as they determine creative possibilities within it. This is an interesting move because it is frequently fused to delivery systems themselves as the harbingers of change and cultural symbolism. Willis (1990) provides early examples of this. He showed how the flexibility of home VCRs encouraged reformulation and subversion of the relationship between broadcast television and the viewers. Home users of VCRs were no longer tied to the time constraints of when the programme was broadcast, nor obliged to sit patiently through the advertisements as the cost of watching the programme. They possessed the technology to subvert the intentions of the broadcasters, at the same time enjoying only the specific components of the programmes they wanted to watch by skilful use of the remote control and the VCR's programming system (Willis, 1990).[2] In such models, the technology looks positively benign, especially where it overlaps with cultural experience, delivering control and convenience into the hands of an enlightened consumer (the real problem Willis' subjects encountered with the promise of the VCR to reschedule their TV-timetabled lives was an inability to programme the thing).

Technology as cultural change

The introduction of culture-changing technologies has never been the smooth, market-led fantasy that dismisses the tensions between idea, development, adoption and evolution to focus solely and predictably on outcomes. By this definition, the best technologies always come to dominate through their capacity to assist and meet the requirements of the market. The assumptions of benign

environments for such technological change forget that resistance from all corners is not only possible, but likely. From the Catholic Church's Proscribed List to the Chinese government's Great Firewall, most authorities reserve the right to intervene in the pace of change, notwithstanding the fact that users of technology can be notoriously fickle and devilishly clever in their application of it. Consumers in all kinds of guises themselves baulk at innovation for a broad range of reasons, giving rise to what Moore (1991) described as 'the Chasm' opening up in front of high-tech start-ups once the early adopters and enthusiasts for technology have given false confidence to investors. Ignoring these dynamics by focusing entirely on the final iteration of a technology does injustice to both the technological process and the social transformations they want to claim in support of their case. As Williams (1974:23) noted when observing the technological progress of television, which 'in its familiar form seems to have been predestined by the technology'. As he points out, this was really a set of social choices in specific circumstances which were so widely adopted that it became 'difficult to see them as decisions rather than as (retrospectively) inevitable results'. It is far easier to patronise the defeated actors of history than to deal with the moments when the competition of ideas remained in doubt.

Such gentle social change as engendered by technology ought to be balanced with a view of technology that is not always so benign. Indeed, what we can learn from the historical accounts of technological change is the necessity of creating frameworks for dealing with the social consequences of technology. This is habitually omitted from the accounts of technological supremacy I have cited above. No speaker halts mid-sentence having made the stunning connexion between the ability to print books in quantities and the fashion for banning books that took off shortly after, achieving institutionalised status in the reign of Pope Paul IV with the publication of the *Index Librorum Prohibitorum* in 1559. For more than 400 years, the Catholic Church saw fit to regularly update its list of banned texts; the existence of print and the concomitant rise in literacy prompting church authorities to be increasingly concerned about the potential for the technology to share dangerous or heretical ideas. True, books had been banned before the printing press, but these were often symbolic acts, given the rarity and expense of a handwritten manuscript. For the church, publishing was giving easy access to certain books for

those with less discerning minds than the Jesuits who ran the system. It is commonplace today to dismiss such approaches as laughable or repressive, but the Catholic Church relented only as its once-powerful religious authority ebbed away in a secularising world and the policy was thus rendered impotent. Preoccupied with power, yes, but it often argued its bans as the responsible method to preserve social cohesion. It took these authoritative interventions in order to regulate the flow of information, the spread of ideas and the pace of change. The effect was that books became a more risky investment to write and to print, as the benighted publishing life of Voltaire, for example, shows only too well.

An honourable exception to this sin of omission is Naughton (2012), who inverts this issue by jokily suggesting a few serious things that happened as a result of print, the undermining of the Catholic Church being chief amongst them. He goes further, after Gilmore (1952), and cites so much of our 21st-century culture as deriving from Gutenberg's press that it seems clear in retrospect that this was a defining moment in culture. But the story of print is still set out as an inexorable technological march of truth against authority, until it finally became authority itself. Neither Naughton nor Gilmore accepts the consequences of the printed word as the vehicle for the distribution of ideas, good and bad, for more than 400 years. Under-mining the church was clearly not on Gutenberg's mind (after all, his bestseller was the *Bible*), but the impact of a print-based culture, like the story of the civilisation that Naughton wants to say it supported, had some terrible, terrifying moments, too. Notwithstanding the jealous guarding of literacy, or the vicious deprivation of it that some societies still encourage, it should be understood that the Catholic Church was finally and fatally undermined by a failure of ideas. The implication that it resorted to the singular defence of prohibition is quite unfair. It didn't simply leave print as a medium to its critics, but generated as much or more in its defence than Luther's 95 (originally handwritten) theses had in attacking it. It happened that these counterarguments were ultimately unconvincing, and its authority was sapped as the ideas that sustained it were displaced by those of the Enlightenment. It was the use of the technologies of print rather than the existence of print itself that changed minds and it is perfectly possible the battle with science might well have gone the other way had the Jesuits argued their case more convincingly.

Just as certainly as the positive contributions Gilmore (1952) claims for the printing press (and is advertising really one?), there have been ideological battles, personal vendettas and profound abuses of the power of print leading to conflicts large and small. The authority of the book has been exploited by many a charlatan, as the self-help section of any bookstore will attest, or worse in the hands of those best-selling authors Hitler, Stalin, Mao or Gaddafi. The point is that as the technology of print moved into the background of civil discourse, its effect as a technology was replaced by its exploitation as a cultural force. Its technological credentials cease to matter, as the dodgy neuroscience Naughton cites to support his view would attest: we become accustomed to it as part of our broad cultural experience. More than this, its ubiquity neutralises its impact. The significance of its make-up as a technology is less relevant than its ability to find recognition and near-universal acceptance as the form for ideas large and small. The fact that we now redefine and study it in the context of technology ought not to be enough to support the idea that we have always dealt with it as such. If the Web were not such a text-based medium, we would scarcely reflect on the printing press in such technological terms. It is only in an environment where its properties are seen in the new light of digital technology that we begin to think of it as a technological and not a cultural achievement. The long view that Naughton so implores us to take must also account for those qualities of an invention, however benign its contemporary manifestation, which are either a mixed blessing or such a deeply seated cultural assumption that they are no longer a site of challenge. In this sense, printing is no more relevant a technology than textiles or architecture. Our questions about it arise because another practice, digital technology, has brought it into focus, given that the ubiquitous expression of it, the Internet, is apparently so driven by text, rewarding a hyper-literacy that can combine text with algorithms to make light of previously intractable problems like machine translation or rapid information searching. The issue is more how to interpret that challenge. The use of Gilmore's list is somewhat disingenuous and one-sided, and fails to accommodate a broader view of the nature of print as a technology, focusing only on how printing supported 'a social environment in which the idea of individuality made sense' (Naughton, 2012: 23). This is unavoidable if it is to be identified in technological guise, though as Mumford (1934) pointed out, for all

the lionising of the printing press, it was entirely dependent on paper and its technical development for its influence. As a form for ideas, it can promulgate some repulsive ones as much as engendering the enlightenment that Naughton comfortably assumes of it.

This implied separation of technology from culture is not Naughton's intention. On the contrary, he seeks to make an argument about how reflective the Internet, his main subject, can be of our contemporary cultural practices. But in citing the advantages of print, he makes the link between technological innovation and cultural benefits, in much the same style as everyone else. Technological progress inevitably leads to improvements in the lives of the populations that embrace it, even if these take some time to turn up. In a similar vein, the virtues of the three-masted sailing ship and the navigational aids developed to exploit their possibilities are a favourite example of the political economist Will Hutton (2010: 110–112). Like many who euphemise about the consequences of technology, he likes to describe them as 'disruptive', but it should be noted that for some people, like the South American Incas or the Australian Koori tribes, it did not disrupt their societies so much as destroy them.

This conflation of technological innovation with social and economic benefit produces the strange effect of asserting the neutrality of technology whilst emphasising the character of those technologies that are broadly adopted as unerringly positive. As Heidegger suggested, this is a fatal mistake, blinding us, as it does, to the values embedded in the technology and the uses to which it is put (Heidegger, 1978/2011: 217). It is simply too inadequate or confused an argument for the complexities that accompany change of the type we feel we are now experiencing, and elides the essence of technology as a force rather than an object. Our suppositions about the technology that is the printing press have thus far been impossible to disentangle from our assumption that it was surely invented at the point when a means of distributing difficult ideas across distance fairly cheaply was required. It was a representation of that idea in physical form. The techno-centric interpretation of history provides an alternative suggestion. In this, it is the technology itself that gives rise to social and cultural change.

In doing so, a further question about the assumed advantages of technological progress in itself remains to be tackled. Behind the distinctions we can make between technology and the culture that

spawns it, there is a more problematic assumption that technological progress is, in itself, beneficial and carries few long-term threats. We will discuss the detail of this further in Chapter 3, but it seems that what technology requires from a culture driven by technology itself is readjustment, often expressed (as we have seen above) as 'disruption'. The inference for those rejecting the technology is that they will inevitably find themselves on the losing side in technological history as the inevitable claims of the technology as the agent of improvement play out. This may well be true, but less for the progression of a culture than for the imperatives of economics, as the historian E.P. Thompson observed of the Luddites (Thompson, 1967: 97). Inevitably, technologies that present economic advantages or develop new economic realities find themselves foregrounded and rapidly adopted if the conditions are conducive or the opportunity for pecuniary gain is too good to pass up. Whether this brings more general benefits is far from certain.

The first revolution in technology

There are plenty of smaller and more isolated examples of the mixed blessings that technological innovation brings. But the greatest historical lessons for technology can be drawn from that first great age of technological transformation, that long process we now refer to as the Industrial Revolution. Over the 100 years from 1789, the transformation of the economies of Europe and North America came about through what most contemporary historians now agree was the capacity to capture energy, and use it to replace or augment less efficient or reliable means of powering a process. In a lesson not lost on those whose business it is to develop technology ever since, those who owned the technological framework benefited disproportionately from its implementation, largely at the expense of those whose contributions were replaced by it, or who required access to it to remain economic and social participants. The values that Kelly (2010) thinks drive technology did not bring about the smooth transitions or uniform benefits that are implicit in his arguments. On the contrary, if history is a guide, we may well be heading into a complex and turbulent future, requiring huge social effort to extract us from the yoke of domination by technological processes whose underpinning science and economics most of us are unable to fathom. There is a

specific lesson we can draw from already, and plenty of more general warnings from history in examples and analysis that ought to guide us. We should regulate our enthusiasm for the innovations of digital technology lest they themselves come to define and reform us, as Mumford noted of the mechanisation of humanity that emerged in the second phase of the Age of the Machine (1934: 146).

The Industrial Revolution was an exchange of such qualities: for the first time the human was being remodelled to the technology of industry rather than using technology drawn from human qualities. Seen in this way, it was the most dubious achievement of the industrial processes of the 19th century, and represented a significant break from the interests of science to that time. We know from the studies of technological and economic progress of the era that the scientific Age of Discovery that preceded the Industrial Revolution was indeed a moment of cultural triumph as much as a scientific one. Patronage similar to that which we readily recognise in the Arts was offered on an equal basis to mathematicians, astronomers and fraudulent alchemists of all sorts. In the 16th and 17th centuries, discovery science was not fuelled by economics so much as human curiosity, the disinterested enquiry by scholars living in diverse places to ask questions about the phenomena around them, and their establishment of methods that would assist the discernment of truth. The conditions of early modernism funded early science by various means, but certainly not from the income generated by their experiment-driven scientific breakthroughs.[3]

For all its amateurism and financial dependence as an ornament to enlightened patrons, the underlying scientific advances necessary for many of the inventions of the Industrial Revolution took place at this time (Allen, 2009: 6–7, 157). Indeed, many of the great breakthroughs began as trifles or toys, diversions or curiosities rather than serious pursuits, before imagination suggested alternative uses for the principles they demonstrated (Mumford, 1934: 101). It took the unusual conditions of Britain in the late 18th century to capitalise on these scientific advances and give them commercial application and impetus, and it is here we will concentrate.

The consensus amongst scholars of this period is that two important factors existed in Britain that enabled the Industrial Revolution to take off there and not, for example, in Belgium, France or Germany. The key technical breakthrough, the capacity to create

and use energy to drive industrial processes, was nascent in the Newcomen engine (1712), but the efforts to improve its operation during the 18th century were motivated less by science and more by Britain's high-wage economy. The relatively high cost of workers in Britain meant that processes using their labour could rarely compete with Continental businesses and products, and certainly not with the vast resources of cheap labour available in the East (Allen, 2009; Griffin, 2010). Allied to the large quantities of coal available at low rates and in close proximity, the potential for replacing expensive and unreliable workers with energy-driven machines promoted the inventive step that turned the science of the Age of Discovery into practical technology. The inventions, processes and factories that emerged were, from the first, enterprises of the commercial kind, focused on lowering the cost of production and expanding the quantities that could be produced. The flexibility of the local economy and its preparedness to adopt new methods and technology was interpreted by Mumford as a reflection of the absence of a technical tradition that might be difficult to displace by machinery. Given England's long history of importing knowledge and expertise from elsewhere to provide it with contemporary technologies, he argues, it was 'England's original backwardness (that) helped to establish her leadership' (Mumford, 1934: 152–153). This assertion of efficiency was, by and large, the main argument for the adoption of new technology up to the end of the 20th century, when it was augmented by the capacity of technology to produce value by entirely different means, a theme we will discuss often in this book. But here, in relation to the assumptions of how technology brings its benefits to humankind, the multiple consequences of this moment are useful to consider.

As Randall (1991:3) remarked, in discussing the riots and civil disturbance that accompanied the industrialisation of the textile industry in the 18th century,

> the process of industrial transformation has rarely been smooth and has frequently engendered bitter conflict. This continues to be the case since changes which threaten to destroy established patterns of work threaten more than just sources of income. They jeopardise status, security, customary social structures and concepts and feelings of community identity.

Those early demonstrations against the impact of technology, which were considerable and popular, especially in the North of England, found their fullest expression later in the Luddites. Between 1811 and 1813, they fought a losing battle against the economic force of technology, clumsily supported as it was by the British Army. As is well known and frequently bewailed, they were unable to stem the tide of technological change and its dramatic impact on the communities whose work and family traditions were being just as surely destroyed by the new industrial economy as their wages had been. This regret is usually expressed as less a defeat by technology than as an abuse of power by government. Their rebellion earned only, as E.P. Thompson put it, 'the enormous condescension of posterity' (Thompson, 1963/1991: 12). But, as Thompson himself noted, this was a simplistic interpretation of their actions made once the historical and economic forces driving them had been played out. The condescension afforded them was because they were seen to have lost the historical battle with technology. They did not engage technology as the enemy for an historical cause. Their actions were motivated by the fright of social elimination with which their communities were threatened. After the quelling of Luddite disturbances by the British Army, and the additional employment of the penal system to hang many of the participants and transport others, the resistance to the industrial innovation ebbed away, leaving only the epithet 'Luddite' in place to describe those resistant to inexorable progress, but the broader implications of their defeat defined working people's experience for the rest of the century and onwards.

The scholarly consensus since the Industrial Revolution became the subject of close enquiry is that the working classes of England were probably right to resist the unregulated impact of so much technological and economic change, and their defeat cost them dearly. This is evidenced by what was to come, the exploitation of an agrarian people, once able to choose their own working hours, practices and occupations, now forced to migrate to the cities and the factories of the Industrial Revolution to endure appalling working conditions for long hours with low wages. The misery of technological change, once the historical processes of futile worker resistance played out, brought much wealth to very few. It provided the basis for the global economic system to which all countries either joined or aspired to join. Measuring the depth of the wretchedness it brought has been

challenging for the historians of the period, resorting to records that were not developed for the purpose and methods of interpretation that leave many things open to question, but this it seems is a question of degrees, not of effect.

The impact of the new steam-powered technologies on the lives of ordinary citizens was slow, steady and eventually overwhelming as they gathered pace from the end of the 1780s. It is clear that whatever the economic opportunity of the mechanised loom on productivity, the effect on workers was less than a healthy one, resulting in shorter life spans and worse nutrition for those 'lucky' enough to work with the technologies on a daily basis (Griffin, 2010). Accounts from the Inquiries set up to inform the series of Factory Acts of the mid-19th century make the misery all too clear: the dignified testimony from the Children's Employment Commission of workers not into their teens is chilling (Children's Employment Commission, 1842) and the description of their working conditions causes consternation to the modern mind (Section M, for example, on the Warrington pin manufactures, sets out the gruelling working hours, boring tasks and abject conditions for prepubescent children).

The assumption that technological and social progress amount to the same thing looks shaky on this evidence, and contingent on what constitutes progress in either field. Conflating the two seems somewhat perverse once the consequences, the disruptive qualities of the technologies, play themselves out for those in their thrall. It becomes clear that those who own the technological framework benefit grotesquely from such changes, at the expense of those that become dependent on it to remain connected as economic and social participants. The social institutions and legislative interventions that were invented by political imagination to offset the impact of the stunning engineering feats of the Industrial Revolution, for example, were not a symptom of the development of affluence, but necessary to mitigate the force of technological advances.

As noted above, the essential ingredient of the Industrial Revolution was not the steam engine that is often its symbol, but the capture of energy to augment or replace less efficient (by which read 'expensive') means of powering a process. As such, the second inconsistency we discussed above assumes the fundamental change in the properties of the technologies themselves to be the value of technology in and of itself. Where we can observe and assess the

impact of historical technologies by measuring their effect on an economic system already in operation, it is useful to observe that the driver of technological innovation was the perceived need to have impact on processes and products already in existence in some other form. The Newcomen engine had been around for more than a century before the conditions for exploiting its properties matured, and made possible the rapid development of the secondary technologies that unleashed the tumultuous social and economic changes that we now characterise as the Industrial Revolution. As we have seen, these were driven by the necessity in a high-wage economy to reduce the costs of labour as the most obvious approach to seeking a competitive advantage. The early innovations in the cotton industry (not all steam driven, though eventually they would be), from carding to spinning to weaving, meant that British mills could eventually compete in quality and price with fine muslins from Bengal, a situation impossible to imagine even at the end of the 18th century. The science was transmuted into technology because of the commercial opportunity afforded by it, a theme repeated throughout the age of industrialism and a configuring feature of the early Digital Age of business. It requires viable business models to convert the science into the disruptive power of technology. Technology, as I have said above, is science with a business plan.

The Industrial Revolution, and what we would now define as its standard business model, was clearly focused on an existing demand for things, tangible stuff like textiles and pens and the like, moving these items downward in cost, upward in quantity and into everyday demand. Spinning thread with a jenny still resulted in the production of thread, just very much more of it than had previously been expected (though not as much more as might be assumed). Sometimes it took only marginal improvements in productivity to completely alter an industry or stimulate demand for a product. As a result, the possibility of real increases in production and real decreases in prices for the commodities thus produced were feasible. Schumpeter (1943/2010) describes these as the real 'capitalist achievement'. Indeed, they were often achieved with such devastation that industrial sectors or the workers who populated and depended on them for an income and position, who would not or could not adapt to the changes, were doomed to failure and penury.[4]

The details of this process will be examined in some detail below for their useful insights into what their direction can tell us about the social future of technology, but taking the technology at face value, its contribution was to add, and add significantly, to what I would refer to as 'the World of Things'. The purpose of industrialised production was to add to the store of stuff available to what we would now refer to as the consumer. Indeed, the expansion in production stimulated demand for a vast range of hitherto unaffordable items. It wasn't just large-scale industrial production of necessary infrastructure (water pipes, engines, building materials) but items like watches, pens or hosiery that would in turn play their own role in determining the character of industrial conditions. These were tangible benefits of the industrial process, a way in which the evidence of energy generation could be balanced against the social problems it created. The success of Matthew Boulton's enterprises in Birmingham were predicated on the development of processes that enabled larger scale manufacture and comparatively low-cost retail of objects that were previously the preserve of only the very richest, the top end of the market. Even his habit of giving some of his production away to aristocrats was a means of stimulating demand for similar stuff by the bourgeoisie.[5]

The historical record of technological advance certainly suggests that there can be tremendous gains for those who are the masters of the tech, but what of those who are its servants? Griffin's study of the Industrial Revolution and its impact on the experience of ordinary people contains a salutary lesson in the distribution of benefits in a rapidly changing economy. In the context of digital technology, it offers a counter-argument and an alternative means of assessing technological change, and some lessons about the manner of its implementation. Her work focused on how the available evidence might offer a clue as to how the vast populations of the industrialising economies of the 19th century experienced the radical changes the technology was bringing to centuries-old forms of life, beyond the cultural critique to which they have long been subjected. The results are somewhat disappointing for those wedded to the idea that technological progress inevitably brings with it economic and social reform for those most in need of it. Like Sowell (1998), she notes the availability in the UK of large deposits of coal as a means of improving energy outputs. In common with others in this area,

like Morris (2010), she uses energy generation as a metric for technological capacity. But her work combines this knowledge with that of quantitative studies of longevity, diet, mature adult heights and other contributions to the patchwork quilt of our understanding of those times, and makes for sobering reading for those who think technology represents by definition an improving force in society. The economic impact of industrialisation in the 18th century, when it is deemed to be emergent and largely reconciled with society at large, appears to be relatively neutral from the evidence available, during a period where some sort of measurable uplift might be expected. But it is the period after 1820 where Griffin detects the strongest moment of change, when the Industrial Revolution was having its most dynamic influence on economic conditions. From the evidence, it is clear that the productive capacity of the economy was significantly enhanced by the coal-using technologies that were then emerging to maturity. The mill owners and patent-holders were seeing exceptional improvements in their wealth. There are plenty of examples of such types (Crump, 2010), as well as accounts of the implications for families when economic activity moved from the cottage to the factory. The benefits for the owners and exploiters of the technology, those who could find the markets for products hitherto impossible to manufacture in the UK without the 'clockwork' to replace the expensive hands, created a new manufacturing and merchant class. However, the gains for the poorer sections of society can only be described as 'extremely modest' (Griffin, 2010: 160). Moreover,

> Life expectancy remained depressingly low in the cities; infant mortality remained high, even rising in some places; and (adult) heights were stagnant or falling, reinforcing the suggestion that living conditions were deteriorating... Considered in this light, modestly rising real wages appear a very small compensation for the high price extracted in terms of health, longevity and well-being.

Griffin even leaves out the Dickensian squalor on offer for the working classes of the 19th century. From her work we can deduce that one advantage in the technological sphere is derived from the means of exploiting the benefits as exclusively as possible, not in redistributing the proceeds or sharing the understanding. Indeed, the penurious

Crompton, the inventor of the spinning mule, was ridiculed for making virtually nothing from his popular machine, allowing the technology to enter the public domain without patent protection. On the other hand, the stupendously wealthy Arkwright was seldom out of the courts in litigating against anyone who infringed his patents on the water frame that he hadn't even invented himself.

Against this background of civil unrest and disproportionate advantage, the economic advantages of the technologies and their human cost were allowed by the authorities to progress unchecked. As Crump notes, the government 'acted according to the principle that suppression, by means of new legislation, was the best way with dealing with popular agitation for reform' (Crump, 2010: 160). The government was, in any case, only following the example of the great industrialists themselves.

They were already introducing draconian regulation into their workplaces as a means of instilling the discipline they required for the new processes into their workforce. This was often justified as morally improving for those workers leaving the land and joining their enterprises. The heavy-handed efforts of early industrialists like Crowley or Wedgewood to make a fundamental change in the responsibilities of work were justified by them as desirable social modification as much as economic advantage. This, as Thompson suggests, encouraged a movement by workers away from confrontation and towards self-preserving subterfuge and workplace resistance (Thompson, 1967: 86). Government, for its part, interpreted the disciplining of labour as the right of those offering them work and sustenance, echoing the oleaginous examples of governments of our own times and their uncritical worship of entrepreneurs as wealth creators.

Kumar, in his study of the same period, reached a similar conclusion, noting that one of the period's 'most striking features...was the virtual absence of a political, governmental element' (1978: 125). This notion, that the role of government was not to interfere with the apparently natural order of industrial change, was one with which the politicians of the time agreed and could afford to support, given both the gradualness of change and the eventual absence of direct resistance to it. It also appeared to be genuinely improving in the Methodist sense. As Kumar saw it, the justification for this stance was the contemporary view that industrialisation had to be seen as the project of the whole society and, as such, protected from the malign

influence of the state or of other nations as distorting forces. This left a massive imbalance between those who husbanded the technologies of the time, and those whose livelihoods and living conditions were increasingly defined by dependence on them.

Technology and politics

For the oppressed workers of the industrial age, it took social movements that emerged in the second half of the 19th century to counter their domination by technology and improve the basic conditions of their employment and lives beyond the workplace. Without the brutal economic exploitation of the labour force by those who commercialised the era's innovations or serviced the new demand for cheap sources of energy, there would be no union movement, health and safety culture or child labour laws for example. The British instinct for suppression of public disorder was fortified by the example of the French Revolution and encouraged by the docility of the workers themselves. Successive governments proved tardy throughout the first half of the 19th century in responding to exploitation of their working classes. Their later attempts, focused mostly on children, were almost always devoid of enforcement measures. Addressing issues like safety or the working hours of most adults happened only from mid-century onwards, despite the not unreasonable protests that were being made (Crump, 2010: 159–160). It was as the processes of the Industrial Revolution became more efficient and productive, and to counteract the impact of industrialisation, that a social conscience about the plight of others came into being with such urgency in the late 19th century.

Technology becomes validated only in the social milieu that generates it, and where its very novelty meets a prevailing ideology, there are no countervailing forces to restrain it. The use and abuse of technology gave rise to new ideas which to this day determine our interpretation of society, politics and economics. As Kumar sees it, for Marx, this was evidenced in the accumulation of special interests into centralised nation states, demonstrated by the use of national armies to put down internal strife. In the case of J.S. Mill, Kumar suggests that his support for resistance to domination by popular opinion, given the craven behaviour of politicians, was essential in establishing a democracy based on tolerance and consent. As Kumar

shows, both Mill and Tocqueville linked democracy with central-
isation and industrialisation, seeing all three forces as convergent,
interdependent and inexorable (1978: 94). The argument that tech-
nology is a catalyst for social change is agreed as the starting point for
discussion about its social impact, but an understanding of the direc-
tion from which it may be coming, or the consequences it may have,
will be severely compromised in examples that dismiss the process
and focus only on the results.

The example of the Industrial Revolution provides an alternative
version of the impact of the technological on human experience. Far
from the utopian, liberating claims that might be made, it is plain
that technology has a dark side that often remains undetected in the
dazzle of its presence.

The point is that some disaggregation of technology and human
experience is necessary to give a more honest account of techno-
logical impact and its concomitant failings. The difficulties arise
when accounts of technological progress are blended with totalis-
ing arguments about humanity itself. To conflate imaginative creative
practice of the cultural kind with technical development looks mis-
placed, and distorts both processes as we have understood them into
new shapes not previously recognised. As we have seen, the popular-
ity of doing so emerges in the absence of an explanation or agreement
about where the technology is taking us, or uncertainty about the
future and fate of the culture we already know. In the case of digital
technology, this proves doubly troubling. In any period of uncer-
tainty about the impact of new ways of living, or earning a living, the
arguments may come to look somewhat theistic in their demands to
believe in the benefits of the new. For the modern technologist we
can add to this the satisfactions of engagement and cooperation with
the Internet as a global project. Like the industrialisation projects of
the early 19th century, this promotes a greater sense of moral pur-
pose for those that seek to argue up its claims. The moral charge that
the connectedness and freedom that the Internet apparently brings
improves democracy is redolent of the late 18th-century claims by
Methodists like Wesley, who thought that time-based discipline for
manual workers made them better Christians. For digital technology,
built as it is on believing in the intrinsic value of concepts and replac-
ing the exchange of things with the circulation of bits, this takes
more than a customary level of belief in the abstract. It is conviction

as much as potential that fuels arguments about our possibilities, and it is clear that we are at one of our technological and, by association, social turning points.

Eventually, as I have already indicated, the unregulated power of the dramatic engineering achievements of the Industrial Revolution as exploited by the new industrialist class led to the emergence of new laws and social reform to protect those not so well placed to enjoy their benefits. These were as a response to the inhumanity of the circumstances that arose when economic exploitation of a workforce combined with the technology it was now dependent upon it. Such measures were introduced to offset the impact on ordinary people of child labour, inadequate education, long hours, gloomy conditions, appalling urban environments, poor nutrition and short lifespans. The technology unwittingly created a new polity and this led, eventually, to new politics. It took intervention, driven by an enlightened social conscience, to match the technologies for power and for purpose. Without the brutal economic exploitation and dependence of the labour force by those who commercialised the era's innovations or serviced the new demand for cheap sources of energy, there is no union movement, no old age pension and no health service. This runs counter to technologists' ideology that the benign technological forces in themselves always produce some quality of freedom, prosperity or justice, concepts often cited in defence of the protection of the exigencies of technology from regulation, or that the market is distinct from the polity and can provide solutions to all our problems. It is often only when the destructive consequences of technology make themselves fully apparent that there is enough remorse to change things for the better.

This reality in itself should not lead us away from technology, and that is not the purpose of this book. The urgent task ahead of us as a society is to move beyond gasping in awe at the achievements of the technologists of the Digital Age, or being beguiled by the seductive alternatives to our current lives they promise. As a society, we must begin properly to shape a future that will be shaped for us if we remain passive about the digitisation process. What we have had up until now has been a process dominated by technology and its advocates. The encounters I have described here, skirmishes in the battle between software and wetware, indicate that whilst we understand the gravity of the possibilities of the digital future, we have not yet

examined in a serious way what we want them to be for us as a society, a civilisation or a species. Too often, it has been left to the technology industries themselves to impose the technologies upon us and to define the benefits of them entirely on their own terms. Today, they do this using the superhuman strength of processing power and corporate business plans that present us with no alternatives, and our all-too-human suggestibility completes the picture for them, using our imagination and creativity to overcome their shortcomings. Exactly how this happens, and what this means for us, is the subject of the next chapter.

2
Science with a Business Plan

The object of technology

We have seen in the previous chapter how the technology industries behaved when free from restraint to impose their values in the crucible of the Industrial Revolution. The leverage new inventions gave industrial entrepreneurs was magnified by the absence of a regulatory framework and supported by a moral crusade exhorting industrial discipline as a manifestation of godliness. The extent to which this served them in pursuit of profit and economic stratification, as they swept away the old stability of the agrarian economy and its associated technologies, can be measured by the disparity between their own acquisition of wealth and the misery this created for the rapidly urbanising poor. These latter were sucked into cities without the infrastructure to cope with such an influx and threatened with starvation lest they offer their labour at whatever rate may be arbitrarily set. They endured appalling conditions that eventually roused government into intervening as a matter of protecting itself from its own citizens, despite a disposition to do otherwise and a preference for allowing the market to operate freely. We have seen there is plenty of evidence to suggest this was a poor deal for those who were forced to accept it, but regardless of the concomitant problems, it was not without some seductive benefits. It was the existence of these that would ultimately make acquiescence possible.

Whatever the wretchedness inflicted on the workforce, amongst the great feats of the era was the expansion in productive volume that occurred. This was achieved firstly by the capacity to capture energy

from sources other than human labour, especially (but not solely) by the coal-fired technologies that emerged as viable alternatives to manpower in the late 18th century. This is not the whole picture, as Mumford (1934) elegantly illustrates when he charts the irreconcilable demands of the disciplines of the monastic day as it turned into the factory shift (reified in the evolution of that most powerful and precise of early technologies, the clock), with the vagaries of the best utilised energy sources known to that time, water and wind. Technical ingenuity in harnessing the new sources of energy for improvements in production volumes and product quality was the necessary corollary of a reliable energy supply. Coal eventually triumphed, and did so not only because of a plentiful supply, but because it conformed to the practical purpose of keeping the works running.

This effort would have counted for little (and it should be noted that Matthew Boulton often declined to sell steam engines to coal mine owners when, in his assessment, it would make little economic difference to their situation[1]) had the other major challenge for technology not been identified. As significant in the history of industrialisation as the capacity to generate power would be, the need to overcome the dependence on skill or craft possessed by manual labour is at least its corollary. This factor remains a powerful influence on education and creativity, and can be traced to the ingenuity of the clockwork in replicating human craft skills, as we shall see. Regardless, in growing ever more effective as the century drew on, these two factors undoubtedly resulted in the creation of a new supply of goods that had previously been available only to the very wealthy. It enabled significant expansion of markets for such stuff as textiles and metal goods, with material improvements in design, housing and manufacture that moved these previously luxury goods into the purview of even the most modest of consumers.[2] What emerged from this was the understanding that scientific breakthroughs would always be limited until they were oriented towards business planning.

The Paleotechnic Age

Armed with this new set of postulates, the industrial concerns that sprouted as a result of plentiful steam power conjoined it from the outset with removing or replacing their enterprises' dependence on

skill, above and beyond the opportunity to demonstrate the raw power or energy in the form of rail transport or the power loom. As these technologies multiplied in what Geddes (1915) called the 'Paleotechnic Age', a fact emerges from the histories of these technologies, and their scientific provenance in particular, that becomes inescapable: the key relationship for a given 'paleotechnic' technology is not with science. This historical legacy, which Mumford (1970) identified as emerging from a Baconian view of the instrumentalism of discovery, elides a far more important coupling for the history of technology. The conflation of science with technology miscasts scientific curiosity to perform a function for which it is clearly not designed and has rarely cared for: the Age of Discovery was looking to identify the qualities of nature, not to exploit them. This shift set science in a clumsy partnership that is not necessary for it to function, and indeed technology often abuses science in ways which are intentionally contrary or a perversion of it. This association doesn't sufficiently support an understanding of the forces that produce technology and technological change. The more serious interdependent relationship is not between science and technology, but between technology and economics. In particular, those who master the processes of power, in law as much as in technology, as Arkwright's or Edison's enterprises show, take command of an age in doing so. This was a fact Geddes understood perfectly well a hundred years ago when criticising the 'machine-and-market order' that was assumed as man's destiny and his evolutionary achievement, debasing as it did even those whose best humanitarian efforts were directed at mitigating its worst excesses (Geddes, 1915: 62). It is what economist Brian Arthur unwittingly confesses when he declares that 'a technology that exploited nothing could achieve nothing' (2009: 46).

The invariable object of technology since the Industrial Revolution has been the pursuit of profit, disguised as a demand for efficiency. As a rationale, it provided competitive advantage, defined by the need to reduce costs, especially labour costs, and to expand productive capacity through ingenuity in the name of progress. As Mumford identified as the Age of Steam was drawing to a close, this was often emblematic or symbolic rather than a realistic assessment about the relative capacities of a technology (1934: 161). Quite irrationally, steam came to stand for efficiency in much the same way and with as little evidence as Davis (1998) identified for the personal computer

of the 1990s, or Lanier (2010) cites in his railing against the ubiquity of MIDI systems of the 1970s. Once an economic infrastructure begins to accumulate around these technologies (and that is the aim of their business models), they become difficult to displace. As a consequence, they begin to act as a metonym for innovation rather than having some specific, demonstrable qualities that may be usefully applied to the task at hand. This diminishes the notion of market-determined purity of technical superiority into a game to exploit the existing infrastructure whilst arguing up the benefits of their extension in the form of saleable products.

Labour-saving devices are in reality makers of labour redundancies, creating the nexus of conditions required for the miseries of the 19th-century worker we encountered in the previous chapter and the mass unemployment of university educated people in our own time. Setting aside the claims of technology as an enabling force, these can properly be seen as the two main thrusts of the technology narrative. At this point it helps to restate a dictum voiced earlier: technology is science with a business plan, rather than science itself. This distinction is important to bear in mind as it helps to explain exactly why some technologies find themselves adopted and others are seen as failures. In the latter case, failure of a technology is linked to its performance in the market, not its effectiveness in resolving a problem, and that success is dependent on many factors, not all of which take into account its suitability or quality (remember BetaMax?).

As we have seen from the example of the Industrial Revolution, the engineering concepts that underpin technology have been based in an ideology of efficiency that focuses on cost and volume of output. The neo-liberal justification of this process, set out by Kelly et al., is a distortion of the Schumperterian concept of 'creative destruction'. The assumption is that despite the personal tragedy that tumultuous technological change may bring to individuals, the destruction of jobs, systems or processes is the inevitable means of creating new ones, making the process a kind of capitalist purification ritual. Schumpeter would not have recognised this oversimplification of his key idea. He noted that the sort of 'perfect market' assumed by economists of his day (and ours, as Joseph Stieglitz pointed out in his introduction to the 2010 edition of Shumpeter's work) simply doesn't exist, and that market distortions are the result of many factors, including the behaviour of companies with something to gain or lose by taking their own perverse actions in the market. The literature on

creative destruction of this type focuses almost exclusively on corporations, whose governance lacks the individual accountability that might come from other forms of organisation, and whose actions have been anonymised and justified on purely economic grounds. It is apparently fine to abstract human experience in this way, mitigating as it does the pressures and trauma created in its victims. We can also see that such destructions are not always permanent. Vinyl is making a comeback, and despite all the strenuous efforts of oil companies in the 1920s and 1930s to obliterate the tram forever, light rail has returned to many UK cities.

We saw in the previous chapter the impact this had in the 19th century on an agrarian population forced to urbanise to survive. How does its 21st-century counterpart cope with the demand to digitise, and indeed, where is the evidence that this is quite as urgent as is being forced on us? The public debate about the social impact of doing this is currently obscured by the singular assertion that economic growth in advanced economies can only be achieved by such a process. We must accept the digitisation of our workplaces and our home lives as the price to pay for economic prosperity. We must adapt and retune our analogue skills to the digital economy because, we are constantly reminded, there is simply no other way to grow.

The Internet economy

Nowhere is the ideology of technology as the benign source of exciting freedom more respected and conscripted than in these discussions of economic prosperity. The lesson that technology is science with a business plan was learned the hard way by some in the dot.com boom and bust at the turn of the millennium, when the enthusiasm for the science met some harsh technology market realities. We will return to why this happened, and how this has determined the mindset of digital technology entrepreneurs ever since, but there is a slightly more pressing issue to examine, given that we live in a moment of profound economic crisis. The crisis, exacerbated by the ability of digital technology to enable bankers to execute complex and unbelievably swift trades with ever more complex financial instruments from anywhere in the world, is seen with some irony as a great opportunity for reasserting the economic importance of digitising the Western economy, from schools to aged care, from spreadsheets to computing gaming, from social

networking to e-commerce. Indeed, shrill exhortations from the technology industry continue to insist that it is the *only* possible route for economic growth in the future for Western economies, the Internet delivering as it does a worldwide market with low distribution costs.

A reasonable question to be asked, then, is what does the Internet contribute to the economy? Indeed, it was exactly this simple question that was posed to the consultants A.T. Kearney by the chief executive officer of Vodafone, Guy Lawrence, in 2012, resulting in their report 'The Internet Economy in the United Kingdom' of the same year. The answer to Lawrence's question was not quite so simple: whilst the Internet is now ubiquitous, and represents half of all media consumption, the 'value chain' of the Internet itself represents less than half of the £82 billion pounds claimed as the 'total UK Internet Eco system' (Page, 2012: 3). The bad news for Vodafone is that capital infrastructure investment is a disproportionate component of that figure. The maintenance of this infrastructure demands similar investment, requiring regular upgrading of networks as technology improves and customer demand increases. This kind of infrastructure is not permanent like the Victorian sewers or extendable like the early 20th-century electricity grid. It requires complete replacement on a regular basis, as new means of resolving technical difficulties meet ever-expanding demand. The return on this heavy investment, despite the expanding revenues, are projected as being flat. This is despite a five-fold rise in network traffic predicted during the same three-year cycle. The trouble is the necessity to replace the infrastructure on a rolling basis for meeting the demand of consumers for cheaper and cheaper services accessed through them.

But what isn't clear is what the contribution to the economy from the Internet actually consists of. The report wisely separates out the e-commerce components from the infrastructure (referring to these businesses as 'e-enabled'), and we are essentially left with the rump of Internet services like search tools, connectivity services, hardware manufacture and software development. Two-thirds of the value in this economy is located between the computer and the web service. Of the £11 billion remaining in this value chain, more than half is advertising. As the report itself comments, although 'online services are perhaps the most obvious part of the value chain to the consumer, the size of the connectivity and user interface markets highlight the prominence of infrastructure that delivers those services' (12).

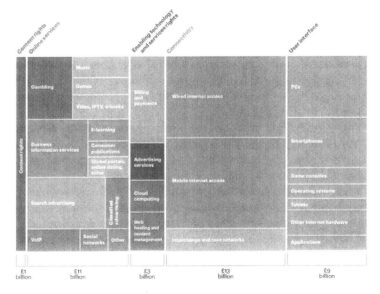

Figure 2.1 From the Kearney Report, indicating the location of value in the UK Internet chain

Source: The Internet Economy in the United Kingdom, copyright A.T. Kearney (2012). All rights reserved. Reproduced with permission. Available at: http://www.atkearney.com/documents/10192/260353/The_Internet_Economy_in_the_United_Kingdom.pdf

The infrastructure, it turns out, is a disproportionately expensive and frighteningly transitory method of delivering very cheap or free services. It also struggles to cope as demand rises, noting the infrastructure is global and more instable for this very reason. The Sky Deutschland broadcast of the first Champions League match of 2013, Bayern Munich versus CSKA Moscow, was frustratingly buffered, the process by which a small amount of data is stored to ensure continuity of viewing. It gave rise to angry web subscribers' complaints to the station from virtually the beginning of the match. It took until the second half for the broadcaster to work out that Apple's iOS 7 had just been released in the United States, and it was this upgrade that was sapping the bandwidth to the modest number of subscribers who were watching in this way. The infrastructure, despite the significant investment made and remade in it, was not capable of supporting the

demands of a relatively small number of customers, even at this stage in its development, and it will require regular reconfiguration and refurbishment to keep pace with the voracious appetites of the users of services. Moreover, an economy like the UK's does not participate greatly in the production of the means to connect: where there is the most value in the Internet economy, the nation, like most Western countries, imports and outsources.

This significantly weakens the argument of the Internet as a driver of economic growth, though it also explains the oft-times overwhelming contributions and threatening presentations made by technologists about the future of the economy of the consequences if their demands for further investment are not met: we may be disappointed when we discover we have reached the limits of the technology. By conflating the capacity of science with the potential of your competitors, they excel in creating a certain level of fear, stirring up a technological arms race as the means to continue funding investment and to show profit in their own businesses. These are rarely involved directly in the development of the infrastructure, but are riskily dependent upon it nonetheless. This has also pushed the technology industry to new heights of ingenuity in finding a use for the expensive hardware and interoperable capacity into which it has managed to inveigle us all to invest. So, consistent with the exploitation of existing infrastructure as a means of eliding the absence of technological innovation, companies involved in social media have examined the potential of the bits to operate in relation to the lives we already have. The new business model for technology is how to smarten up the urban environment around us, using our smartphones or our PCs to resolve all the small irritations in life: when is the bus coming? Where is the nearest garage? To whom do I report this litter? What do I need at the supermarket? A flow of the day-to-day trivia that constructs our lives seems about the best that can be offered. Consumers also seem to be perfectly happy to pay for it as well, but only directly in small transactions for apps, or indirectly through the advertising that is supposedly better targeted, yet still remains a ubiquitous irritant.[3] The rise of the app is the technology industry's ingenious solution to reducing the options for users to access other providers' content, or encountering critical content they might find via a conventional web search for a brand, being directed ever more specifically into the domain of the provider

once a download happens. It is the antithesis of the governing principles of the Web, which emerged from a scientific culture of sharing. The intention of these commercial applications is to overcome the capacity of the users to seek answers elsewhere, but be satisfied with what they can get from a proprietary platform.

The phrase 'the Internet of Things' has grown up around this concept, broadly defined as the means of identifying all the stuff we have and managing our needs for it by linking it to us via the Internet, often via an app. It posits the future as one informed by the constant vigilance of technology in supporting our needs, whether it is to order the shopping or to prevent the onset of boredom. Indeed, I am frequently struck in my international travels by how similar the pastimes of commuters are between big global cities, with those on the Muscovite Metro as avid fans of Candy Crush Saga as their counterparts on the London tube or the Berlin U-Bahn.

This does not exactly reflect the promises or speculations about digital technology as an economic (or political) force. Some of the complaints about its limitations are visible through examining its present claim to be the exclusive platform for future wealth generation. The patterns of the recent past suggest that rather than generating much that is new, the Internet is more a repository of stuff that is old, and we simply consume it differently when we use the mediation of the World Wide Web. The Web at least has the property of opening the world up to us. For commercial apps, the desire to bypass the Web completely is overwhelming. From accessibility to a wide range of source information and sources about the same thing, we now corral users into the app, retaining them in the narrow space defined by the provider, who sells their enforced loyalty to the advertiser.

The historical deployment of technology as an efficiency measure is usually one requiring less investment after time, especially in labour. The quality inherent in digital technology to create economic prosperity seems somewhat mysterious, and certainly the argument about how it contributes to economic success is different. The commodity is not the tech but its users, and holding on to them is a rather tricky business. Often, as shown in Andrew Keen's (2012) pursuit of cashed-up Internet entrepreneurs, it seems it is only the credulity of corporate investors that keeps afloat the notion that there is money to be made through buying up a popular app or a website from their

creative founders, only to find their investment considerably reduced by the imposition of their corporate governance. It is commonplace to suggest the corporates 'don't get it', that their models lack the imagination and innovation of the founders, but there is also the nature of the Internet itself that means all projects eventually run aground. The Internet is like vast grazing lands, where the cattle wander off in search of something new once their appetite is satisfied in one place.

Quite rightly, the initial innovations of digital technology fell into the broad category of the 'delivery systems' of one sort or another that concerned Jenkins (2008). For communication technologies in particular, the lineage has a fairly conventional feel to it: semaphore begets telegraph begets telephone begets Internet. These things represent a continuity of intention, if not exactly in technology, demonstrating the same idea reprised in a new iteration. It becomes useful to expand Jenkins' usage slightly (which is mostly applied to the consumption of cultural production, like videos, books or music) to accommodate the extended capacities of better bandwidth and faster graphics processors, to make the case about the quality and direction of innovation that we have as a result. What is clear is that whatever digital technology is or could do for us, no one seems to think they can gain a great deal in the long term from the hardware it runs on.

The hardware

Digital technology, for all its wonders, creates a modest boost in economic demand in a direct way, where production is stimulated for the products of technology (computers, mobile phones and the like). But this is science with a business model, and there is a reason why many of these things are often either given away, in the case of mobile phones, or heavily discounted in the guise of, say, games consoles. The Aakash, a tablet computer available for Indian students for a mere $35,[4] could not possibly cover its manufacturing costs. Likewise, Russian oligarch Alex Shustorovich's E-OK tablet[5] is 'loaned' to 'lucky' Russian schoolchildren for free. Shustorovich's aim is to build 'a giant, real-time spreadsheet of personal data. Once millions of teenagers get used to learning, interacting and connecting

on Shustorovich's proprietary system, then what need will this and future generations have for social networks such as Facebook?'[6] The economic opportunities these young people represent to the owners of their means of connectivity are the justification of limited technological distribution, locked in to the technology as supplied, about which we cannot feel anything less than ambivalent. Authorities like universities, education boards or local government are delighted to have the cost burden taken from them in exchange for proprietary access to the online behaviours of their students and citizens. The exchange value of the bits they generate creates a new economy, of selling direct access to the choices and decisions of users.

The philosophical shift required for the technologist and citizen alike is to understand that our economy and our culture has left the World of Things and entered the World of Bits. We have become entirely dependent and focused on small chunks of information, the mastery of which promises to unlock riches in the same way as the application of the steam engine once did. That such riches are certainly possible on the individual scale is without doubt. That a couple of post-grads can start Google, or a college drop-out creates Facebook are encouraging stories of the acquisition of wealth that dwarfs tales of Mancunian mill owners or American railway pioneers. The manipulation of bits has spawned a huge industry devoted to it, in ways both practical and abstracted, but this isn't the area that attracts justifications of technological interventions. Nor does it represent the basis of arguments adumbrating our technological future, what it will look like and why that image, in itself, is presented as the inevitable destiny of our culture. The hardware is the technology of background. It does not attract the kind of interest or form such an obvious part of how our daily lives change as a result, regardless of the contribution it makes to that change (which, as I have said, is not inconsiderable). Instead, cheap hardware is the hook to creating a dependency, the so-called *razors and blades* technique for charging for the services that can be sold through it, and locking the user into a specific money-making platform for the owners of the tech. Their focus is in providing services and content as exclusively as possible in their framework. This part of the discussion is left out of academic conferences that focus on the potential of the science,

but such restrictive technological solutions often feature quite heavily in the presentations of the psychopathic capitalists that happen in the commercial sector. Their enthusiasm is a gruesome combination of the pathological need to control and bug-eyed avarice, offering a glittering future for those who can insinuate their technology platforms on the unsuspecting, creating devoted users that will keep the cash registers ringing with advertising dollars. It is worth noting that Mosaic, the first World Wide Web browser, was invented by researchers from the National Centre for Supercomputing Applications at the University of Illinois in 1992, a time when the Internet was seen as a cumbersome library inhabited only by academics and the military. When support dried up internally, the Netscape venture that succeeded it (with most of the same personnel) took with it the ethos of flat structures and user decisions. This culture made it more difficult for commercialisation of the Internet to take place via the Web, given that its early users enjoyed the freedom this provided. It took the proprietorial Apple to bring this to a close through the invention of the smartphone and its monocultural app environment.

The seductive draw for speculations about the future of digital technology, and reinterpretations of its past, are built around the capacity for digital technology to reduce what were apparently tangible things into binary code, effectively to make redundant the World of Things, encouraging this notion that our destiny belongs to the World of Bits. The assumption that this can adequately compensate for our sensory experiences in cultural and economic terms is quite a promise. This is reflected in the ambitions of the 'Internet of Things', conspicuous in its lack of definition, except in the aspiration to make claim to the material world. In our current experience, both technologically and economically, the bit, that tiny switch simply indicating if the signal is on and off, has already forced economies, companies, governments and education systems into reorganising themselves in order to make best advantage of the opportunities for growth presumed to flow from control of it. Having learned the lessons of intellectual property (IP) exploitation from the past, and seeing the popularity of the possibilities of a bit-based culture, the opportunity to renew their operational models is seductive. This reorientation is predicated on the conviction that the underlying technologies will be the determining force of our economic future. The social impacts are already assumed, on some pretty slight evidence as well, in some

of the more ludicrous speculations about their potential effect. There is something seductively attractive about the idea of the Knowledge Economy, of an economic and social system built on principles of the exercise of human intelligence for societies that feel they have outgrown or can't compete in the dirty World of Things. However the thought is expressed, the notion has taken root that the future of advanced societies is based in the capacity to create financial value out of ideas, and that this is critical to the future prosperity of such economies. This is despite some disappointing realities about how that has played out in practice, as we will see.

The secular sermonising about the link between the expansion of the Internet, the freedom it provides as a space and the attenuated arguments about pious links to the spread of democracy seem trite. They are a poor compensation for the privilege of giving over every aspect of one's private life to the public space of the Internet for the proprietary benefit of a technology entrepreneur. Social and economic participation for all of us is now increasingly dependent on digital technology in which few of us have a direct economic stake, but will all rely on as the only available marketplace for ideas if the best hopes of technologists are realised. Worse, like the Industrial Revolution that no one identified as such until it was more or less over, it has come upon us without our really noticing, and certainly not in any planned or orderly fashion. Indeed, the regular successes of tech companies in influencing the authorities not to legislate against their interests are evidence of the extent to which their arguments about economic growth through connectivity have been accepted. Likewise, the responsibility for abuse of their services is laid directly at the feet of their users. They are a force that will not be denied their autonomy, whether it be in tax jurisdiction, employment law or data confidentiality.

This ubiquity provides the gauze through which we now experience the world. It is evidenced by the shift in our notions about what and where we locate value, and how that affects our economic and social activities. We have taken our tentative steps as a society to relocate value, real economic value, away from things. Things are the commodities and industrial production and manufacturing capacity that the Industrial Revolution was so adept at creating. At the urging of technological boosters like Nicholas Negroponte, we have placed our faith in bits, those particles of individual information that make

up the substance of anything digital. As the fundamental element of digital technology, these tiny pieces of information into which all our digital production must be broken down, the bits, it turns out, are always cited as the only possible future of our economy. This is a jump we are being impelled to make without evidence for the need for it or a broader based discussion about its social implications. At its best, technology might make us change, but perhaps not in this direction if we gave it some more thoughtful reflection. The importance of the business plan in achieving this level of dazzle cannot be underestimated, though its effectiveness in introducing new technology is haphazard at the best of times. Patterns of new technology usage emerge at least as often through user decisions as through the planned implementation of companies, which are often scrambling around trying to understand how exactly to understand the behaviour of their customers (think of text messages, for example, whose day may have been brief, but was entirely unexpected).

A monopoly on information

If technologists regularly and erroneously declare the historical success of the market in determining the value of a technology, they believe even more in a monopoly. The proprietary nature of technological innovation is an integrated part of the business of technology. As we have seen, a key component of early Industrial Revolution business practice circulated around the development and exploitation of IP. Towards the back end of the 19th century, as technologies grew more complex, the distinction between the processes and the marketing of them became more critical. Amongst the best examples of this, and particularly apposite given the company concerned went on to become IBM, was the invention of a punch-card system for accounting, first used in the 1890 US Census. Under the leadership of inventor Herman Hollerith, the precursor of all digital technology businesses set about establishing itself to exploit its technological superiority through the legal system as much as through market demand. It is useful to understand how that original experience of innovation was translated into a business model given that it has been such an influential example.

Hollerith's career as an entrepreneurial technologist began in 1884 when he filed his first patents to protect the technology of his

'Apparatus for Compiling Statistics'. His experience of working on the 1880 Census as an agent had awakened his creative engineering impulse. The challenge of a rapidly expanding population whose accurate assessment had political implications for taxation and investment was being compromised by the census' increasing reputation for dubious quality. It occurred to Hollerith and others that this could surely be resolved by doing something more than adding large numbers to the census payroll and continuing its unreliable data-collection methods. According to Pugh (1995), in his hagiographic corporate history of IBM, it was Hollerith's colleague on the census, the physician John Billings, who first suggested the potential of a perforated card system for doing the routine work of tabulation. Billings wasn't interested in exploiting the idea, but Hollerith clearly absorbed the possibility of it as a practical solution to the vagaries and errors of existing statistical modelling, and more importantly, as a business idea.

From there, two beneficial things happened to Hollerith: the first was his appointment to the engineering department at MIT. His former census supervisor, Francis Walker, had become president the previous year, and had been much taken with Hollerith's enthusiasm with resolving statistical problems through engineering.[7] The second was his consequent move to Washington as an assistant in the Patent Office. This gave him experience of patent law and the conventions of patenting, but probably more importantly, and consistent with the history of the exploitation of IP before and since, access to the patent applications of others working on the same or similar problems. Whatever his virtues as an engineer, this move enabled the use of the intellectual capital he now owned in the form of patents, background IP and his contacts in the Census Office to be exploited on a major government project. This was a serious challenge given that neither his use of punch cards nor of an electrical circuit to detect the punched holes were, strictly speaking, innovative enough steps to justify a patent. To resolve this, he constructed a prototype device, and it was this that formed the inventive step that saw him granted three patents in 1889. In the meantime, in a diversion into braking systems for trains, Hollerith would learn another lesson about technological adoption. In what we know now to be something of a cliché of technological entrepreneurship, he discovered first-hand that the best science does not always get adopted as a

technology. Having proven the superiority of his design for electrical air brakes, he still found that the dominance in the train industry of the Westinghouse Air Brake Company pushed him and others out of the field. The train companies preferred to stick with what and whom they knew.

As far as the punch-card system for tabulation went, and notwithstanding the invaluable support of his insider network at the Census Office, Hollerith's system was undoubtedly better than its competitors. We know this because the Census Office set up a test in 1889 between the three main competing systems to prove it. Hollerith's machine beat the others hands down and was duly selected to process the data for the 1890 Census, though not without some residual concerns expressed about the fairness of the selection process given his connections there. But it was the business plan that accompanied this opportunity that would define the way the as yet unborn IBM would operate. Rather than sell the census the machines it needed, Hollerith proposed renting the machines to the US government, at the then eye-wateringly steep sum of $1,000 per machine. For that amount, Hollerith would take responsibility for the maintenance of the machines with financial penalties imposed where they were not in working order.[8] Given the census would require 100 of these machines, the cost was astronomical, and forced the census to consider day and night operations as a means of reducing the number of machines it rented. When the shift-work patterns proved unsustainable, the Census Superintendent Robert Porter negotiated a further batch of machines at half the cost, with Hollerith agreeing only on condition that they were not operated outside stipulated working hours (Pugh, 1995: 13).

Despite the success of the tabulating machines, their suitability for census work limited their commercial applications (aside from some European nations using them for their own census needs). Hollerith turned to the railways as having the sort of complex data needs that his cumbersome machines could support better than the smaller desktop calculating machines that were also emerging. Given the relative expense involved in confirming the sale of an installation and calibrating it for the data required, as well as an unwieldy deal over patent rights in the UK, the business only expanded slowly. It took securing the contract for the British Census in 1911, and some further

expansion into other European markets eventually to stabilise the company. By then, Hollerith's limitations as an entrepreneur, and his preoccupation with practical detail, would combine with concerns about his emotional well-being to question how the company could move forward with him. He was becoming temperamental and unpredictable, and it was having a marked effect on the reputation of the company.

At the newly renamed US Bureau of the Census, an incoming regime was also concerned about the business model for using Hollerith's machines. Improvements in the machines saved time, but added significantly to the cost. The government was being charged per card processed, giving Hollerith an incentive to improve this aspect of the machine, doubly so considering he was also the sole supplier of the cards. As Pugh puts it, 'the faster his machines worked, the more cards he sold' (Pugh, 1995: 21). The tempo of the times, however, was in reining in the tendency to monopoly that major capitalists preferred to the uncertainties of market competition. The Sherman Antitrust Act (1890) was being more frequently invoked to inhibit companies from seeking to make competition in a market impossible, either through cartels or monopolies. This was especially so after the elevation of Theodore Roosevelt to the presidency in 1901, and would cause great trouble for Hollerith's successors in deciding how to exploit the value of his patents.[9] The result was a bad-tempered withdrawal of the machines from the Census Bureau, who had been working on alternative machines in the knowledge that the original patents were, in any case, due to expire.

The process having taken its toll, Hollerith agreed to arch-monopolist Charles Flint's proposals to merge the company with two others, under the eventual chairmanship of the legendary Thomas J. Watson. This resolved the long-term problem of sufficient reinvestment in research, but the patterns for exploiting IP in the technology business had been thoroughly established by the manner in which Hollerith developed his tabulating machines: it placed a premium on owning the entire process, from hardware to software to consumables to maintenance to data.

As the company proceeded, it discovered even more ways of taking the operations further away from potential interference from its customers. Eventually, it came to the conclusion that it should define

the types of data that clients could request as well, and imposed limitations on the sharing with clients of what it thought they needed to know. It did so whilst generously arguing that this lifted from them the burden of responsibility for all those bits. The premise was that clients would be (and indeed they often were) grateful for their dependence upon the company, and even if they were not, or were not happy about it, there was no escaping the system once it built up a powerful monopoly based on IP, customer dependency and research investment.

For IBM, and every technology company to come afterwards, the premise was simple. If you own the process, you should deny access to its secrets wherever possible, something IBM were comfortable doing for years. It was hugely successful for many decades, and remains the formula that Apple, for example, continues to employ. What other product can you buy where the manufacturer retains the right to modify or upgrade the features it has as they see fit or to determine how it is you are going to use it? They can make it redundant at their behest, restrict your use of it without notice or share the information you generate with it. Worse, they can limit your imagination about what it could do, exchanging this for the parameters they determine. The complexities of Photoshop, however sophisticated, are finite, and it is now so ubiquitous and central to the process of image-making that many of us can no longer imagine how to manipulate an image in another way, a matter we will deal with more closely in Chapter 5. Only in the world of digital technology does this opportunity exist, what Zittrain (2008) calls 'tethered devices', iPhones that turn into iBricks, alterations in operating systems that disable third-party software, changes of chip manufacturer that leave expensive machines incapable of updating or rows between companies that leave crucial programmes out of hardware releases. For all the technology industry's clarion calls for market freedom, criticism of government participation, lack of contribution through the taxation system or dismissal of concern about their intentions, the strict enforcement of their IP remains one area where the businesses that characterise digital technology as a force for freedom, best left untouched by regulation, demand the fullest protection of the law. It is support they frequently get as well, with government only ever stirring itself in this area to intervene to protect and extend their IP rights (Lessig, 2004).[10]

Coping with the business plan

The historical moment we have arrived at is the point where, for a certain proportion of the educated population now in full maturity and at the height of our influence as a generation, the changes from telephones with cables and rotary dials to ones with screens and area coverage has occurred well within our working lifetimes. We have been witnesses to the moment when so much of our cultural experience turned from manufacturing to exchange, from things to bits. The astonishingly rapid progress of the technologies is undeniable, as is their capacity to reconfigure the social experience of those seeking to understand them. This is not solely an issue of technology, but from the changes to everyday experience itself, especially the impact on cultural production, distribution and consumption. The GenXers (of whom I am one) are not so bewildered by such change, confounding Toffler (1970), who thought we would all be suffering future shock by now.

We have been the instigators of it (or at least its early adopters) and its enthusiastic advocates. We are curious as to what it is that can now be exchanged given this exchange was our response to the unavailability of too much to which we wanted access. Looked at as a social process, we invented it, or at least provided the market for the business plan to approve effective. The slow pace of change in a record industry in denial, for example, opened the door to the much more serious phenomenon of changing things into bits by its hitherto regular customers. In the absence of a formal process initiated by the record companies, they began exchanging them with speed and flexibility unknown in the past. More importantly, they discovered this could be done at no cost. Such a failure of imagination was catastrophic for the recording industry because of its obstinate refuting of the redundancy of its business model that had served reliably for decades. It underestimated the potential of the technology to meet the needs of its own customers, and the tech savvy of a coalition of people with a curiosity about helping them. Matt Mason's (2008) analogy in this context is that of genetics, once again drawing on a kind of scientism for justifications of new conduct in the digital domain. Noting the relationship between freedom and economics, and the dangers of a profit-seeking legalism acting as a scavenger on science, he observes

that it is the absence of trust that encourages pirates. The motivations of the companies were to preserving their preferred way of working rather than responding to customer demand, with the resulting anarchy that required enormous legal and technical effort to salvage.

But this was simply the first phase of a digitised rebalancing of economics and culture. Computers found their way into the workplace as the means of resolving problems that already existed, the efficient management of information in particular. This was certainly the claim originally made by IBM, and more latterly, and rather more speciously, from the 1980s onward, by Microsoft and Apple. Interestingly, it remains a somewhat disputed assertion, with a number of studies pointing to the expansion in the volume of data enabled by the introduction of computers as fatally undermining their pretensions to efficiency in the modern workplace. On the other side of the ledger, if efficiency were really the prize for expanding computer use, why do so many employers resort to email monitoring, keystroke logging or Internet filtering?[11] Lim's identification of 'cyberloafing' (Lim, 2002) as a new office activity would scarcely be possible without networked computers. Her condemnation of such behaviours is the modern equivalent of Thompson's identification of worker observance of 'St. Monday' in the 18th century. She accuses workers of using personal justifications to sufficiently rationalise their work time habits of cybersurfing whilst looking industrious. In doing so, she omits the possibility that some of it might be a response to the Sisyphean tasks of the modern work environment, from the overload of information facing them in the company email box to the impossibility of individual action in the team-oriented tasks that constitute the corporate life she was investigating. As Gleick (2011) has recently pointed out, we are now awash in a flood of data from which we can often only with great difficulty retrieve what it is we are really looking for. This is frustrating, and not very efficient, a direct result of organisations where everyone can type and publish their work, and legal obligations real or imagined make deleting anything a difficult and emotive task.[12] Exactly how we got here needs some consideration, especially as it seems to have happened without our noticing or being asked for consent, save those ludicrous End User Licence Agreements (EULAs) that get in the way of using the software.

The new efficiency

It was only after the computer's adoption by the World of Things that digital technologists began their own push to create a World of Bits, noting that historical models of dependence were the ones that appeared to be the most profitable. The technology industries focused in the first place on improving 'delivery systems' for existing things, reflecting the model of efficiency they had in mind, noting their intentions to keep computers expensive.[13] Only after having become accepted, a computer on every desk, did they move on to the new agenda of pursuing digital opportunity as a justification in its own right. The idea that computing could be seen as a cult was reinforced once it was adopted in fields in which it creates no value other than dependence on its use. Such fetishism has benefits for the technologist, but it is less clear how the introduction of computers to the classroom, for example, amid great hype about their efficacy as learning devices, has done much more than to close the circle and simply stimulate pupils to learn more about computers and proprietary software at the expense of any other sort of learning they might be doing (Bauerlein, 2008).

This is the reason why many of the things of digital production are seen as the bait of the business plan, whether they are free mobile phones or heavily discounted games consoles. The products of digital technology are not the tangible things that our predecessors in the 19th century, engaged in their own technological revolution, were seeking to manufacture as part of their own profit-making schemes. Equally, this is not to say that digital technologies are not engaged in improving the production of things. They certainly are, and in many ways are both practical and abstracted, but this isn't the area that attracts the boosters of technology, nor does it represent the basis of arguments that endorse our only possible future as a technological one. The seductive draw for speculations about the future and reinterpretations of the past are built around the capacity for digital technology to reduce apparently tangible things into binary code, effectively to make redundant the World of Things, encouraging the notion that our destiny belongs to the World of Bits. This is the magic that astounds in its simplicity. The new possibilities for production through bits are based on the sophistication of First World societies, their expensive labour costs and their assumption that bits will

generate economic growth. Technologically and economically, the bit, that abstracted, easily decipherable and reconstitutable switch, will define our future, and that means the culture that goes with it. Given the absence of resistance to this modernising project for mankind, and having noted some of its present limitations above, we should also survey some of the more riotous speculations about its future impact.

Central to this is a battle about who defines the future and how closely that future will be tied to technology. The digital technologies, as they now exist, were at least part of our imagined cultural future once not so long ago, just not the most exciting part. The flying cars and jet packs have taken significantly longer to emerge than ubiquitous information and ever-present connectivity, and there are clear reasons for this that ought to alarm us about what existence might turn into under their domination. They are also short on specifics in exactly how they can stimulate economies currently in serious trouble. The capacity to calibrate and redistribute risk has been one of their significant early failures. The colonisation of every social media platform as a new means of advertising has been their most durable initial success, for all the dubious benefits this provides. The narrowing of web choice into app structure tames the wildness of the Web into the new mercantile opportunity that the Web itself struggled to deliver. For now, social media are certainly the present: for most people in the sophisticated post-industrial economies that represent the wealthiest societies, we use them on a daily basis to do the everyday tasks of working and living. This happens in an expanded world that can easily include close professional relationships with others across the globe, some of whom we may never meet in person. It enables collaborative propositions built on mass participation or marketing opportunities that can be directed to the smallest subset of those who might make a global industry for something viable when a local industry might collapse through lack of demand or fatal variations in the regional economy. We only ever dreamt about such stuff in the quite recent past. But we also feel we are still just guessing at digital potential. For all the changes digital technologies have wrought in so short a time, there is something about the technological present that leaves us uneasy. Our imaginations play with the possibilities of a future, informed by an interpretation of our knowledge of how the past was transformed into how we could live now by the inventions

and innovations of the previous moments of technological progress. If this approach is flawed, it is because we place too much emphasis on the technology, and significantly less on the social implications of our complacency about the ability of a market-driven economy to filter good technology from bad. We are only just discovering our critical voice about the services and systems that were given to us for free, and note the value they took from us in return. This leads to speculation and experimentation, but also to challenges about what we know about ourselves as actors in culture.

3
Technology Adoption as Ideology

The best tech triumphs!

In the previous chapter, we have dealt generally with the arguments that underpin some of the ill-founded rationalisations about the technology we have, and how they are being extrapolated into evidence for the shape of the future. Both strains of the argument we have seen about technology as a creative force are based on contextualising and connecting the massive impact of digital technology we are experiencing as really the latest in a much longer technical narrative. In the first case, the history of technology is defined as the form ideas take, then represented as evidence for enthusiastic support of its most recent manifestation, in our case, the digital. As has been noted, sometimes this takes the form of technological Darwinism of the more brutal kind, with the social version not very far behind it. The idea that displacing prevailing technological paradigms always produces something categorically better is the ideology that reinforces the notion of technological evolution as an inherently just process. It is seen as unstoppable, logical and filled with the promise of economic benefits through innovation wrought from disruption. This, I have argued, puts a false face on the processes of technology, which have far more in common with the partiality of business models than the disinterestedness of science or imaginative leaps of creative practice. In the second variation on this theme, the assertion that the megabit is possible because of the telephone attempts to create a more linear view, claiming technological development as the continuity of a practice. It posits this narrative as essentially

progressive, with each innovation in communication or replication technologies as based in the previous iteration, and thus a response to the shortcomings or desires that were identified there. This ignores the effect of the expediential growth in energy generation we have experienced since the dawn of the Industrial Revolution which represented an unprecedented change in the human capacity to do so and, as a consequence, unleashed the domination of the West over the rest of humanity for the first time in 2000 years (Morris, 2010).

This second main argument offered is to make a claim to the future, that the technologies that are hyped up as the natural successors of the printing press will be as influential in determining modes and models of social organisation as it has proved to be. It is a model that goes back to Toffler (1970) and his identification of print and its distribution as the key driver of the then forthcoming post-industrialism (which didn't quite turn out the way he thought, but no matter). The shape of the future can be calculated from examining the ways in which our ancestors adapted to the technological possibility of their day, and thus so shall we follow them. I will deal with this in detail below, though it is worth noting that these assertions come in many different forms and with a similarly inconsistent evidence base. In the first place, it is worth identifying the types of historical argument that are made in preparation for it. They generally run in two directions, but these can overlap to magnify the claims and the historical force of their making. One looks at long-term trends based especially on the implementation of concepts into models (mostly in the commercial environment). It is a variation on the model of scientific history that separates science as discovery from technology as application. The other cites visionary individual researchers, scientists often unheralded in their own time, as the inventors of what for them was the future, and for us is the present. These often centre on unrequited intellectual tragedies. The work of Babbage or Boole, for example, who were clearly failed seekers of worldly renown, are rehabilitated by this method, their work the logical precursor of the desktop. Turing is recast as a man completely misunderstood in his own time, his insights into human suggestibility defining the direction of a discipline that did not exist before him. These misunderstandings were social (and inexcusable), but not technical, as the respect accorded to him in his day made him as much a part of the origins of computing and information theory as Norbert Weiner or

Claude Shannon. What both of these approaches have in common is the need to situate the present in the past, a curious method of arguing the distinctiveness of the present moment, and its logical future, from all we have hitherto understood (see Gleick, 2011, or Morris, 2010, for examples of this phenomenon). Thus, the present we are experiencing is explicable by examination of the shards of historical, scientific endeavours in the past, but as an exceptional moment, we really can't understand it all.

This creates something of a mess in assessing and arguing in these ways about the technological age we have entered. On the one hand, the potential of the bits is apparently important in itself and, on the other it seems it is only symptomatic. Either way, we reach the confused conclusion that however we interpret the narrative, these developments will be only beneficial, because this is how the historical journey of technology is now assessed. The techno-centrism of this version of human history as technological evolution will be discussed below, but buried deeply here is the assumption that technology is teleology, and the problematic issues of human development were resolved, or will shortly be and to the mutual benefit of all, through technological processes. Technology is assumed as our destiny and that destiny is defined by the autonomous processes of technology itself. Underlying this premise is the idea that the best technology rises through the structures of technological Darwinism into the perfectly designed tech, when it remains quite apparent that the capacity to prosecute the business case will trump this every time.

Innovation is beneficial

The motive of either argument when decoupled from its broader social and cultural context remains essentially the same. The history of technological progress is presented as overshadowing our other achievements as a species. Indeed, as I have suggested earlier, the claim is often made for technology that it is the enabler of aspiration, cultural or otherwise, and acts as a catalyst for imaginative possibility or economic opportunity. For such thinking, the current moment is one where we are instructed to review selectively the past as if technology were independent from other phenomena, and examine it for the trail of clues that explain how we arrived at this point. We then reverse the process to show the dependency on specific technology

and the concomitant infrastructure that enabled the aspiration or formulation of desire to take place at all.

The purpose of this approach is clear: the slow processes of cultural adoption are a sure sign of the unsuitability of human beings to their task of serving technology processes that, in the end, are precisely their support and generated for no other purpose. This is consistent with both variations of this techno-cultural theme. The notion of technological disruption as a powerful and unstoppable creative force, unappreciated until now, is justified because we are now able to see the transformation of society by technology in full flow. This approach is evidenced by selectively citing the unpredictable emergence and impact of new technology in previous times, especially where it was used to devastating effect on those too slow to adopt it by those with the vision or compulsion to harness its power. In the jargon of business technology, this is usually referred to as 'discontinuous innovation' (Moore, 1991: 10), and is distinguished by the necessity to require behavioural change in its users (think about the household trauma and inversion of authority created by the need to programme the VCR). On the other hand, the progressive development of an area of technology that evolves via subtle tweaking of the existing framework is described, somewhat predictably, as continuous innovation, but probably more accurately as 'contiguous innovation', the sort of thing we experience when a car engine becomes more efficient or a microprocessor a bit faster. By simply extending the performance of the product, the benefit can be technical, imperceptible but reassuringly subtle enough not to require some massive change in behaviour or application.

There is no question which type the technology industry prefers or those technological boosters hooked on the rhetoric of the transformational. Their approaches to innovation and technology are determined by a false notion of science, technology and market behaviours, as we have already seen. Technology of the transformational type validates itself in the public domain by demanding a change in the human users in order to exploit the opportunities it offers. This demand is an important part of the story of technology in the Digital Age, and shows how its dynamics work on daily life. Having proved the science, it becomes the role of technologists to convince their investors and customers of the competitive advantage to be achieved by its adoption.

The technology adoption life-cycle (TALC) has been the standard interpretation of the process of market penetration of technology since Beal and Bohlen's (1957/2012) work on farm practices in Iowa found itself applied to high-tech industries by Everitt Rogers in 1962. It posits technology adoption as a Gaussian bell curve, starting with small numbers of innovators and then a larger group of influential early adopters who subtly win over the early majority in a community. This leads to the top of the bell curve: eventual adoption by the majority (or 'late majority' for Everitt, who is keen on distinguishing the impetus of technological adoption from the timing of innovation and its rate of adoption in the conditions of a particular market). The non-adopters (or 'laggards', in Everitt's terms) never come to terms with levels of change, and in the original 1957 study, are characterised as somewhat stubborn and isolated, rarely influenced by neighbours or publications. For technologists, these are a dead loss.

In addition to what became adopted as the TALC bell curve, the authors of the original study posited that the acceptance of new ideas and, by association, new technologies, was essentially a mental process. The farmers they were studying went through stages that the farmers themselves were capable of recognising as having distinct parts and different authoritative and evidentiary bases. This foregrounded the role of information and influence when moving between stages, beginning with awareness building in a mass media sense, to reliance on more trusted sources like neighbours and friends. Predictably enough, the group least trusted to help form decisions about adopting new ideas were the salesmen and dealers, whose vested interest outweighed their reliability as sources. Their value was expressed in their technical understanding of applications once the decision to go for innovation had already been made. Such contributions only became useful after the fact.

Everitt's tweaking of the diffusion process for the technology industry was set out in his book *Diffusion of Innovations* in 1962 (revised in 1971 and 1983 as further understanding of the technological adoption process became more apparent). It was mostly concerned with the interchangeability of innovation and technology, and the complexities of persuasion where the social embedding of innovation was concerned. Into the ideas of diffusion, Rogers added 're-invention' as a critical intervention by adopters of new technologies in order to

adapt an innovation for their own requirements. He also identified 'opinion formers' and 'change-agents' as vital parts of the process of change; the former group using their added authority to reflect and support communal concerns, whilst the latter group offered specialist advice on behalf of an external agency of some sort, whether governmental or commercial (Rogers, 1983: 16–29). The criticism of these change-agents was their supposition that innovation was invariably successful, and they paid little heed to the consequences of innovation. Their assumption was that 'adoption of a given innovation will produce only beneficial results for its adopters' (371). As has been seen, this is a shaky proposition, as most innovation of the technological variety comes at a price, and the price is extremely difficult to discern at the outset.

Essentially, Rogers' examination of the dynamics of innovation was an attempt to square the commercial opportunities of innovation with their social progress, but noting along the way that innovation does not have the consistently benign character given it by its strongest advocates. More important for Rogers was the identification of the characteristics of groups in the adoption cycle, identifying the distinctive characteristics that defied attempts to create symmetrical models or to elide significant differences between types of actors in the innovation adoption process. His model offered up the smooth bell shape without mitigating the differences between the populations and their dispositions in relation to innovation in itself. Rogers understood that the variables of innovation are based on an assessment of risk and application, and that the key population of innovators encountered at the forefront of the TALC were attracted to the gamble the risk presents as much as to the function the innovation was intended to fulfil (248). This group recognises that risks entail failure as a condition of their acceptance, and are prepared to accept the consequences of failed innovation, both economic and social, but little thought was given to those on the far side of the TALC for whom neither the gamble nor the function seemed worth the bother.

Innovation without risk?

As the technology market expanded dramatically from its nascent population of hobbyists in the early 1980s, and technology-based

companies looked away from business to direct consumers as a market for their products, so the TALC model creaked. Beal and Bohlen (1957/2012) had already noted the vagaries of time and disposition amongst their farmers (and, indeed, the role of government agencies to support decision-making for the most complex of choices). The need for reassurance from trustworthy and accountable quarters also featured heavily in parts of their paper that marketeers found most useful. Whilst Rogers focused on the sociological differences within the taxonomy of the TALC, Moore (1991) was dealing with the practical failure of many of the technology businesses he was observing to complete the cycle of innovation. Unlike Rogers, who thought there were 'no pronounced breaks in the innovativeness continuum between each of the five categories' (1983: 248), Moore thought the problem lay precisely in what he observed as the discontinuity between them. The existence of the categories themselves suggested as much, though he considered these generally manageable with a major exception.

Moore's 1991 adaption of the TALC was fashioned to account for the point of difference between techies and the rest of us. His model posited that gaps between the market segments indicated a difference in perspective by the respective groups of innovators, early adopters, majorities (both early and late) and the dull-witted laggards. In particular, he identified a significant difference between early adopters and early majority types that inhibited easy transition between these sectors. As distinct from the contiguous patterns emerging from Bohlen, Beal and Everitt, Moore suggested the specifics of technology created a division between those who were happy to subscribe early in the process and the largest part of the market (the early and late majorities). Describing this as 'the Chasm' (Moore, 1991: 20), he set about identifying the different motivations for making purchasing decisions in relation to technology. The thing that makes the Chasm so obvious for Moore is the distinction between motivations for those in the earliest adopting categories (innovators and early adopters) and the serious economic benefits that come with early majority converts and their expectations. Their respective relationships with technology become the defining feature, and the failure to account for it as the market transits from one phase to another was (and remains) the cause of business failure in the high-tech sector. For Moore, when you are selling technology, you are selling change to early adopters.

They are in it for the thrill of the newness, the excitement of the tech and the promise of different ways of working. But the Chasm opens between these groups, who have fired up the order books and filled the company with optimism and new capital, and the so-called early majorities. These early majorities care very little about the technology as such. Their interest is more practical and focused on fulfilling their specific purposes, and not the joys and diversions of technology itself. For these groups, vital to sustaining a vast technological change, efficiency turns out to be the decisive factor in their decisions. Regardless of the beauty of the technology, if it does not deliver efficiency gains, it is merely troublesome (57–59). We can ask in this context what efficiency means, and beyond the rhetoric of technological visionaries, it is clear that, especially in the business context that Moore knows so well, these pragmatists recognise the potential benefits of technology to the industries. They simply prioritise differently, seeing industry trends first, their own business acumen second and the purchase of technology a distant third that only features because of the first two.

This is further complicated by the work in the original Beal and Bohlen paper (1957/2012) that noted the difference in magnitude when decisions about adopting new ideas come up. In some cases, it is not feasible or possible to limit exposure to risk in making a serious decision if it turns out to have large cost implications, either directly in the form of new capital, or indirectly in the form of training needs and opportunity costs. Where the change belongs to the process of 'discontinuous innovation', the disruption is far more significant and the benefit far more doubtful. The human element of the decision-making stages becomes increasingly important, especially the disposition of those intending to implement a change and their assessment of why they need to do so. The next market segment, the conservative late majority, is looking to the pragmatists of the early majority for evidence that a decision on technology can bring tangible benefits. Like the early majority, their interest in the technology *per se* is tangential. But what differentiates the late from the early majorities is their need for reassurance that the innovation will actually work without too much disruption. They are not quite at the stage of feeling compelled to adopt a technological solution because everyone else has, and they are often forced into it, but their reticence is understandable when so much expensive technology, sold before being quite as market ready as it might be, has turned out to

be funding technology companies' research and development (R&D) effort rather than solving their customers' problems.

There are some distinct advantages in arriving late on the scene: the burst of enthusiasm for the technological component of an innovation is likely to have already been deflated, and usability engineers will have been hard at work on humanising the product for everyone past the tech-head innovators and few early adopters. Its 'cleverness' will have been overtaken by some other fad. In short, the technological aspects will have been tamed. As a technology, it can now be assessed on its effectiveness to perform a task, and this is where the bulk of a given market remains. Moore identified that this sound platform for serious exploitation of the investment is located on the other side of the Chasm, and it is precisely into this space in between that so many technologists find themselves tumbling.

One more issue: technology adoption is marketing

What Moore shows is that when selling technology to 'early adopters', you are best off selling discontinuous change by focusing on the technology itself. These customers are not buying a proven opportunity to improve their competitive advantage. They are inured to the reality of new technology as requiring significant investment in time and training, know that bugs will inevitably occur and will defend the investment against those who would seek to resist or criticise it. But 'early majorities' are not at all like this in disposition. Unlike the early adopters, they are not investing in technology so much as efficiency. For this group, improving the productivity of existing operations is the priority (Moore, 1991: 21). When you are selling technology to this group, you are selling change, though it can be distinguished from the early adopters as change organised around efficiency.

A very useful insight can be gained from this examination. This is that the model for technological adoption is no different from the model for marketing technology. The two are not distinguishable in the literature of tech, reinforcing the relationship between the technology and the business plan that I have posited as dominant. We see this reflected across our enquiries into the validity of the technology business plan: all developments in the Internet economy (as differentiated from the Internet itself) have been co-dependent on the

support of advertisers, investors or content providers, with plenty of examples of investment taking place without much evidence of efficacy or a defined return being offered. As Keen (2012) shows with monotonous regularity, the game is about finding something someone else will believe could produce a return and selling it to them. It is more like the fine art market than anything else.

As a proposition, this should be of more interest to us than simply a passing concern about the relative importance of the other ways, beyond technology, in which desire manifests. How we choose or are compelled to live our lives in the framework of technology as the only sphere of human action that really makes a difference is a matter of great significance. This simplistic ideology of technological Darwinism has come to substitute for a broader social dialogue that acknowledges the achievements of technology, but must also calibrate its failures and its dangers. The banality of this model of cultural development dismisses those other lives and experiences that play out beyond the fringes of a digitally powered society. They are functionally irrelevant where they have not accommodated the technological fancies of their age, their anachronistic nature found out by nostalgia for a reality that is easily simulated. This texture to human experience is excluded from consideration because, whatever the sophistications of a practice, there is no doubt but that it can be replicated at some point by the same technology that has brought us overcrowded email inboxes or newspapers that can be read on telephones. This end of the argument asserts that the past is the best model for understanding how we accommodate and assimilate the technologies that insinuate themselves on our existence. The past it refers to is the uncontested victory of technology, so easy to see as the now resolved and stable platforms that defined the Age of Late Analogue.

Whose innovation?

In the first version of a techno-cultural history, one determined to mark our current moment as part of the history of technological development, well-informed writers like Naughton (1999) or Zittrain (2008) work to make a link between the concepts and the technology. In a fashion that reflects Foucault's usage of the word (Foucault, 1977), technologies appear as the forms that ideas take,

the translation from blue skies science to practical application is over in the blink of an eye. They seek an explanation for technology development from human behaviour, from context, and it is from there the ideas emerge that would set a challenge for the scientists and technologists of a given moment. For Naughton, it is Vannevar Bush's attempts in the 1920s to stabilise the electricity network. His differential analyser was a practical solution as well as proof that 'dynamic phenomena in real life could be represented in terms of differential equations' (Naughton, 1999: 54). This intellectual and technical breakthrough was set aside for some time before its potential was properly understood, though it now operates as the key technical, philosophical and economic premise for the digital technology industries. In itself, it is a perfect example of the processes of science eventually being caught by the demands of the technology industry. Despite the importance of this moment in the creation of the information society, Naughton also muses on the difficulty of determining *when* it could be that the first steps towards a digital network like the World Wide Web were taken. Couldn't it legitimately belong to Babbage? Doesn't it look logical in retrospect that Pascal's adding machine or Leibniz's improvements on it could equally form the beginning of the process that leads to the Internet? Naughton's most important argument is not to foreground the technical process, but to comprehend the ideas that were driving it. Whether it was the need to understand the distribution of the electricity grid, or Wiener's ingenious solution to aiming anti-aircraft guns, it was the concepts that inspired the development of the technologies with which to carry out the function. In Naughton's history, a convection of technology with culture, it requires a situation and a context to posit a problem that is apparently insuperable (armed conflict features heavily in his account, as does the seriousness of the economic and social challenges of the Depression). From this, a necessary investment in human capital to resolve the dilemma is made, with a solution that can be scalable (and therefore not in constant need of the originality of genius that cracked it in the first place). For this reason, he acknowledges the role of warfare in determining just what would or wouldn't be pursued and by whom. Vannevar Bush's participation in the US war effort is acknowledged as important in the development of his practical thinking. In the end, it is Bush's visionary paper, significantly titled 'As We May Think', that posits

a system based on the retrieval of information by association as its central premise (Naughton, 1999: 212–213). Thus, the path to the World of Bits becomes perceptible to that small group of cadres able to understand engineering and mathematics as interrelated fields. But if my suggestion that technological innovation is more properly represented by its effective marketing than by its scientific credentials, the mantle would be more correctly bestowed on Steve Jobs, something that a younger generation of technology fans think in any case, impressed as they are by business models above all else.

Open or closed?

The other crucial idea that can be drawn from Naughton's version of technological history is the differentiation between computers and the network, something increasingly elided as the means of communicating across the network became dominated by the mediation of computers. Naughton notes the dissimilarity between calculation and distribution, and how two almost entirely separate systems came together to form a useful exchange of both attributes. It was this breakthrough that makes the Internet the remarkable and unprecedented technology that it has become. It also presages the really big idea that we are all struggling with: the move from invention to innovation. Through a computer linked to lots of others, we are enticed to substitute things for bits. The implications of this for our understanding of exactly how computers and the Internet came to dominate our lives is crucial, given this is the key to the economic power of both: suspension of belief is required to ascribe significant value to a concept built on nothing more substantive than a few ones and zeros. It takes our imagination and suggestibility to make this work in any meaningful way and when we stop believing, it can have dramatic consequences for those heavily invested in bits. Thus, in a reversal of the open-ended and public-service way the technologies were developed and merged, we have the rise of the app to trap users in one place, and the closed systems of Apple or the comprehensive ones of Google that draw us back into their power.

On this point Zittrain (2008) takes as his alternative starting point the innovations of the 1890 Census that we have already encountered. As we already know, these would eventually lead to the founding of IBM and become the source of a discussion about how

the potential of the technology can be circumvented by commercial imperatives. For Zittrain, the challenge of the Internet is how to distinguish between the ownership of technology and the freedom to operate in order to obtain the benefits or realise its potential. Zittrain's proposition is that it is not the relationship between technology and society, but the one between commerce and innovation that is inherent in technology. Along with a technical solution to the problems of data collection comes what we refer to as a 'business model', inseparable from the technology which becomes dependent on it, setting the pattern for generations of innovations in technology to be supported by economic structures. Capitalising on the success of the census exercise, Hollerith's Tabulating Machine Company sold its services through leasing agreements. These allowed it to operate its technology in tandem with control over its machines, rather than giving them over to clients. Companies using the machines passed all control of them back to the manufacturer, who made life easy by providing comprehensive agreements for every part of the function, application and servicing of its devices.

As Zittrain points out, this had a number of advantages to the company, rewarding them both financially and technologically. By locking in the companies it served to IBM's technology, it was able to create a monopoly of its system, and use the inflated revenues derived from it and information acquired by its operations that it alone knew to reinvest in improving its technological framework. The result was the domination of a market that endured for decades, until a combination of anti-trust law suits and technological innovations reduced its advantage significantly in the 1970s. Indeed, so wedded was it to its structure that it almost collapsed as a result in the rapid expansion of the PC market that it had so ignored, convinced as it was that its package of machine, software and support would leave users so dependent they would not seek to own their machines or develop their own software. The infamous guesstimate of the international market for PCs (the story is apocryphal but remains instructive) illustrated the tendency for such comprehensive systems to believe so profoundly in their business model and its longevity that alternatives were impossible to imagine. That it took the near collapse of the company to change its mind is a case in itself, but not the most important matter to emerge. The lesson here is that in this approach to the history of technology, mastering the economic context was at least as

significant a factor in its emergence as the functions it could perform. For IBM, there was no difference between the capacities and applications of the technology and its business case. They were inextricably linked, the one only possible when implemented with the other, and a model of symbiotic development has remained with the technology industry ever since. The legal and economic framework emerges as a corollary to the practical benefits and never independent of them, with much time and effort expended to ensure they made a good match. This co-dependence of business and technological innovation is something that rarely features in the assumptions of an evolutionary technology model. The adoption of one technology over another is assumed to be driven by its efficacy for a task, market efficiency at work in the time before markets of the sophisticated, international kind we have today, and this assumption is one people now take up as logical. The preparedness to invest time, money and behavioural change is elided by marketing rather than markets. Such an approach was clearly known and understood in former times, differentiating the entrepreneurial Edison, say, from the originality of Nikola Tesla. It made the former rich despite his limitations as an engineer, and the latter an eccentric pauper despite the brilliance of his inventions and our dependence on them today. The entire package of the technology has always worked beyond the technical innovation that a product might represent. The relationship between technology and economics is indivisible, and it is no accident at the macroeconomic level that something like the Internet grows up at the same time as the globalisation of international financial markets, given how much these two forces have in common in terms of values and practices. What we learn from this account is that, regardless of the state of the science, it is the commercial viability of a technology that determines if the science might be fruitfully exploited. Like the Industrial Revolution, whose basic scientific principles had been established much earlier, digital technology emerges as science having eventually been resolved with a business model.

Technology as evolution

There is another, more deep-seated, more ideological and less convincing strand of this narrative, going back further into history, seeking to identify the technological impulse as an atavistic impulse.

Accounts like Kevin Kelly's explore this by declaring the ubiquity of a technology they themselves fashionably eschew, as if their evasion of it strengthens their claims to rightness (2010: 4–5). There is a modish posture about this, suggesting that whilst they are too cool for technology, their detachment positions them as quite the best qualified people to offer an objective critique of it. This quickly falls away once the relationship between the technology they argue for and the implied paucity of environments that lack it become a subject of argument. Kelly charts the development of technology from our pre-historic times, in an attempt to argue that technology has its own exigencies independent of human action, reliant on humans only in order to initiate the process. It suggests the reverse of Naughton (2012) or Zittrain (2008), who clearly see the nascent human desire in the first place and how it is met by the capacity to innovate and imagine. Kelly's anthropology is condensed by examining the need for primitive society to improve nutrition, longevity and the ability to fight, Kelly finds the impetus for technology as the natural response to deprivations of all kinds. This is too simplistic for something as complicated as the technological history of humanity, and even Kelly thinks it proves inadequate as an explanation of the sort of technological dominance we are currently experiencing (though he himself has coolly avoided). For Kelly, the chief trick that distinguished *Homo sapiens* from the other species of early humans was that of language. Kelly argues that it is language that distinguished this early proto-technologist from those 'competing hominins',[1] and not for its communicative possibilities, as might be conventionally first thought. Like his overarching argument about the autonomy and nature of technology itself, Kelly thinks of language as the first tool, a 'trick…a magic mirror that allows the mind to question itself' (2010: 26). Thus language becomes the means with which to discipline the mind's potential and release its creative possibilities, its communicative function simply a secondary feature that enables a collective memory to emerge. That talk becomes text emerges as an important theme in his chronology, a conversion that will eventually lead to some stunning insights into the potential of language, but essentially, once the creative possibility enabled by language is achieved, the job of the human is simply to float along in the wake of technology's own deterministic path.

Arthur similarly conflates technological advances with evolution, the technological processes initiated by our logical response to the slow speed of biology in resolving our practical problems. His key argument is observing that apparently new innovations that are in reality creative recombinations of technology that draw from an increasingly large body of technological knowledge that, in itself, 'begets further cumulation' (2009: 20). Arthur's 'combinatorial evolution' works with the very nature that he feels our technological hopes are in tension with: the observation and utilisation of natural phenomena, resulting in a consideration of potential solutions to speeding up the whole process. Like Kelly, though for different reasons, this dynamic creates an impetus that works beyond the slow processes of human thought and imagination. Once the technological genie is released, there is no stopping the processes it will put in train. Technology demands autonomy of action and application, and in neither instance should there be impediments to the fulfilment of technological destiny (even allowing the impediments were actually possible). It remains unclear if this could be the case, given the strong steer towards the essential independence of the combinatorial evolution that Arthur is so sure about. But the role of human imagination or human desire is less of a configuring force on the technology than the impetus provided for technology in itself. It is no longer possible to extricate overlapping technological processes from one another (and this is certainly true in many areas, as Arthur shows), but whether this is an outcome we can all feel satisfied with may be another matter.

In both cases, Kelly and Arthur seek to make an argument that technology and its autonomous demands are deeply embedded in our history and pre-history, and there are Promethean dynamic imperatives that require us to address our hopes and creativity through the possibility of a technology whose development belongs to our most ancient instincts. This approach to technology as an atavistic impulse is borrowed from Kelly's colleague at *Wired* magazine, Erik Davis (1998), but what makes it so nonsensical is the illogical pathway from the capacity to use tools to the assumption that the highest refinement of such a process is an intangible collective body of interactions between machines called the Internet, through which our computers are connected to one another. By association, but not by necessity, we ourselves are further removed from the real

destiny of technology which is autonomous from us. Davis' selective account of Greek mythology that foregrounds the technological includes an eccentric account of the Aristotelian notion of *techne*. In discussing the nature of electricity, for example, Davis questions whether we do, in reality, know what electricity is, or have we merely been content to understand what it does. He goes further and asserts the power of the 'electromagnetic imaginary' (Davis, 1998: 41), that is to note how the phenomena of nature gives rise to its investigation and implementation, and is entirely consistent with a notion of technology as a natural force. It is not the technical processes in themselves that count, but what it is to know them in this way (23). It is the craft practices of computing that we should be acknowledging, not their conventions that would count under such a definition. He bases this idea on the historical narrative of making sense of our feelings about the world by applying what we feel certain about. Technology becomes a dark presence in human culture that usurps the Popperesque arguments for scientific rationality and makes the leap from the concrete to the intangible that technologists of our time are invariably seeking to make. In this there is a clue, not so much to our historical account of technology, but as to why it currently matters with some urgency. It is the importance of promoting an understanding of the conceptual jump from things to bits that our future appears to depend upon. It rejects Popperesque rationalism for an ideological position that I have argued draws on a market-driven notion of technology very similar to the assumptions of the IBM of old. Whilst acknowledging the significance of technology as a force in our considerable cultural progress from hunter–gatherers to web surfers, the assumption that this has happened without countervailing forces like social responsibility or ethics (an Aristotelian concept that Davis chooses to ignore) looks unbalanced. It also implies the promotion of a particular view of technology: that as a force of nature and, by implication, a force for good, it is not the business of humanity to question its operation in our lives or to critique its self-regard.

Of course, these accounts are offered by those with a strong, vested interest in the development of ever more satisfying technologies, especially in a world where the consumption of bits provides economic advantage, and as such seek to present their histories as the benign manifestations of Hephaestus. By doing so, they join that

long list of technological boosters who have always claimed of new technologies that they will bring peace to an otherwise unruly and violent world. We cannot surely still believe this, after our disappointment that so many other interventions of technology, from weapons to communications, having made similar claims, subsequently left the world in a worse state than ever. These are essentially economic arguments for technology, not cultural ones, or technological ones for that matter. The demand made on behalf of the technology is to operate freely and without constraint in the economic sphere, given it is an elemental force. It is here it will find vindication in the form of adoption or oblivion in the guise of neglect. The arguments for technological autonomy are less a disinterested assessment of how its potential can be realised and more an assertion of the desirability to keep other interests from interfering in its economic opportunity. In this, such an argument has much in common with the prevailing views of government and industry during the Industrial Revolution, and will produce similarly unequal results until their cultural significance demands counter-action.

Quite frequently, these accounts of the natural flow of technology come with a summary of a personal journey through it. Nicholas Negroponte, in his early book, *Being Digital* (1996), begins by puzzling over the superiority of the production, marketing and distribution system for French mineral water to those of intangible bits. Another member of the *Wired* editorial staff, he recognises the difference between a trade based on commodities to one based on invisibles, but failed, like so many others in the 1990s, to understand the fundamental flaws of an economic system based on the potential that the bits could be worth something. The dot.com bubble burst, with considerable consequences for technologists given the difficulty in persuading investors that there was value available in the exchange. It was a question of trust. The businessmen whose models so confused Negroponte in their efficient capacity to distribute heavy, if commonplace, commodities across the world, did not yet believe that the exchange of bits contained within it the potential to support the global economy without the hassle of trading things. That he was not alone in that only partially explains his mistake. Consistently with arguments we have already seen, the enthusiasts of technology had already made the emotional journey to belief. Knowing the potential of the technology was one thing: converting this

into business models that would turn a profit was another, but also crucial in attracting the investment required to bring the technology to a market. Negroponte had been an energetic booster of the World of Bits, believing in their possibilities as an alternative growth strategy for developed economies. The diverting of resources into this new market could be a key component of future affluence, if only we could find a way to believe in the story of how bits could change who we are and what we have.

This transformative technological and cultural march is not solely told in the language of inexorable fate. Others invoke a distinction between a generation that recalls the Sony Walkman and not the iPod as their first portable music hardware purchase (Palfrey and Gasser, 2008). This is less a trivial matter of delivery systems than it may seem. The critical feature of this example is the movement from a manufactured commodity to a concept made of bits. A cassette tape that required manufacturing processes and complex retail distribution to reach a market of consumers ready to march to the store with their cash turns into a download culture that may not see money change hands at all. This process took the music industry so unawares that it remained in denial until it saw demand dry up, stores close and the revenue stream diminish never to return. The record companies then behaved as if without them there would be no more music, whilst the players of the music, the artists, saw that if they wanted to survive they would have to find new ways of making a living, by reinvigorating the tradition of live performance, for example. For the MTV generation, who were frequently warned that their habits of watching music on television and then buying the cassette for their Walkman would lead to bands that never played live in their whole career, it was a revelation. In Matt Mason's account of this process, the conservative forces of respectability, who can't believe their property is being stolen, battle with pirate rebels and their superior handle on the technology. For Mason (2008), what is at stake is just the conduct of enterprise, not something more fundamental, on the premise that the pirates will win and one day seek to replace the establishment they have sought to annihilate. This is serious enough: during the 20th century an entire globalised industry grew up around the idea of charging for recorded music in formats determined by the producers of it. Dispositionally, he sides with the pirates, and claims their actions are just because of the vast, unwieldy and untrustworthy

system they seek to undermine (61). The technology is engaged in a war with analogue commerce that it seeks to replace as part of the move from things to bits, knowing that it must substitute the things to make good its promise of efficiency.

But there is something even more serious going on in the process, linked to the change of technology and delivery systems, and the apparent empowerment of a listening public, but something not precisely coterminous or concomitant. The creation of a download culture is more than the process of obtaining music speeded up by Arthur's 'combinatorial evolution', more than an alternative delivery system outmoding an older one, and more than a row over property rights between publishers and consumers, as it is often framed. The basis for the exchange has changed forever the relationships of all these parties. It is a fundamental shift in the value we ascribe to music, how we acquire it and, ultimately, what we do with it. It is the first and most obvious point of departure from the analogue world and demonstrates what happens when we exchange things for bits. We change as a result, but not in ways we may have predicted, nor in ones anticipated by technologists. As Mason shows, the foot-dragging of the record companies has led, if not yet to their demise, then certainly to some significant damage, compounded by the unedifying sight of pre-teenage girls being taken to court for infringing the property rights of already rich companies. It had apparently not occurred to consumers before that music *was* IP. They assumed it was music. But Mason thinks he sees something further in the interplay between music as source material and the way it can be recombined in many forms and formats. The 'mash-up' is born, and creates a new form of creation (and a wider pool of creators) and distribution (with a far wider pool of distribution possibilities). This exploits the potential of the bits in creating an impossible task for the IP lawyer, and when prosecution becomes counter-productive, this encourages a world of reformulation. Mason's pirates then become increasingly difficult to identify, given their vast numbers and increasingly flexible tactics that enable them to engage with the music they love in so many different ways. The previous order of things can scarcely be put right under such conditions, defying as it does so many of the existing structures of the music industry. Beyond the technological framework, for Mason this shifts the imagination of people as well, who take the technology into their own hands for their own

creative purposes. It turns out that a digitised culture is also a commercial one by definition, and there follows the means of creating their own small niche economy as a result. Whatever the excitement about the beauty of the process, the process itself is determined by economic advantage, making a decades-old business model redundant in the process and encouraging the sprouting of new economic models.

The slow pace of change in a record industry in denial opened the door to a much more serious phenomenon of changing things into bits and then exchanging them with flexibility unknown in the past. Despite the fact that the record industry ought to have paid heed to the progress of home taping with the VCR, which was eventually halted by quality proprietary tapes sold at reasonable prices rather than by cheap, faulty blank ones, its failure was more catastrophic because of its own refuting of the technology: it simply did not believe music could be sold at a profit in this way. It underestimated the potential of the technology to meet the needs of their customers, and the savvy of a coalition of people with a technological interest in helping them. This allowed a download culture to become fully established before rear-guard actions of the clumsiest kind that only brought the companies into disrepute. Mason's (2008) piratical analogy is apt, given that piracy is commerce by other means, when the rule of law finds itself unable to regulate or legislate the behaviour of those it would seek to control or to protect the interests of those who support it.

I find an approach that seeks to omit the reality of a business-driven technology a curious phenomenon. There is a pretence that somehow the purveyors of expensive technological solutions to problems we have never had are acting in the public interest rather than for private profit. It is a rare argument about the implications of applications of technology that does not include at least one gesture that dwells on the sanctifying influence of science. As I have suggested, science as the discovery process takes place long in advance of the technology opportunity, often without clear outcomes in mind. The 'blue skies' thinking that seeks to challenge the imagination is often supported by grants rather than investment. This is quite different to the point where that science turns into IP and the commercial imperative takes over. Such an opportunity requires a business model because it requires an investment beyond the science to develop

it into something that can have practical application and enough customers to be viable.

The conflation of the business model with science serves to dignify the technology component, and to reinforce the message that any specific technology is the next incarnation of the natural evolutionary desire of human beings to create and communicate. As an approach to the issues around the use and impact of digital technologies, it seems all too patronising. Its attractions as a creed at this point are obvious, if misplaced. The sense in which we feel our technologies are somewhat out of our control turns out not to be something we should be concerned about, just something we should accept as the price for their manifestations. Given the bewildering speed of change, and the regular advent of further and newer ways to do things we like, it comes as something of a comfort: this is simply the way technology evolves and we are powerless to resist it. Frequently, the case for the technology is radically overstated, often to the point of threat, as a means of cowing those who do not understand why we might need to double our processing power every two years. In the imagination of the technologist, the capacity will produce and reinforce the operability necessary to make it all work as a system. In that case, it becomes easier to move with the tidal shifts in technology than to defy them.

The impetus is clear: in the world of the well-educated and communication interdependent economy that we have inadvertently structured, there is an acute dependency on digital technology. It is a system that belongs to this class of economic and social actors, a domain of activity that binds together in the notion of what counts as cultural form in technological guise. Coming at a time when so many other logical trends in technology have apparently reached the end of their historical arc (air travel, for example, has remained static in terms of delivery for 40 years whilst becoming considerably cheaper), the energy of innovation can rightly be said to coalesce around digital technology as the most creative place or space for new ideas and new practice. The imagination doesn't only foster technological development, but a theism that writers like Negroponte, Kelly or Davis have happily adopted. The notion that digital technology is a belief system as well as a practical solution explains something of why we have placed so much faith in its capacity for transformation. As Morozov says, ' "The Internet" is holy – so holy that it lies

beyond the means of democratic representation' (2013: 18). What follows from this is that in dealing with the configuring and defining technologies of our time we need also to understand the belief system that underpins their operation and those of the culture that has put them there. Distinguishing between the innovation of practice in the tech industries and how this manifests as the product of cultural imagination is part of making progress towards understanding digital creativity. There are a nexus of forces gathered with tremendous power that are altering the way we create in the cultural domain and these are not always connected in a fashion that allows us to see how we are changing as a result.

Alternative belief systems

It takes Morris (2010), in his magisterial study on the emergence of Western hegemony, to point out the shortcomings of these accounts of pre-history and their implications for technological development. As he shows, palaeontologists and archaeologists can barely agree on the impact of the environment on toolmaking and technological progression, though it seems there is consensus that climatic conditions and geography rather than an instinct to make tools are definitive. It took significant changes in the weather and the landscape for early humans to discover the usefulness of developing technologies to assist their survival, and they happily existed for many thousands of generations without contributing anything much to the sum total of humankind's knowledge (39–80). Rather than the technological inclinations of Kelly and Arthur, for Morris, the more decisive human qualities in what he refers to as 'social development' are laziness, greed and fear. None of these suggest the complexities and hardships of continuous failure experienced in most R&D labs. In Morris' view, it is the imagination, a subject to which we must return, that is instinctive to *Homo sapiens*, but the possibility and purpose for exercising it are less clear than the confident accounts of modern-day technologists. The impact of the last Ice Age in forcing action to protect the protean societies that were developing was decisive in encouraging the use of human ingenuity to avoid catastrophic destruction. Some of this energy, perhaps most of it, was focused on religion rather than the practical technology, suggested as the more obvious response to need by Kelly (2010).

This is, however, perfectly consistent with the notion of intangibility, a point Davis (1998) would accept in a moment. It seems that in the face of the irrelevance of direct technological invention in such a difficult environment, ancient humans' first instinct was to seek divine intervention to allay their troubles, bringing together larger groups of people than ever before. For Morris, it seems that the critical mass this formed, and the complex social interactions and sexual competition that resulted, provided the impetus for changing the experience of modern humans. It was to faith rather than to logic which these early peoples turned. The rise of technology as a crucial factor in social development comes much later, and according to Morris, becomes somewhat cyclical for both Western and Eastern cultures. For some 2000 years, on either side of the Caucasus, whatever the effect of cultural stability or turbulence, societies and cities were unable to break through significant social-development barriers because of their inability to create new technologies with which to do it. Despite repeatedly hitting peaks in this cycle, social development would invariably wane with the lack of capacity to invent the means of sustaining and expanding production to support larger cities, or to fight more one-sided wars. Whatever the limitations of Morris' work, and his prognostications are somewhat pessimistic about Western culture in particular, it is his historical analysis that is worth considering, given its support by plenty of other historians more interested in a more limited timeframe. In common with historians dealing with more short-term industrial and technological history, he picks up on the moment the steam engine emerged as the critical one in leaving behind the previous limits of human social achievement forever. The ability to capture and exploit energy turns out to be the moment of human destiny. That this should be the result of an atavistic desire for technology seems highly unlikely, given quite how long it took.

These varied accounts are unacceptable as history or archaeology, but none of these examples are really intended as such. What is more clearly projected is the association of digital technologies with the fulfilment of humankind's destiny. The reason for such significant debate and disagreement amongst the palaeontologists or anthropologists of the era of pre-history is the fundamental absence of definitive accounts, and the level of imagination and interpretation that needs applying to the evidence. The absence of what could pass as authority means there is mostly speculation, well informed,

as Morris indicates, but any endeavour so speculative always leaves itself open to be misconstrued and attacked as guesswork. Morris' term for his analogy about imagination is telling: for him, theism is 'hardwired' into human beings. It is a technological term to be sure, but he doesn't see imagination and technology as being coterminous or necessarily leading ideas into technical or practical solutions. His implication about imagination is that it gives the capacity to believe. Instead of explaining how this enhanced the technological progress, he discusses the prominence of religion to early societies with the assuredness of an atheist. He notes the comparatively rich resources put towards ancestor worship in societies that struggled for survival. Their desperate attempts to invent technologies that might save them from changes in the weather had far less consideration.

This is why questioning such a hypothesis, that technology is destiny, is so important. The development of a critique of the ideas that support it balances the pressing of an unceasing argument that the technological impulse is connected to the imagination, and through it, humankind makes its mark on the world. They are implying a relationship between people and technology that is shaped in a more prosaic interest – the freedom to create and exploit whatever technologists want to impose. It is an argument loaded with threat: to freedom, to imagination, to economic prosperity, to cultural development, and a means of muting opposition to the need for thoughtful, broad debate about whether, and how, we should seek to control technology more closely, and monitor its effects more carefully before simply giving in to the vagaries of the World of Bits. That world is by no means benign. It is a means of capturing the mood of the present, where social experience is being reconfigured by those delivery systems that Jenkins (2008) thought of as marginal in our access to the content. It creates a false argument through our experience of the present about the creation and development of technologies in the past, and the association between them and notions of progress. It passes control of the future to the fusion of imagination and technical ingenuity as the means of experiencing our existence. It is as if, because of our bewilderment about the impact and role of technologies in our current moment, when they are carving a blistering trail of newness through our lives, they can come to explain our confusions about the past. Further, and more importantly, these justifications act as guides to light the way to our inevitable future, the

'noosphere' or 'the Singularity'. These visionary projects aspire to collectivise and globalise our consciousness, effectively making our presence as we currently experience it redundant, as we volunteer to upload ourselves onto a self-organising and self-maintaining version of the Internet (Kurzweil, 2006; Lanier, 2010, though they have sharply conflicting views on the usefulness of such a thing). It is the exchange of ourselves as physical creatures for a notion of humanity as an intangible phenomenon that invites correlations with the ancestor worship that Morris and his colleagues suspect initiated the impetus for technology in around 10,000 BCE (Morris, 2010: 94–96). In a secular age, apparently supported by science rather than faith, what could be believed in with more certainty than technology?

Consciously or not, Mason and others writing in this vein borrow heavily from Thomas Kuhn's ideas about scientific revolutions. This is to say, science progresses in a series of paradigms that are challenged at the point where they no longer fit the data or phenomena they should be capable of explaining. They are replaced in a paradigmatic shift that makes possible new discoveries and insights that will answer these pressing questions. In turn, these become conventions which eventually become inconsistent with new observation and so a new paradigm emerges and with it, productive 'normal' science (Kuhn, 1962: 24–25). According to the vast numbers of presenters of conference papers, writers on the pre-history of digital and underwriters of its future, the history of technology, like the history of the science that underpins it, is apparently replete with paradigmatic shifts determined by the implementation of technologies that in turn impact on social arrangements. The implication of this claim is that technological development determines the models of thinking and behaving available to the public experiencing their opportunities to 'play in the space', to pick up a cliché often heard in the same context. This is an important logical progress to follow, given the claims that are made relating to creativity, but it is clearly flawed as the ontology of technological evolution. After all, in a Foucaultian world, the one that Naughton or Zittrain would identify as the one technology occupies, it is the form ideas take to determine solutions with which we should be concerned. As pointed out above, no one, least of all those with the strongest grasp on the technology and its implementation, thought there would ever be much of a market for a PC, or that text messaging would be more than an oblique additional feature

to the mobile phone. It took engineers' ideas to create the possibility in the first place and then user choice, sometimes user subversion, as people searched for solutions to utilise the tech in the way they felt there would be most advantage to them. Many of the social networking tools we take for granted began and will end in this manner, with cultural behaviour determining their function, rather than the design decisions of engineers. In itself, this has spawned a range of misplaced assumptions about the nature of that behaviour, but our interest here is in clarifying the basis of the emerging belief system of technology. Engineers of technology, it seems, can rarely predict what will happen with their collaborative constructs until they meet the testing environment of culture. What makes them so confident that they have either shaped the past, configured the present or can predict and manage the future? This is especially pressing at the point where the ambitions of technology meet its rather patchy history, a point that has often necessitated interventions in the implementations of the technology as a means of controlling and regulating their wider impact. The failures of technology, both in their design (not fulfilling the function for which they were conceived) or their operation (making lives miserable, creating poverty) are seen in the models put forward by Kelly or Arthur as the failure of people, the inability of the human to understand the capacity and beneficence of the tech. The technology often disappoints, and quite profoundly too, as the founders of many a dot.com or software designers can attest. But the real failure, and the potential remedy, is found in how it has been applied.

If Kuhn's ideas are more suited to the impact of the technologies themselves, rather than the science that has driven their development, a discussion needs to be had about how and why some technologies come to be adopted and others do not. As Kuhn observes, the history of science is not progressive, with better ideas necessarily pushing out worse ones. Like all other areas of human endeavour, it is conditional on context. One of the major problems we have in determining the importance and impact of digital technology on human organisational arrangements is the absence of a context to which we can point authoritatively. Thus we end up in a world of justification and conjecture, with the proffering of hypotheses that cannot be tested or proved erroneous, and the absence of a past record to categorically confirm our projections of the future.

Critics of Kuhn point out the spirited language and the attractions to young scientists and sociologists of a notion of science (and of history) that exhorts following generations to overthrow the science they have inherited, often ignoring the benefits of a rich period of 'normal science'. It is a model that encourages innovation above convention, the pirates over the navy, and has shaped the economic as well as technological basis of science. It comes as little surprise that most scientists prefer Popper's model of concerted attempts to test the data, to disprove the hypothesis through rigorous experimentation, and that the interrogation of the results of the experiment is both morally and professionally superior. It is a notion of science that supports the perception of what scientists claim they are actually doing, and they derive their authority from it. Attempts to prove themselves wrong fit their self-image of conservative verifiers of evidence better than irresponsible revolutionaries looking for untested ways of explaining what has thus far proven elusive or developers of forces they cannot easily control. That power, as I have suggested above, is the mighty power of the dollar; that means of spinning scientific flax into so much technological gold, acknowledging that sometimes this is done in the most unlikely of settings.

For digital technology, this is an extremely important issue. Many of the successes of digital technology, the main drivers for their adoption beyond the techies themselves, were developed either by accident, often in the face of massive corporate or institutional resistance, or to fulfil quite different tasks to the ones they have come to perform. As Zittrain (2008) notes in his brief history of IBM and the PC, it was the accidental convection of a variety of forces that configured the digital technology landscape we have now. Similarly, Naughton (2012) shows that it was the inability of the governing authorities at the Bell Telephone Company to conceive of an alternative use for the telephone network, especially as the stakes for the company would be so very high. From the determinism of IBM mainframes, to the development of standalone PCs that improved precisely because they weren't networked, to the era of open interoperability of the Internet, culminating in the present spectre of lock-down devices whose manufacturers use the Internet to decide how you can operate them (Zittrain, 2008: 7–18) and proprietary apps to capture your attention, some common threads emerge. What is fairly widespread in his narrative is the difficulty of predicting either

user experience or user preference. Whether this is hardware like the PC, applications like email or Web 2.0 systems like Flickr, the intention of the technologists was one thing, the actions of users another. The concomitant problems that emerge in a system without significant control over who uses it and how it is used create instability that technologists have responded to by imposing order onto digital chaos. Thus, Apple continue to control their appliances long after they have left the crowded Apple store, on a short leash. With frequent upgrades to both the software that provides the features and the firmware that determines the operation of the hardware, they are perfectly at liberty to reduce the product to uselessness if they discover hacks they don't like on it. This has given rise to the phrase 'iBrick', referring to Apple's ability to reduce the device to being something no more useful than a house brick, regardless of the fact that it has been bought legitimately by a consumer. This tacit acknowledgment of the imagination of its users is interesting for what it reveals about the agenda of the company and its future policy. What Zittrain describes as 'lock-down devices', tethered to the vagaries of company policy, emerge as a means of engineering control over the potential of their products. For many, it is also consistent with a more sinister agenda, to control and manipulate the behaviour of consumers who are forced, one way or the other, to access the products and services they want to enjoy through the authorised channels of the manufacturer. It has also inadvertently unleashed the possibilities of surveillance on a mass scale, with intelligence analysis no longer interested in the individual but in how enormous volumes of data can be mined for patterns that might indicate a threat. This process is presented as the benign protection of the user from themselves (technology being far too complex to allow ordinary people to tinker with it), though it flies in the face of our attitude towards just about any other product. It encourages intelligence analysts to reveal the scale of these operations in antipathy, and governments to rush through legislation, in obvious mutual interest. One may ask what other product, once we buy it, is not ours to do with as we see fit? The further irony is the extent to which the producers of these products are prone themselves to cite freedom as a core value in their operations. In this, these developments have much in common with those paradigm-shifting technologies of the past, the apparently useless telephone, Tesla's dangerous alternating current system or the

hated spinning jenny. However, I think what those seeking to explain these forces are reaching for, and continuing to do so with banal regularity, is an explanation for why the present feels so conditional, why the debate on the social application of technologies has changed over the past 20 years from discussing the impact of a television industry controlled by a small number of publisher-broadcasters to whether a system as ubiquitous as television was once will survive at all in the Digital Age.

Invasive technology

What they are experiencing are our own attempts at sense-making of the flexibility and pervasive nature of technology that appears to be able to achieve just about anything demanded of it, whilst being unsure of the right questions to ask about what it might be the implications in practical terms. By assessing the technology at a functional level, we grasp its distributive nature and project social implications based on our assessment of its effectiveness in this task. Whatever the subsequent direction of the arguments, whether it is about economic advantage, social cohesion, technology adoption, democracy spreading, creative production, or all of the above, there is always the expression of imminent change, the second phase of a revolution that takes the people with the technology. It is driven by the observation of the personal impact of technology on individuals and the way it has, without serious debate, reflection or regulation, come to occupy our experience of living in the 21st century. It is presented as invariably positive in terms of the potential for the technology to impact on our lives, bringing with it a value system derived from the beneficial nature of the technology, reinforced by the apparent creative power of the consumer who subverts the more sinister aspects of the tech. More alarmingly, the projects of those applications of technology that are the chief interest of such musings are always represented in terms of their success, especially where they can be posited as lighting the way of future practice in a particular area. The assessments of technology that I see want to excite and inspire, whatever form this takes. This, as suggested, is fraught with problems and is invariably misleading, but it isn't really the intent of such rhetoric. Often it is designed to encourage us to buy in, not just emotionally or technically, but religiously and especially financially.

Great claims are made for capacity of the technology, exhortations in the spirit of the creative age of digital transformations. But the dark side of the technology is often elided: the determinism of engineers to subvert the imaginative use of their devices is more than a question of professional pride. It is linked to the business model that connects technologies with their market which, as we have seen, is rarely effective in determining the shape of technological use, but crucial in unlocking resources. The unavoidable impression emerges of a purpose for technology far removed from the natural instinct to overcome the limitations of evolution. What technology wants is autonomy of action, deterministic models of usage and mountains of data drawn from users, in their behaviours and preferences as a means to identify new services or methods of reaching into their wallets. This has become an important part of the lifeblood of the technology industries. From the original computer hobbyists, it became clear that the only way to fund further R&D was to sell less than perfect technology, sometimes barely serviceable stuff, as early users of PCs can remind you. To compound this, the urgency of change, the necessity to upgrade, is part of the cycle of technology culture. Whilst the aforementioned Moore's Law, that the number of transistors that can be placed on an integrated circuit doubles about every two years, no longer remains true, it has long ceased to be of any interest to the consumer, whose computers have caught up with them in terms of speed of use for most of the applications used in conventional computers. It is virtually impossible for most users to tell the difference, thereby limiting the apparent effect on anything but computer-to-computer actions. New parameters come into play in impressing on us the limitations of computers.

Often it is both of these versions of technological change, technology as the manifestation of ideas or its identity as a continuous narrative, that are proclaimed in defence of technological revolution and as the means of understanding what is happening around us. These drivers of change are both the movement of our instinct to technology in a process over which we no longer have control, only forward impetus, and the social need to resolve the problems of 21st-century cultural experience. Thus, the Internet emerges both in its own inevitable right as a technology proposition and a means of resolving the problems of loose and remote social ties that go with living the lifestyles that have become commonplace in advanced

societies. It feels that supporting both these propositions as correct is possible, if awkward, and it requires some explanation about the dynamic flow between forces and ideas. The technology framework, and whether these two notions of technological determinism and social problem solving can be reconciled or not, now determines cultural experience, even if we didn't think pre-historic man was really searching his imagination for the basis of what we now call the Internet.

Technology, power and creativity

It is worth considering the motivations behind this model of technological evolution, particularly given the burgeoning power of technology and our increasing disillusion with it in its practical manifestations. That the liberation from paper or proximity has made many of us in the Knowledge Economy slaves to email or that Internet connectivity often creates more trouble than it solves, permanently switched on via our smart phones wherever we are to everything from text messages to status updates, has become a commonplace. Our private lives are ever more marginalised by a publicised online persona that requires constant managing, and eventually overcomes our private self, which is subsumed into developing in ways that can feed our public selves. To criticise the invasive nature of the technology we have so gleefully taken up is dismissed as the discourse of Luddites. However, it is increasingly joined by people who really do understand both the basis of the tech and the implications of not dealing with its current trajectory as asserted across a range of fields of human activity. Essentially, it has spawned a new story about what is happening to us because of technology.[2] For an expanding number of writers about technology, we are getting more stupid and less able. Whether it is in carrying on our social lives, thinking about complex stuff or learning things, there is sufficient scepticism of the capacity of the technology to live up to its promises to demand a serious appraisal of how it operates in everyday terms. There is also the thorny question of whether the current state of play represents a new model of creativity or a perversion of it.

For the tech enthusiast, the knowledge of the impact of technologies of the past ought to provide two clear reasons to be joyful. The first is the confidence that it is not possible to stop the inexorable

march of technology as it kicks away existing social paradigms. As a narrative, the tale is always one about the success of the technology, rather than systemic failure (the French Telegraph is only ever discussed as creating the concept of rapid information transmission, never as the expensive flop it turned out to be). The second is the reassurance that time is on the side of technology. These assertions are far more conditional than they are normally presented as being, but neither is categorically false. It is the history that is invoked that is frequently misplaced. Understanding of the social force of the technologies cited is rare and seldom remarked upon. It is usually assumed. This is not surprising given that the picture that emerges is one that can be generally traced to a military or commercial advantage acquired by a specific party, to the detriment of someone else.

We have all had the experience of being in an aeroplane or listening to the radio, and understand the impact of warfare on the development of both of them, at least in the abstract. This is inconsistent with the claims to distributive power of digital that is unfailingly produced as the evidence of the benign nature of technological advancement. As Sowell (1998) puts it, 'while ideas have been historic in their consequences in science and technology...ideas by themselves have not been enough' (361). There is a social context as well as a temporal one that impacts upon the perceived opportunity. As Sowell shows, the Chinese often led the way in innovation, but China was not sufficiently receptive to ideas and innovations in such a way that books or gunpowder could lead them to enhanced economic prosperity. This echoes Morris' contention that without significant energy capture, social development stalls. For Sowell, the 'human infrastructure' becomes at least as important, evidenced by the necessity of those without a sufficiently adequate education system to import throngs of trained technicians to make viable the technologies in which it invests (the doomed Russian Empire in the 19th century comes to mind as a prime example). Technology depends on complementary inputs to succeed, explaining why it can succeed in one place and time and not another.

Sowell's insight is of vital importance. Whilst some spheres of human activity can be based on individual endeavour, the more interdependent an activity or application turns out to be, the more it requires the concerting of forces to make it happen. Technology

is exactly that kind of force, requiring collaboration and organisa-
tion of a type that is not demanded by, say, painting or composing
(a point also made by Kelly, 2010). The culture of specialist collab-
oration required to achieve has reached an apogee in the capacity
of interlocking disciplines to produce technologies on an industrial
and global scale and, as Lanier complains, for engineers to promote
interoperability of the kind the Internet produces. As an engineering
solution to the problems, this always trumps the fidelity that might
be prized by others seeking to use the technologies for purposes not
conceived by its army of creators. If the redolent belief amongst tech-
nologists is that their vocation represents the zenith and sum total of
creative and intellectual achievement of the human race is true, then
it appears that we are in trouble. At the very least we can see oppos-
ing forces in the struggle for purpose. What is computing really for?
The answers from technologists themselves ought to be a cause for
concern, given their assumptions of human benefit that often lack
evidence if not conviction. It is not an uncontested claim (see Lanier,
2010, in particular for a full and brutal account of its shortcomings),
but it has come to support some particularly ugly ideas about what
it can do for our future as a species. Once more, as the specialised
knowledge of a small section of the community comes to dominate
our experience (and in some cases, no member of any community
knows what is going on: machines have been designing machines for
some generations now), we need to challenge the idea that all this
energy is genuine achievement.

The interconnectedness of systems is what Kelly refers to as the
'technium' (2010: 12), the systemic intellectual creativity that sur-
rounds this process. In his identification of the technium, Kelly
suggests that at a certain stage, 'our system of tools and machines
and ideas became so dense in feedback loops and complex interac-
tions that it spawned a bit of independence'. For Kelly, the whole
proposition centres on the self-reinforcing exigencies of technology.
Technology apparently has its own autonomous agenda. Kelly sees
nothing inconsistent with believing this agenda to be contiguous
with and encompassing activities that might seem at first glance
to be incompatible with the self-perpetuating machine culture of
the technium, like paintings, literature and music. Unlike Sowell,
whose distinction between creative individual action on the one
hand and technological forces on the other rests on the conditional

dependence of large system support, Kelly appears to suggest that all things creative are all things technical and vice versa. It is a common conceit amongst technologists (see Graham, 2004, for another example of this sort of creative hubris), and has underpinning it a particular model of creative practice that the products of such thinking reflect. By this means an expanded definition of creativity is forced into being, one that replaces the individual vision intended to express with one that aggregates a broader capacity to reify function. Like so much else the agenda of technology has forced into redefinition, like what constitutes intelligence or ideas about feeling, the meaning of creativity changes to suit a newly emergent discourse about the value of technology to our experience. As such, ownership of terms becomes an important battleground where the insurgent technologists must not only fight but win in order to consolidate the gains they have made in offering digital technology as the defining feature of social and cultural life, as well claims to the practice of science and the only remaining credible economic opportunity available to the West. That there are some very different interpretations of the slippery concept of humanity out there does not inhibit such thinking.

Believing its own rationalism to be justification enough, especially in the face of examples of creative practice (like modern art) that appear to have no proper function at all, a redefinition has clearly been attempted. Whether or not this particular model will stick, it has plenty of support, not least from those creative people who seek out new technologies as the basis of their practice. We will address this problem at a later point, but here we merely introduce it to demonstrate how seriously the project of technology chooses to take itself. We have noted that it has sought to appropriate history into its support, to which we can add ideas about creativity and intelligence.

Amongst the more important problems thrown up by these irreconcilable attempts at history is the singular failure to note the authority derived from the mastery of the technology of the time. Indeed, perhaps it is understood as implicit in the technological process, but the progression from historical paradigmatic shifting through technical achievements into the kinds of social utopias suggested as the obvious result of the implementation of technological innovation is characterised by the absence of evidence. It also assumes the benefits of technology are in the control of its inventors, and this is not the case, a situation made more complex in the

case of sophisticated technology that requires collaborative author-ship or corporate exploitation. The rhetoric of technological change is that it brings with it a range of claims for itself as a panacea for those problems most immediately concerning the society around it. Thus, as Nye shows, successive inventors, sometimes of the most destructive technology, have claimed it will assure world peace or guarantee political freedom by creating international understanding (Nye, 2006: 151). The reality is far removed from that, and more dis-appointing for the lack of its capacity to create the changes in society it had promised. As Negroponte pointed out long ago, decisions over the exploitation of technology often have little to do with the excel-lence of the technical specifications to resolve problems and more to do with the decision-makers at corporate level (1996: 40).

The historical experience of technological integration enables us to accept there is some truth in seeing the ways in which the processes of technological development determine the culture in which we live. This argument is one where those of us who have access to the digital present whilst recalling the analogue past sense the evidence in our own daily living. But this barely reflects what is now openly promoted as the technological direction of humanity. The ground has shifted beyond celebrations about the future of technology as a liberating social force and now focuses as much on our future as the human race. There are moments when this seems more rhetorical than practical, but there are others when the practice of technology and the deeper agenda of its advocates edge towards some uncom-fortable scenarios that have a foot at least in some kind of reality. This is done partially by challenging the validity of the reality in which we think we exist. We have begun to fold the real and the virtual in together as a means of discussing experience *per se*, in sens-ing and seeing our digital experiences as part of our broader lives. We are less and less concerned with distinguishing the differences in these experiences and what our motives and operations within them might mean in cultural (or biological) terms (think of the massively multiple online game, or MMOG, or their role-playing counterparts MMORPGs, where vast economies have sprung up for so-called gold-farming players to exploit). Our imagination is at work once more, conflating and rearranging what we experience as a means of sense-making. But what is absent from this atmosphere is more than just evidence for the superiority of technology, though it is that, for sure.

The lack of a broader discussion about whether we want or should think about ourselves as a species from a technological perspective opens the way to being dominated by specialists. All around the world, in well-funded laboratories, some of the most intelligent, imaginative, insightful and thoughtful people of the Digital Age are well funded to invent and deploy technologies that will ensure that we won't need to be any of these things. Questions need to be asked about how a version of history and destiny comes into conflict with other accounts of who we are and what we want to be, as individuals, as participants in a culture and in the aspirations for our species. As we move from things to bits, we will surely discover we are made of more than either of these could ever satisfy.

4
Technological Systems and Creative Actions

The corporation as creative actor

One of the ironies of the corporate technology sector is the easy manner in which it stakes its claim on creativity. Giant international corporations project themselves as creative forces, enabling the users of their products to discover individual artistic impulses as mediated by their technology-driven constructs. Part of this myth is the presentation of the corporation as a creative environment, the sort of stimulating place that begets such imagination. As most people with some experience of such organisations can attest, creativity is quite rare in such places, with plenty of pernickety bureaucratic types to keep the maverick creatives at heel. Large tech firms, who experience this sclerosis every day, clearly have no trouble claiming that unleashing consumer creativity is their new mission.

Apple, the past master of this sleight of hand, dominates computing in the creative sector by connecting its brand to creative possibilities. Having positioned itself as the default solution for creative applications of technology, it regularly asserts a claim to understand creative production and its computing requirements. This is based on simplifying the computer experience to push the tech to the background, a laudable aim in many ways, but it elides something more sinister in the company's motives, as we will encounter later.

The invitation to creative fulfilment through technology often seems a pragmatic response to the expense incurred in developing technology for which there was no clear application other than the need to market something – hardware, software or web space – to pay

for a further iteration of it. As we saw in the previous chapter, this was linked to the opportunity to sell innovation *per se* to a subsection of the market that would be up for this challenge. The association with creativity has been presented as an adjunct to the development of technological solutions for as yet unidentified conundrums. Challenging users to invent problems that the solutions can tackle has long been part of an inverted game within technological adoption, noted by technological sceptics from Mumford to Morozov. The absence of an obvious practical purpose is reframed as a creative space for potential users. The fact that the tech may not work so well provides an avalanche of feedback in an online context, with plenty of willing amateurs committing time and energy to a critique of the products, or exploring their functionality for secrets that were not obvious even to the engineers. In the business models of new technology development, it may sell enough units to fund a further round of R&D, as in Moore's Chasm (1991) discussed in the previous chapter, to inform developers about a market they have hitherto ignored or of which they have thus far been ignorant.

If the critique of technology offered to this point seems plausible, that it accrues disproportionate benefits to its owners, that it creates dependency and that it distorts the discoveries of science into the creatures of the market, then the character of this creativity, and the redefinition of creative terms required for it, needs some examination. This move to frame creativity in the social space has profound implications for the creative and cultural sectors that existed before digital technology decided to colonise it. The modes and methods of creativity offered by the technology industry need to be distinguished from creativity as we might define it in an artistic context. To suggest the shape of this corporate ruse, and what it means for 21st-century creative practitioners, or the creative industries as we have come to recognise them, I want to start with an art work that reminds me exactly of this problem.

Seated in the mind

On a large television screen, the artist herself enters what appears to be a therapist's consulting room, contrived to look both cosy and professional at the same time. There is a Le Corbusier chaise

longue of the type on which those with money and worries might relax in designer comfort and freely express their feelings. There is a professional therapist, who speaks in a calm, easy manner with a classic mid-Western American accent. It is just the sort of voice, one thinks, that a psychotherapist ought to have. The artist, looking slightly tense and indistinguishable in dress from any young busi-nesswoman, is welcomed in a courteous manner and briefed by the more casually dressed therapist about the procedure in which they are about engage. We are watching British artist Carey Young's *Product Recall* (2007)[1], a video installation originally commissioned by the Paula Cooper Gallery in New York, later shown at the Tate Modern in London. A video artist whose ambiguous work is sometimes referred to as 'corporate art', given her background as a corporate trainer, it is often not entirely clear whether Young worships the corporate sector or offers a critique of it from inside (Figure 4.1).

Young arranges herself on the couch, but looks none too comfort-able despite the designer sofa and professional environment. It is a tightly framed image, which adds to the sense of tension. The thera-pist is virtually on top of her, his knees almost touching the couch, but he looks relaxed as he holds his clipboard and prepares for the

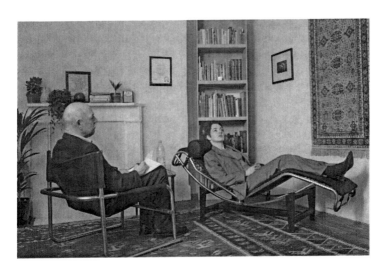

Figure 4.1 A still from Carey Young's *Product Recall*
Source: Young (2007) © Carey Young, courtesy of the Paula Cooper Gallery, New York.

session. After making half-hearted and insincere enquiries about her everyday feelings, the therapist explains in mellifluous tones that he is going to read out some well-known corporate slogans. Young's task is to match these to the companies they are advertising. She is assured that they are all recent, and Young indicates she is confident she can do it. Over the next few minutes, the therapist offers up the products of advertising's finest minds when they are put to associating a company in the public mind with a concept.

At first, this seems amusing enough, like a set of Trivial Pursuit questions that anyone, including the viewer, may know. Young gets most of them, is sometimes wrong, and sometimes she has to pass. At one point she says, 'No, I don't know that one', and looks slightly annoyed at her therapist for asking. As the list develops, it gradually dawns on the viewer that it is populated by companies that are seeking to posit themselves as creative and innovative, technology companies branding themselves as a link to imagination and inspiration. This is the first surprise, the implication being that these are the economic powers that are defining and dominating the epoch in which the patient, the artist herself, is living. Through their advertising propaganda they are asserting their social role, seeking an association in the minds of customers. With a regularity that becomes monotonous, and even appears to confuse the self-aware patient, these companies are seeking to claim something very important in the social space. Without exception, the slogans are fixed on the creativity of the corporation, its capacity to engage the imagination and to implement the innovative. The dilemma of the artist–patient, as she lies impassively on the couch, is to restrain her rage at the colonisation of the space of artists as the means of fulfilling the business plans of the corporates, whilst recording their triumph over the realm of creativity within the codes of civil behaviour as reflected in her corporate dress. For Young, the flip side of this, and the one that gives hope about individual freedom, is the fact that she cannot remember all of these slogans, despite her apparently sincere attempts to do so. The colonisation of the memory by corporate advertising is subverted by the very fallibility of human memory itself. What is the use of such sloganeering if not to posit an involuntary association in the consciousness? Does it matter what creative claims might be made by the corporation if it cannot lodge its essential message in the mind of the consumer?

The session finishes, and Young looks distinctly less cool than she did at the beginning. She is disturbed by what she could recall and what she was incapable of remembering about how the corporate world seeks to position itself in relation to her own domain. It was never quite clear if Young's task was to remember the slogans or to forget them. The therapist offers her a glass of water as she sits up, confused and disturbed. Like the rest of us, she is no longer sure who owns creativity or what it is, but she knows for sure there are companies that are seeking to make a claim on it.

In this installation there is no ambiguity, only the writhing of a creative soul whose behaviour has been thoroughly corporatised in both senses of the word. Its looped exhibition presentation means we might have started anywhere along the line of its five-minute length, but the lesson it offers is clear. One way or another, as the repetition of the process continues, we will get the sense of the intimate exchange on which we are eavesdropping. Hewlett Packard exhorts its product users to 'invent', IBM challenges us to 'think', Apple to 'think different'. Microsoft joins up its software with the user's imagination by asking 'Where do you want to go today?' Young herself is pretty clear about what all this means:

> I have been collecting slogans about corporate creativity for the last decade. It's a little like building some vast textual graveyard of the imagination stone by stone, except this is no mausoleum: such slogans express corporate vision for the future, a desire to be associated with imagination, innovation, with artistic endeavour and the avant-garde new. This image of imagination allows firms to suggest they have a handle on the future, and as a result, a greater market worth.[2]

This association of imagination with corporate power might once have seemed unlikely, but it is also a means of them making a claim to social and moral worth, too. Google does plenty of harm despite its much vaunted sloganeering. This forms part of the process of redefining notions like imagination and creativity by appropriating them into the corporate story. It is through that story they find customers to buy into the idea that a connection with the products through purchase and usage magnifies the benefits of the investment in creativity by company and consumer. How else to explain the magical success

of Apple? The act of 'techgnosis' Davis (1998) saw as an article of faith in the unproven virtues of the computer in the workplace extends into the creative space in the form of their devices. These are powerful, make no mistake, and they excel at parsing technical and creative processes into seamless workflows that carry the material with them.

This shift by the corporates into the language of creativity indicates something of the challenge they face, internally to stimulate the line of products they offer, and externally to develop a market for the results. As Young (2008) suggests, their approach is deadening to how we once thought of creativity, disguising the need to sell as an invitation to the imagination defined by the products on offer and the open space for the imagination they represent. It is a vacuous claim of empty promises. Their own creative achievement is defined by the successful negotiation of the substance of the project with the software. This is rather a long way from its manifestation in the Arts.

If this were all, the claims made for them could be easily dismissed as the desperate rhetoric of marketeers, but Young is surely right when she notes this as a genuine craving to be associated with innovation and creativity. The newness of new technology can't be overlooked as part of its appeal, as exemplified by Moore's Chasm. The edginess of the engagement, the relationship between the hardware, the software and the wetware, is presented as a dare. Unable to stand as creative stimulus in their own right, the hardware and software of the Technological Age wait for the consummation of their potential with the user, given that in themselves, these devices and processes are passive, at least for the time being. As any software developer will tell you, this state of passivity may not be permanent for too long. Creativity, or something approximating it, is a target for reconfiguration as well as an opportunity to sell some tech.

Creativity used to be seen as a personal rather than a corporate attribute, part of a personality or disposition. Imagination for the ordinary person was limited within confines set up at school, and in social behaviour more broadly. It was not an attribute required to do most of the work of the Industrial or Paleotechnic Age. As Alvin Toffler pointed out some decades ago, the intentions of Industrial Era education were 'punctuality...obedience...and rote, repetitive work'.[3] Imagination was not useful, difficult to predict and destabilising, though it persisted in elite areas, like culture and design. Creativity, in its fullest flower, was the province of the Arts, and

a separate category of human experience whose boundaries were tolerated precisely because it engaged a narrow subset of a given community. The social logic of giving free rein to a small section of society to think about and do whatever they wanted, sometimes with subsidy, was the harmless indulging of the creative on the off-chance they may do something challenging, amusing or beautiful in the public space.

They could also give the impression of freedom to those palpably unfree citizens of the industrial workplace, through music or painting, which might inspire the feeling of freedom without the risks associated with grasping it. They could thus expand our cultural consciousness and capacity to define ourselves without threatening a broader change in social experience or economic arrangements.

Young's work reminds us of how this part of the social contract has gone wrong. There has been a fundamental redefinition of how corporations see themselves, and invading the space of artists is the least of their inhibitions. Gone are the stolid, stentorian tones of patronising stability that defined old corporatism, to be replaced by the unlikely notion that working for the corporation is actually fun (think of those awful Intel ads). The ambitions of corporate power don't stop there, but actively seek to claim the space that was once thought of as creative. The method for taking on this task has been consistent with what we know of the technological process thus far: to define the tools and framework that constitute a creative practice, and learn from their use ways in which further refinements may be made to create dependency in users and material for new applications. For artists, formerly the keepers of the cultural imagination, the turn towards redefining creativity in this manner is a deep and accurately placed threat to all they hold dear. This chapter is about how circumstances have evolved to give the corporation the upper hand in defining the creative space.

Technological systems and creative actions

In this first instance, in the spirit of the enquiry, we need to examine what has passed for creativity in the technological world, identifying its fundamental values and justifications. This can be compared to the world of the Arts and its way of managing the complex forces at play in its own version of creative achievement. Arthur (2009)

makes attempts at forcing traditional arts practice into a techno-
logical definition to make exactly this point: a Mahler symphony
can conform to a notion of technology only if that definition is
rendered so broadly as to be practically meaningless. If a defini-
tion of technology covers all things with purpose, then we are only
technologies, and we will require other words in which to frame a
discussion about ourselves or the process we use (55). To do this cer-
tainly requires a level of reductionism and cliché, but within these
necessary constraints are forces we need to understand if we are
to negotiate the relationship between technology as creativity, and
creative practice as we have known and understood it until now. Fun-
damentally, it is a difference between process and practice, between
collaboration and individual vision and what Lanier (2010) notes as
a dichotomy between the interoperability so beloved by engineers
and the fidelity to a vision that drives the artist. Buried in this is the
slippery definition of innovation and its relationship to invention
in the technological sphere and creativity in the artistic one. More
importantly, it is the artistic proposition that seeks to explore some-
thing more intangible than a purposed system (indeed, it is this very
systemisation that artists often seek to avoid). If we think of a sym-
phony as a technology (as Arthur and others bid us so to do), then
we miss what makes it a distinctive entity. There are, to be sure, tech-
nologies at work in the symphony orchestra, but Mahler's intention
was not to create a methodology that could be replicated so much
as a proposition of human expression. The composition process itself
opens his own capacity to express and invites the musicians' interpre-
tation. The methodology, or even the structure, is the means to make
that expression possible. Where we face issues about method, we see
clearly the irreconcilable difference in basic principles of production.
For the scientist, the ability for others to replicate an experiment is
the chief means of validating the research. For the artist, adopting
the methods of others is an admission of creative failure. The value
of the work is determined by the originality of the proposition being
formulated, including the method of developing it.

This principle is ignored in the application of the kind of digital
technology artists sometimes find useful and companies find prof-
itable. When they use Photoshop, image makers are proceeding as
if the contested ground of the image is played out elsewhere, but
in its ubiquity, Photoshop has surely become a test of who uses

the software better. There is a distinction to be made between the aggregation of technologies that enable methods of expression, and the mode of expression itself as it seeks to deal with distinctive instances of an image or a sound. Artists are fairly clear that whatever the means of production they are employing, the real value emanates from their own individual shaping of the results. Conversely, the notion of accumulation (or history) may be at best a reference point, but could not possibly support a significant arts practice, no matter how rooted it may seem to be in the complexes of technology.

The danger of attempts like this to extend the definition of technology into areas in which it has no meaningful role is not the most potent threat facing the practice of creativity. It is merely symptomatic of the reductionism that comes when complex abstracted questions require concrete examples. What it does do is give permission for the engineers to reframe the process and intention of creative practice into their own governing paradigms. This misplaced faith in the systemic processes and their evolution gives rise to the possibility that creative processes and systemic ones might well be the same at a basic level. This space has been cleverly identified by the technology industries as one with significant possibilities, and though it has limitations for the creatives who buy and use their products, it has fuelled a lucrative market for creative practice mediated by digital technology. The extent that this defines the parameters of creative practice of particular types is well trailed (see Jenkins, 2008, or Lanier, 2010), but the more frightening prospect is the way it sets the scene for their reduction and redundancy.

Before exploring these ideas, I need to declare a hand that, whilst passionately supportive of the freedom of the Arts and its unique contribution to society, does not wholly believe its self-regard or the apparent sanctity of its frequently expressed piety. The motivations of artists are less high-minded than they are often presented and, as a community, the Arts and its bureaucracy are well-versed in twisting a nascent practice into something that looks public-spirited, when the real answer to their motivations is sometimes more venal. Too often the Arts are defended in an overly simple conceptual framework; that it provides society with a critique of itself; expresses deeply held societal views that cannot be expressed in other ways; and through such expression, it alters culture. These principles of art are regularly

invoked in social discourse to justify more selfish motivations on the part of individual artists and protection for practices that can be difficult to defend without the mantle of art to dignify them. Art and its industry regularly claims as public (and socially improving) work which is merely the personal presented in the public space, work that doesn't deserve, and will not receive, a defence in these pages. If technology can be accused of using the altruism of science as a fig leaf for its avarice, it must be acknowledged that art has a dark side too, but it also has its own internal systems of regulation and critique. One of those is that to be art, it must play itself out in the public domain. Private art is not a category that can be treated meaningfully, and despite the obscurantism of some art work, it remains dependent on a public for its validity.

Part of the challenge of working in the creative domain in the 21st century is finding a distinct enough identity and working method. The movement towards art as a reflection of the individual branding that is evident in say, the personas of Grayson Perry or Tracy Emin on the one hand, or the gargantuan outputs of Damien Hirst or Anish Kapoor on the other, is based less on the system and more on the quirks of strongly asserted individualism within a clearly recognisable market. This demand for expression of individual interpretations and engagements with the world leads to a kind of fetishised individualism at the intimate end, a search for validation of personal experience. At the other end of the spectrum we see more industrial-scale bombast, more likely to represent the artist's brand than their own hand. In their own way, both of these approaches foreground the individual, not as a prompt of common experience, but as a reminder there are people out there who are expressly not like you, and do not see the world around them in the same way. For artists navigating a world beyond craft, the post-skill age problematises any assertion of an object or idea as art.[4] It not only configures the art produced, but undermines any individual claim to understanding as part of the process. No one 'gets' high art anymore, at least not in a totalising and definitive manner that would produce consistent results. Art, of all sorts, remains a matter of conjecture and interpretation, and open to easy criticisms as a result. As its global reach expands and the artists of emerging economies make themselves known, they do so in much the same way as their Western counterparts, and for the same reasons. Art is essentially international and operates across all

kinds of political divides, but essentially seeks out the same audience wherever they may be located.

The other major issue when dealing with the mismatch between art and technology is that, as a cultural practice and an industry, art has far less impact on social, cultural or economic life than either the technology with which I counterpose it, or the exaggerated claims it makes for itself. It is usually addressing a self-selecting audience. Even when that audience can be very large (say, in the case of public sculpture), art and artists can prove remarkably hostile to external interpretations for which they do not care. Artists can often manage to maintain this position whilst simultaneously claiming the truthfulness of all interpretations, a tolerance for dissent and a pretended curiosity about the legitimacy and provenance of alternative ways of seeing the work, as noted above. Artists do this whilst knowing it is the connection with the art tradition that secures them a place in culture, and this is the audience to whom it ultimately plays. However it might be interpreted, it must be interpreted in a category that agrees the work is at least art.

This cul-de-sac of expression and intention is a legacy of 20th-century, pre-technified art. The weakness it created in a technologically defined culture was not intended at the outset. From the moment of Duchamp's *Fountain* (1917), the notion of what stood for art and meaning changed dramatically. If Duchamp's work was a timely critique on misplaced notions of intention and representation, intended to engage the mind as much as the eye, it also expanded what we might think of as creative practice. His 'readymades' removed old certainties about the importance of the artist's hand or notions of execution of skill, and challenged art audiences to engage with art as a proposition by the artist. *Fountain* also celebrated as art a prosaic product of the industrial process, as Barthes (1957/1972: 88–90) would do later with the Citroen DS, and in either case, the selection of the product as subject is not exactly arbitrary. The idea of art as an assertion of the artist, constructed from the world and repurposed as creative intention, would come to characterise a particular kind of artistic gambit: that within the most humble of workaday objects, the idea of art might be found. In this, there seems a direct corollary to Arthur's attempts to claim all purposed systems as technological: in art, the proposition that it takes an artist to draw attention to the properties of a thing or a system, and make a claim of

artistic originality, is all that is required to recast it as artistic practice, to count as art. When artist Mark Wallinger (1994) named his horse *A Real Work of Art* (Tate Gallery: 10–11), and planned to enter it in horseracing events, he found himself nominated for the Turner Prize.

This intentional problematising of art, whilst often somewhat knowing, does not however justify a wholesale invasion by the marketeers of technology as in Carey Young's example. The present weakness of its preparedness in accommodating all acts as potentially creative ones is that a cultural model of creative practice is easily colonised by a corporate one. Duchamp's strategy has been ultimately counter-productive. It creates an internal inconsistency that substantially weakens the position of anyone to adjudicate on a definition of art. Any time attempts are made to address the matter of what constitutes an artistic statement and what does not, art's own 20th-century relativism returns to undermine the defence. By conceptualising, Duchamp changed the terms in which the game of individual interpretation may be played, and opened this field for abuse from within the Arts and beyond it. That art has not ground to a halt is not evidence that no damage has been done, only that its specialness is compromised when reduced to an extension of a technological or corporate project. The absence of a distinction in the character of creativity in two essentially separate spheres enhances the claims of corporatism to creativity, whilst reducing the achievement of creative practice in the Arts.

What should be understood is not the abstraction of art as a concept, but how qualities of art are discerned in playing out in its own examples: art, even the 21st-century variety, still usually leaves tangible traces of its sometimes intangible intentions. More importantly, it represents a channel of Western social and economic behaviour that does not conform to the business models I have decried elsewhere. It presents itself as an alternative socio-economic model, and as such, is worth preserving in a world of dodgy technology companies stealing its clothes. We will parade its virtues momentarily, but first we need to look at what technology considers as being creative, and show how different this is from most of our notions of what constitutes the achievement of the human imagination. By doing so, we can begin to see the depth and importance of the encounter between art and technology. What they share is a process of creating physical manifestations of concepts, a definition of practice that

draws authority from its own tradition and applies it as it sees fit. This seems horribly unsatisfactory, extremely broad and leaves us with two competing spheres that might never intersect. If we could assert the existence of a craft practice of computing then we might see a clearer relationship between the areas and equate or blend technical processes with creative intention, or at least acknowledge their part in the expression-building process.

This draws us back into an argument about the means of artistic production and its relationship to the technology that supports it. In ways that parallel the emergence of the engineer in industrial processes, the technician exists in the art world to bring to fruition the work from the idea. This was adequate for the task so long as the processes of production in both spheres of action demanded specialised expertise not expected of the scientist or the artist, but where the very essence of the work is created by the technical process itself, such an arrangement is rather difficult to justify. It remains a mystery to the public how a Hepworth or a Rodin (or a Hirst) can be considered as such when the artist may not have played more than a supervisory role in it taking its final form, and for this reason the existence of such support is rarely advertised. It has a very long history, from the earliest days of art as a distinct cultural practice, but the model of artist as independent genius comes to us from Michelangelo: an exception and not the rule. By contrast, the means of production in the digital sphere seems so dependent on an understanding of the underlying technologies, the manipulation of the substance determining the expression, that it feels impossible to reconcile as 'creative' the results of the processes undertaken by coders on behalf of an artist without the craft or an understanding of the complexities and possibilities of the underlying technologies.

Industrialising creative essence

The starting point for resolving such a dilemma may well be Heidegger's well-known objection to the typewriter as a technology. He saw the device as tearing writing 'from the essential realm of the hand' (Heidegger, 1982/1998: 81), in a manner akin to my assertion of the need for the identification of a craft practice. For Heidegger, the involvement of machinery degrades expression into mere communication, disassociating the idea (that which requires

expression) from the physical craft of writing. Thus, the typewriter mediates what he refers to as 'the relation of Being to...essence'. Worse, it does this without engaging our consciousness about the implications of exactly what it is we have done. These are hidden from us in the utility of the device. Technology, through the typewriter's capacity to elide the writer's character, becomes a 'signless cloud', an anonymising implement that reduces the individual hand (the writing script itself) into a standardised form. By custom and practice this diminishes the gravity of expression of the word, distracting our crafting instincts with its machined efficiency. It changes the way we think, and what we think about, by changing the means of thinking, moving expression from the painstaking hand to the rapid clickety-clack of the machine. Heidegger, aware of the cultural impact of print, suggests that this, in itself, 'offers advantages and conveniences, and these unwittingly steer preferences and needs to this kind of written communication' (85). This is not a mere transfer of the process of bringing thought to substance, but an unacceptable subversion of the substance of thought itself, reduced by the technology into a thing of the Industrial Age, and ultimately preferred because of its conformity to the demands of an industrialised and mechanised life. The only thinking that can emerge from such a life is that which is consistent with and informed by those qualities. For Heidegger, such technologies were unwanted interventions into our expressive capacity because they mediated and distorted the moment of expression. We are remoulded by them into the constraints of their mechanism. Heidegger understands that the technology is making us, and determining how we can express ourselves, by changing something essential about us, forcing us to adapt to its demands. Accordingly, elsewhere he properly warns against the temptation to treat technology as something neutral (1978/2011: 217), given that however we feel about it, all instances of technology have values and qualities that are inherent as part of their essence. As he indicates, this is no minor thing, but the means of creating our framework for thinking and being. If these observations are true in relation to writing, what might this mean for painting that turns into image-making (David Hockney's iPad drawings come to mind), or dance as generated by motion capture (choreographer William Forsythe's Motion Bank project)?

Yet, despite the evident conservatism in his views, it seems that Heidegger identifies the very core of my argument. If we accept technology as partial, in that it has specific aims and prejudices that determine potential outputs from it, we need to use this awareness as a means of wresting back from technologists the understanding of its possibilities. Technology is too important to be left to the corporate sector to determine the patterns of its development and use, especially when that use focuses on creative action.

Of course, the obvious weakness of Heidegger's argument, much noticed and commented upon, is the extent to which the pen, that mighty instrument of the writer's hand that Heidegger is so prepared to defend, is itself a technology. As Don Idhe, for example, points out, it is penmanship that Heidegger prizes as authenticity (2010: 71), and he goes on to place Heidegger's writing practice in the context of the historical and technological development of the pen.[5] This would suit certain definitions of technology as well as creativity, given the necessity to learn and adapt the body to the processes of writing, of using the pen, a technology demanding 'new bodily skills...to produce the flowing styles of such instruments' (74). There is no doubt (especially noting the phenomenology to which Heidegger and Idhe are committed), that with these new bodily skills come different modes and possibilities of thought, different speeds and alternative methods of constructing and revising.

What Idhe goes on to explain is crucial for any serious discussion of this relationship between thought and action in the creative sphere where it encounters technological enhancement. His exemplars are drawn from the first generation of writers who, far from eschewing the typewriter, celebrated its capacity to facilitate the flow of ideas. From Twain to Nietzsche, it turns out plenty of writers with big, original ideas turned to the typewriter. What these examples show is something artists of all types dealing with technology understand: expressive possibility is located in the system in use and determines the parameters of the possible outputs. These parameters sometimes seem virtually inexhaustible, but they are, in reality, defined by the technology at hand, are value driven and craft-based. These constraints define the outputs as, say, literature rather than painting, to choose an obvious example. It is grappling with the limitations of form that stretches the ideas and practices of artists, because in

these models it is the structural conventions of form that are under pressure from creative activity, not the technology used to produce it. The flat-footed distinction between innovation as the introduction of a new mode of operation and creativity as the exploration of the potential of that mode applies in such cases. It happens that with digital technologies and in their application to creative opportunities, a different model of dependency emerges that falls outside such a simplistic framework, muddying as it does the relationship between technical skills and expression.

Creativity in the Digital Age

We have entered a new creative age. There wasn't a specific event, like the dropping of a bomb, to signify it. As indicated in earlier chapters, no one can quite agree when and who started it, or why. It crept up on us, until one day when we noticed that the computing power in our mobile phone was being put to use on cameras, texts, browsers and apps that did all sorts of convenient things from games to language teaching. We began to notice that our job had become mostly about answering email, that we didn't get much post anymore, except the books we had bought from Amazon, and our furniture was all ordered from the Internet. Its insidious progress from digitising the phone signal to doing away entirely with the corded handset was rapid yet barely perceptible. The move from LPs to MP3s took no time at all considering the ubiquity of the delivery systems that supported them. It was a shift from an industrial era to a digital one, one that required industry for sure, but in a different way. Those differences will have, are having already, a tremendous impact on the way we organise society, in education, property, commerce and manufacturing. Most of all, and first of all, they are having a direct impact on modes of creativity, laying claim to this word with a slew of justifications about democratising art and expression, whilst at the same time eliding the restrictions and framing now placed around our capacity to formulate creative propositions by the technologies through which we express.

The way we can tell it is so important is the way it has crept up on us. Like the Industrial Revolution that preceded it, its arrival can only be detected after the event, requiring a significant repositioning of social capital and a revaluing of skills that are now superfluous

but to the previous age were thought indispensable. The distinction that most needs to be made is that between the models of creativity as presumed at corporate level, and the stuff that artists choose to do, sometimes with their proprietary technology, and sometimes not. In this there are yet more comparisons with the Industrial Revolution and its legacy. I want to briefly revisit the progression of the Industrial Revolution to illustrate the direction we may be travelling in.

As we have seen, agrarian societies extended the volume and availability of their products through processes that demanded new methods of production and distribution. Where once physical endurance and the capacity to marshal it determined economic power, it was the imposition of discipline that moved the social and economic priorities from land owning to factory management. Of greater interest than a simple account of Western economic history, from agrarian strength to industrial discipline to digital creativity, is the way in which we see the Industrial Revolution now. We are only now beginning to see the implications of industrialisation and its rough treatment of creativity. This becomes obvious in the ways in which we now treat the Industrial Revolution and what we think are its most influential contributions to the way we live now. Whereas in former times, the adjustments to industrial production were seen in the context of massive movements of capital and labour, as determined by rationalising accounts of methods of production complemented by improvements in infrastructure that permitted economic expansion, we have now come to think of the Industrial Revolution in terms of the social impact of the new steam-powered technologies. It is the evidence of our ability to formulate an historical narrative that reflects our own present-day concerns and tells us exactly where we are. We are looking into the past in order to explain how we come to terms with the economic dynamics that come with the advent of new forces. The once great levers of the Western economy, in terms of heavy plant and equipment, have transmogrified into computer-generated apps for an iPhone made in China.

One of the lessons for the creative entrepreneur has already been discussed: whatever else, have a business plan. The purpose of such a plan is not planning, but selling. As discussed above, the technology landscape is littered with unlikely successes that could not be planned for and inexplicable failures that looked a sure bet. The intention of the business plan is to raise capital and generate interest

in the potential of the technology to bring economic benefit to its investors. We noted in Chapter 1 that innovation in the technological sense was driven in Britain, the home of the Industrial Revolution, by the relatively high labour costs of that country in the late 18th and early 19th century. From this observation, entrepreneurs invested their hopes in technology that would overcome this competitive disadvantage.

I want to put this argument in another way. The cotton spinning industry, for example, may well have been concerned about labour costs, but its dependence on the skill of a spinner, working at home, in her own hours and at her own pace (for the workforce was almost entirely female), must also have been a great frustration. The aim of the jenny was not merely to liberate manufacturers from the inconsistent productive capacities of the 18th-century homeworker, as described by E.P. Thompson. It was also to reduce their dependency on that worker's skill. However convincing the argument of the reduction of labour costs may seem, and it is clearly a powerful one, it seems an incomplete explanation for the types of machines that were produced. These did not seek to do something entirely new, or to shift the focus of a potential customer onto a completely different product, but to reorient the potential for production away from dependence on the capricious individual and their handicraft skills. For the producer, this was clearly an advantage over the old piecework system, reducing their exposure to the risks associated with reliance on a workforce not yet trained in the Industrial Era's brutish methods of punctuality, obedience and rote learning so beloved of the likes of Wedgewood or Stephenson.

The consequences of this for workers were nothing short of disastrous: a social contract and way of life was destroyed by the desire for men to make themselves rich through the labour of others. The skills in which workers had prided themselves, identified with as their occupation and station in society, and from which they had long earned a living, were no longer an integrated component of an economic system. As Sennett (1977/1986) points out, the processes of early industrial capitalism were something of a mystery to many of those who benefitted from them. Their intentions were to make money, of course, but exactly how this was done was nothing short of guesswork, and remained so for most of 19th century as conventions around the business of industrial capital emerged. The skills and

craftsmanship of the 18th century found themselves done away with once the entrepreneurs settled on steam as the solution to dependence on people, who in turn had been dependent on their craft to ensure a living.

Having achieved this, the next step in the process was training the workforce to their own pattern. We have already encountered the justifications of Methodist capitalists, equating the discipline they were instilling in their factories with a misplaced mission of making their charges so much godlier. This in itself may explain why there was so little public disquiet at the economic ructions produced by transferring what we might now refer to as IP from people to machines. Those whose craft skills had been decanted had now to contend with a new problem, one that has beset societies ever since, and one that the Digital Age is hastening: the wresting of skill from the individual to the machine clearly benefitted the potential for economic production by reducing its dependence on people. Effectively, the designers of machines were copying the crafts for which they could see a demand. From the producers' perspective, this seemed reasonable enough. It was not undertaken with the intention of deskilling the workforce, only to reduce an individual enterprise's dependence on skill it could neither control nor compel.[6]

Put simply, I am suggesting the teleology of technological development has two main aims: to cut the costs of production and to reduce the dependency on skill. This double action is important to note as the emphasis in the Digital Age apparently relocates from disciplined conformity to the realisation of creative potential. The idea that creativity, as a human quality, is so unique that all advanced economies have to do is to prepare for the shift and occupy this as a new economic space is rather misplaced, but the machinations of skill-oriented technological displacement that reduces costs are there to see all around us.

Creativity, skill and a cup of coffee

I was struck by the reality of these aims on a visit to a nondescript cafe on the outskirts of London. It was attached to a branch of a supermarket chain in a ghastly out-of-town retail park, a sort of afterthought of the corporate planners to capture those whose shopping had particularly wearied them. Its unprepossessing appearance did not bode

well, but I was about to succumb to retail fatigue and wondered just how bad the coffee could turn out to be. Once I joined the line, I realised something far more interesting, if rather tragic, was taking place. Not only did the coffee not promise to be anything much, but there was the added insult of having to queue for it, in a line that wasn't moving. This was provoking much agitated discussion amongst all parties.

The middle-aged woman serving (or not serving) the people ahead of me was becoming quite distressed at how long the whole thing was taking. The lengthening queue was creating great tensions for her customers and she herself was struggling to contain the situation. As a matter of explanation and forgiveness seeking, she gestured towards some large silver machines behind her. This situation was not her fault, she explained, because the cups she required were still in the dishwasher. 'It isn't like I never washed a few cups before', she remarked exasperatedly at the frustrated customers in front of her, shrugging her shoulders. Her employer had not planned for this eventuality, or had lost confidence in the effectiveness of human capacity to simply wash up a few dishes. This meant there was no sink provided for this task to be conducted as an emergency measure. When the cups finally emerged from the clouds of steam as the dishwasher completed its cycle, she set about making the coffee. Well, actually she lined up the cups under a spout and pushed a button. During the tense waiting period, she could be overheard discussing the problems with her colleague. 'They don't need us', she complained, 'They could do this with a couple of robots.' Whatever mild pleasure might have been taken by providing refreshments to its shoppers, the supermarket was ensuring that personal service wasn't one of them. The coffee wasn't up to much, either. Nor was it cheap enough to justify a machine making it. The whole process reflected the triumph of Taylorisation over common sense. The implications for the imagination are clear; how is it that we will suddenly switch from a workplace that distrusts us our human interventions into one where our creativity is the driving force? Further claims about the role of creativity in the realm of work will be discussed below, but the lesson of this encounter was one we should have learned by now.

The experience was reminiscent of Richard Sennett's studies into how work shapes our character. Like E.P. Thompson before him, he noted that technology does not simply displace people from their

work, but in the process destroys that part of their identity that is constructed by their occupation. His deskilled subjects, the transitory employees of the 1990s, cruise easily between jobs because none of them require the time-consuming acquisition of complex skills that would not be abandoned lightly. There are few defining characteristics of their work that give them a sense of investment in it. Consequently, they are no longer able to significantly identify with their work in a way that may define or build their character, and make them loyal to their trade if not their employer. The result is a level of social vapidity, a void where once a sense of social purpose and standing achieved through work might have stood. Sennett revisits a bakery where a generation ago he conducted an ethnographic study of some real bakers. In earlier times, their work was hot and uncomfortable; they were occasionally burned by the moulds they used, and were resentful about their pay and the unsociable hours. The men (and they were exclusively men at this time) 'used their noses as well as their eyes to judge when the bread was done' (Sennett, 1998: 66). Whatever their issues with the work, they still expressed a sense of pride in doing it well.

Thirty years later, their successors were untroubled by the physical demands of the work, because they were entirely ignorant of the processes of baking. They had only to master a simple software programme to get the process running. They still retained the residual desire to do a job of work well: at one point in his interviews with them, the computers break down and everyone has to wait, to much evident frustration, until some experts are sent for who understand the system architecture. But as he talks to the new bakers, he senses their work identity as slight in comparison to those he had interviewed years before. When one woman laughingly enumerates her many occupational experiences ('Baking, shoemaking, printing, you name it, I've got the skills.'), she is referring to a capacity to operate machines rather than to bake, cobble or print. As Sennett notes, her understanding of work is superficial, and thus her identity somewhat distorted by modern technology and market capitalism into a focus on flexible work situations that require little commitment and few pride-inducing skills. Heidegger's championing of the hand was a means of expressing the value to himself of the skills of his own craft, and the modern software-driven workplace lacks this essential element.

The conundrum is not resolved by positing as practical a desire to march back to a pre-Digital Age. There is no point smashing the computer on every desktop or the phone in every pocket. The question is more about what can fill this void of identity if we reduce work for those dependent on machines to some button pressing. At this point certain optimists are prone to citing the creativity of the Digital Age as the salvation for satisfaction at work. It is a seriously posited claim, and as such deserves some scrutiny. If the opportunities for creative practice are to replace our former work identities, what kind of practice will it need to be?

There remains something unnerving about this level of deskilling, once put into the context of the definitions we make of ourselves. The destruction of skilled occupations is seldom noticed until they pass into the world of craft, and are able to seek a premium on that basis. The examples are many: tailoring, pottery, bookbinding, jewellery manufacture. Once upon a time these were everyday occupations. They attracted customers from all parts of society, until they were subsumed into vast industrial concerns who were seeking to manage demand on the scale of mass production. The exigencies of volume brought with it efforts to make the process efficient, mostly by simulating the skills of human beings with machines. It is this that links the spinning jenny to the push-button coffee maker.

For the creative sector, being regularly exhorted to join the digital revolution is becoming worse than tiresome. We have found our concepts colonised and our professional expertise trivialised by the idea that through technology everyone is now a 'creative'. As I have suggested, this is partly art's own fault, happy as it has been to problematise the notion of creativity and what constitutes a work of art since Duchamp's *Fountain*. By shifting from the traditional necessity of underlying craft as the means to express, much art has evolved into an assertion of ideas, often completed without the direct intervention of the artist (think of Jeff Koons). Not since the movement towards art as the expressive practice of the individual has there been a more significant change. This is not only the perceived relocation of the art impulse from the hand to the mind. This turned out to be the means by which the idea of creative practice could be reformulated. The really noteworthy phenomenon has been how the very openness of our definitions have invited the technology industries, filled as they are with solutions looking for problems, to reduce artistic

achievement to Photoshop filters or mash-ups in iMovie. As a sector, we have even adopted these technologies, and have our own preferred brand of computers, the Apple Macs that are so pervasive in the creative sector and nowhere else.

The main critique of the digital technologies available to the artist is by now well known, and is exemplified by practitioner-theorists like Lanier (2010, 2013) and Jenkins (2008). It is worth revisiting here as the portal through which we can understand a further level of dynamic that operates in the domain of digital creativity, and is linked to the insight that the expressive possibility of the system determines the potential of the creative practitioner. Lanier, a well-known technologist and musician involved in the development of virtual reality, has repeatedly warned about the determinism that drives engineers, and how this is reducing the creative process and its output into models that engineers can imagine and subsequently control. He does so whilst acknowledging that one of the features of creative practice can be to undermine such determinism and produce quite unexpected results, at least unexpected to the original designer. But he also notes the tendency to technological lock-in, the process by which the technology that reflects the values of engineers, with their preoccupation with interoperability, determines the long-term framing of a given area. His best example is the ubiquity of the musical instrument digital interface, or MIDI, invented in the 1970s, standardised in 1983 and still dominant in synthesised music to this day. Despite its shortcomings as a means of reproducing sound, MIDI had the benefit of allowing a large range of devices to speak to one another through its simplified protocols. As Lanier sees it, it was these simplified protocols themselves that limited MIDI's ability to reproduce sound to an acceptable level of fidelity, but this mattered less to the engineers who wanted to create links between their controllers. The opportunity to build a system that might give musicians more of what they wanted in terms of reproduction was set aside for the potential of interoperability that Lanier noted as their main preoccupation. MIDI was flexible, but inconsistent in quality, and circumvented the problem of negligible storage available during its development by formulating the audio as a set of instructions. The limitations of the samples on a given device would determine the quality of the output, in a workaround that sidestepped the issue of sound fidelity. Lanier goes further than this, noting that this

tendency to agree to standards early on in the interests of economics distorts the potential evolution of a technology. This is what gives us MIDI when we might have had something considerably better for a very long time if we had been less wedded to the notion of interoperability.

Distributing power and democracy through creative action

If there is merit in the case for privileging interoperability and the diminishing effect this has on craftsmanship, it surely ought to be the capacity to stimulate creative action for a wider population. For Jenkins (2008), the creative tension emerges between those with corporate and IP rights, and their own consumers who seek to appropriate some level of control and engagement with their products. The complications of this dynamic can be found everywhere, from fan fiction to proprietary software, machinima-based films or games, or commercially owned virtual environments. They frequently produce perverse outcomes as users subvert the functions they find, as well as corporate behaviours that would seem otherwise unacceptable. As Jenkins shows, the problems revolve around access and ownership, giving lie to the overblown claims of democratic freedom as the configuring feature of the Internet. The willingness (or not) of corporations to cede control of their environments more accurately describes his collection of examples. It is prescribed function and regulation of access that a capricious corporation will invoke to protect its rights against its own customers that repeatedly emerges. The virtual environments developed as a means to attract a user group turn into a method of capturing that group and exploiting or regulating their usage for corporate ends. The fans showing up aren't interested in corporate purposes, but seek to hack into the functionality to give themselves the experience they would prefer to the design of corporate engineers. The challenge for both parties is to extract as much value as they can from a given situation, and there are regular victories for both sides in getting what they want. The now all-but-forgotten *Second Life* (Linden Labs, 2003–2013) remains a case in point of how this dynamic plays out in online space. It was the most prominent and popular of the early 3D virtual worlds or simulations (sims), where anyone could sign up, create an avatar and explore the capabilities of the platform.

The owners, Linden Labs, proved capricious and arbitrary governors, who intervened whenever they felt their proprietary rights were threatened, but were passive when it came to porn or cyberbullying. In the same vein, Jenkins cites the model of *The Sims On-Line* (Electronic Arts, 2002–2008), another 3D platform run by one of the world's largest games companies as an extension of the computer game *The Sims*. Once the editorial direction of the user-initiated online newspaper *The Alphaville Herald* turned critical of Electronic Arts, the editor found himself booted from the sim. Jonathan Zittrain (2008), in his work on the power corporations retained over devices through their firmware, gives further examples of the same dynamics as they manifest in an entirely different fashion. His explanations of the extent of residual control illustrate the importance to the manufacturers of both determining appropriate use and learning from user behaviour as a means of refining a product or redirecting it. The capabilities for mass surveillance, whilst appreciated by governments of all persuasions, were put in place by the technology industries in the first place.

The cost of these interventions into technological structures is significant in narrowing the potential of human creativity. They compromise their own use in a way that is both sinister and reductive. It is not pining for the craft practice of old that leads me to this conclusion. Indeed, I have noted that there are new craft practices and creative strategies employed in using computers for creative purposes. It is more that the structured engineering of technological determinists and beloved of corporate lawyers has switched off the options to do something more than those they have chosen to include in the software. We can no longer think about manipulating images except in the terms that Photoshop provides for us, or distribute them in ways other than the Web. This is done in a way that forces the artist into a lifelong fealty towards a brand of computers that rewards them by frequently updating their operating systems, methods of connectivity or software functionality without consultation, in ways that are both irritating and debilitating. That such actions can be ruinous to the individual in the midst of their complex, creative tasks, or incapacitate third-party software has no weight in deciding what constitutes a legitimate action. It is the complex of business and law, not science, which determines the framework in which we operate. For creative practitioners the door is closing on what kind of technology we may want to practise with. Such is the smoothness and apparent

comprehensiveness of the products now available, we risk creating a generation ignorant of alternatives and limited in creative vision except as prescribed by the companies so eager to claim creativity as their own value (Bauerlein, 2008). The ubiquity of the reach of technology, its increasing presence in educational contexts and social ones alike, undermines the regularly cited meme of a digital generation, or digital natives as originally styled by Marc Prensky (2001). This is because of the false assumption that those who grow up with the technology of the Digital Age all around them will somehow 'know' more of it than pre-digital types whose working and social life has been gradually colonised by it. This assumption is hardly safe, except in the consumption of content, towards which the technologies are increasingly aimed. So far as seeing computers and their offspring as creative tools, this is limited to the functions and controls situated in the proprietary technology they have been forced to adopt. This is the lesson the creative sector ought to have avoided. The studies cited by Bauerlein (2008) and Seigel (2009) show that the application of computers to classroom learning does nothing to enhance the learning of a given subject, but a great deal to encourage the arbitrary use of IT and pupils' preference for turning to the computer as the first source of information. This is not a measure of computer literacy, only of computer use. As the technologies that drive computers have been perfected, so have the means of understanding their functions diminished for all but IT professionals. The ubiquity of computers is essentially reductive rather than democratic in practice, belying the extravagant claims of Castells or Negroponte.

This, I would suggest, is where artists have a role to play. Unlike engineers, whose culture is built around interoperability, collaboration and iteration, artists value other stuff. I am not blind to their shortcomings: whatever their view of their own moral superiority, they remain members of the human race, and thus deeply flawed, but there are ways in which they should contribute to the technological dimensions on which, like all of us, they increasingly depend. The best work in this area focuses not so much on artistic production but, as Heidegger would see it, on the disposition that underpins the technological complex. For most artists, fidelity in the artistic sense trumps the interoperability imposed on them by the engineering paradigm that dominates the products and platforms they are able to work with (Lanier, 2010). Given that these determine the

patterns and aspirations for their work, the matter seems somewhat urgent. At the present moment, the compromises artists must make in the absence of partnership with the technology industries reduce the potential of creative work that remains faithful to exploring and presenting the individual vision. It has become an industrialised product. The difficulty of achieving an individual vision in a technological framework is certainly one of the reasons that artists, for all their interest in the Internet, have rarely taken up the creative opportunities it offers. The Internet does not deal in individual visions. It acts more like an Ice Age, seeing great movements of people across its geography as the temperature of its various parts changes. Artists instinctively resist this herd instinct. The extent to which they engage with the technologies is often limited by their interpretation of how far they can go in delivering their distinctive interpretation of the world through them. The answer nowadays is often not very far, and such a conclusion should stop fantasists like Kurzweil (2006) in their tracks. The other opportunity is in claiming back the ground of creativity as the province of individual achievement. Artists should be vocal in rejecting the salesmanship of those companies that seek to colonise creativity in their advertising and their products. Carey Young's *Product Recall* (2007) is both creepy and comic in the treatment of the long list of corporations draping their products in the mantle of creativity.

In the end, this is not simply a confrontation between corporate power on the one hand and artistic expression on the other. The notion of creativity and its social force is at stake, and whilst the artists have a great deal to lose here, it is the notion of personal creativity that is most in danger. Not content with owning our time and taking our money, the modern corporation, through its claims to innovation and creativity, is seeking command of that most human of qualities that it once sought to banish from its workplaces. Having industrialised creativity, it seeks to determine its form. The method through which it chooses to do this is most obviously through digital technology, at once a means of reducing the skill of the consumer in the guise of creativity and suggesting communitarian participation in the great collective, creative effort called the Internet.

These are not the only forces at play here. There is a significant role in creative opportunity being played by hackers and the manifestations of their power in determining the technological platforms

available for creative processes. The conflicts regarding the use and protection of IP, whether commercially valuable or otherwise, have taught all of us the dangers of conservatism in the face of a technological revolution that is often presented as if it had no political slant of its own. The recent claims of damage to the concentration by technology (Jackson, 2008; Carr, 2011; Brockman (ed.) 2011) remind one of the former fears about television watching, with a concurrent debate about the value of information that cannot be processed into knowledge because of its sheer volume (Gleick, 2011). Business arrogates to itself a form of creativity it once violently rejected as the means to, in that ugly word, monetise its ideas. The purpose of this chapter has been to separate out these various strands of creative activity and their concomitant values, noting that the existing models of creativity are currently competing for survival in the 21st-century economy. The endurance of craft-based models of creativity – wet darkrooms or potters' wheels – emerge as intentional celebration of the analogue. They may forever endure as symbols of the handmade – and as Frayling (2011: 67) points out, the potters' wheel was a redundant technology by the 19th century – but they become appreciated for representing the past ahead of their creative potential.

In the midst of these problems, there have been some serious attempts to ask questions about the implications of a new technology space on our identity, our personality and, most importantly, our creativity. In the midst of this, some of the darker sides of technology have gone little noticed, and we need to remedy some of that. Where precisely this moves, we shall explore in the following chapter.

5
Can Machines Create?

Creativity as morality

Thus far I have questioned whether technology can truly justify many of its assertions to represent quite the zenith of human achievement claimed for it. The narrative that insists that the technology we utilise represents objective progression towards improvement for humankind as a species seems little more than a fable to support sales of the products of the technology industries and the exigencies of domination by the technological that appears as a condition of accommodating any part of it. This in itself makes the case for ending our uncritical engagement with it and calls into question many of the generalisations made about technology as a force for good. As Jacques Ellul pessimistically pointed out 50 years ago, there is no moral dimension to what he called 'technique'. It is 'freed from this principle obstacle to human action' in a fashion that should not be confused with neutrality, given it asserts only an autonomy as defined by technical process itself (1964: 134). By comparing our current phase of rapid technological innovation with previous ones, we have seen that assertions about the relative benefits of technology, especially where there is a claim for universal improvement in living standards or economic growth, turn out to be questionable at best. They are as likely to demand significant losses in personal freedom, discretion about individual working practice and economic dependence for those who do not control the technologies that are seeking dominance over them. For, as we have seen, the critical relationship in technology is not the conjunction with science.

The association of the altruism of science and its dispassionate pursuit of verifiable truths with commercial models of technology has been important in managing the image of technology, but it does not help at all in revealing its character, except the propensity to enlist false arguments in its defence or to shape our perception of it. We are encouraged to use the phrase 'science and technology' as if the two were coterminous, but as I argued in Chapter 2, the crucial relationship for technology is not found in the scientific process, its methods or its components, nor in the scientific contributions to the eventual outcomes. Indeed, as Arthur (2009) has pointed out, plenty of technology has nothing at all to do with science, and plenty of the discovery science on which technology is eventually based can be complete many years before its adoption and incorporation into the products of technology, often in ways that subvert the original intentions of the research. It can also find itself neglected or forgotten where a better solution does not conform or support a business model, or the existing investment in infrastructure makes an improvement founded on new science unattractive. The association of science with technology is sought more for the credibility and independence that science represents as a moral and cultural construct than for its contribution to the design and operation of the products of the technology industry.

Without the aim of attracting investment, and the stratagems that invariably come with protecting investment, the technology simply never comes to market and never imposes itself upon our lives. We have seen this process in action, and noted that for all its pretensions to asserting the sanctity of market economics, the reality is that technological capital prefers monopoly to competition, and where this cannot be secured, the exercise of close control and limitations to the use of its products. This is particularly important in building a dependency on technological systems that can be exploited once the relationship is established. It may well be the case that someone could invent a chip that enhances individual intelligence,[1] but no one would be likely to sell it, preferring the control that comes from alternative forms of ownership like leasing. The pretensions to a disinterested search for scientific advancement belie the tactics of commercial domination that come with the development of new technologies. The conflation of this idealism with idealism of other kinds, the political, cultural or creative freedom often invoked as the

consequence of technological innovation, makes this a legitimate subject for examination. In itself, this indicates how far new technologies are from the neutrality in which they are readily presented. This truth has been noted by most observers of the technology industry, going all the way back to Geddes (1915). Critics of the efficiencies of the Information Society and its benign features are characterised as conservative sceptics like Siegel (2009) or dismissed as pessimistic doomsayers like Morozov (2013). A critical position on the technologies as they manifest is dwarfed by the false moral claims of the improving qualities of existence brought about in the technology of the time. Thus Manuel Castells' regular assertions of the democratising power of social media appear to have much in common with John Wesley's sermons exhorting the godliness of discipline and hard work to the exploited workers in his congregations at the dawn of the Industrial Revolution.

A definitive difference

We have looked closely at the credibility of the claim of technology and its development to be a creative practice in itself, and attempted to distinguish between different modes of creativity as they manifest in a particular sphere of activity. For engineers, what it means to be creative and how that creativity manifests needs to be distinguished from how the creative process operates in the Arts and cultural sectors, a point I have made earlier. The emphasis in engineering and technology of the accumulation of innovation is irreconcilable with the importance of individual expression or an ascribable contribution that characterises work in the Arts. The notion of collaboration, for instance, has distinct definitions in either sector that cannot be easily resolved. In technological development, the method looks more like aggregation, and its working practices are drawn from a process related to production lines and decision trees as they reflect the training and practice of engineers, where the results of one solution become the building blocks of another. For the Arts, this would lack the rigor and originality required for credible artistic intention, but is also overwhelmingly collective in a manner in which contribution and achievement in the Arts is not. Successful art work in itself is presumed (often wrongly, it is true) to be the vision and work of an individual, rather than the collective efforts of a group (though this

has some traction in the form of curated group shows, theatre ensembles, symphony orchestras or artists' collectives). In the context of creative practice of the cultural kind, a process predetermined or systematised by existing knowledge would be rejected as derivative, and lacking the originality in method that the best art is assumed to embody.

This is especially true if the foundations are the working practices or systems developed by others. It is not possible to distinguish between the aesthetic and technique of, say, Jackson Pollock. Nor would it be a viable proposition to adopt his methods and still be considered original. This would be judged as little more than pastiche and of limited value in its expressive content given the boundary that would have been crossed.

Having set out the case for an alternative for creativity in a technological context, in this chapter, I want to reformulate an older technological question. The reason to do so is not as technical as when Alan Turing, the British mathematician of 'Enigma' fame, originally raised a version of this question in 1950, though he certainly had in mind something more than what he thought a computer could achieve technically. When Turing first explored the notion about whether computers could think, he was not doing so in anticipation of their possibilities but their limitations. There was, it seemed to him in any case, no means of replicating the sort of thinking he understood people to be doing, and no likelihood of this changing anytime soon, given the direction of research into computational power going on in his time. On the contrary, he was clear that a great deal of human thinking needed to be done, and some of it would be done by Turing himself, in order to reformulate the question into something computers could realistically achieve. The problem of a thinking computer was too far beyond the technology of his time, so far in fact that it encouraged Turing to think about an alternative method of approaching the issue. Based on the technical work he saw emerging, he speculated that an alternative way of synthesising intelligence might be possible.

Turing's ideas are important to the development of creativity in the digital domain for two reasons. The first is that, rightly or wrongly, they have informed the development of computing in this direction, in the guise of artificial intelligence, ever since. The second reason is something Turing could not possibly have guessed at, but that

has come to define our perception of the role of technology in the domains of culture and economics. This is the contemporary rhetoric that has conflated a digital future with a creative one, and suggested this is a way to drive an advanced economy, the modern claim that asserts creativity as it manifests in the digital framework as the new economic saviour of the West. Noting that models of technology proceed according to their ability to replace expensive humans with far cheaper machines, this is fertile ground, and somewhat comforting to those who may concede that, with certain qualifications, computers may be able to think, but creativity is surely reserved for humans.

Such has been the domination of the economy by the machines of what Geddes (1915) and Mumford (1934) after him described as the 'Paleotechnic Age', that we are left, well into the 21st century, with that model of education Toffler (1970) saw as inadequate to the task as long as 40 years ago. It is this shift to what Mumford called the 'Neotechnic Age', and Toffler described as 'post-industrialism' that this chapter will be concerned, and more specifically how this is thought to determine our economic future in the context of creativity. The capacity for people to be able to master the forces of computational power and convert them to some creative and therefore economic advantage has become a strategy enthusiastically adopted by governments and corporations alike, and even those encouraging the adaptation of our education system towards more creative endeavours do so with the justification that the necessary exploitation of the technology demands it (Robinson, 2009). Today, the idea has many names, some of them mutually exclusive, like the 'Digital Economy', the 'Information Society', the 'Knowledge Economy' or Richard Florida's more general formulation of the key workers of this new age as the 'creative classes' (Florida, 2002). There is a great deal of faith in the West that it will be this sophisticated turn from heavy industry to lighter than air data that will continue developed economies along the path of growth deemed necessary to sustain them in the manner of previous models, to symbolise progression in the form of ever more attenuated relationships between work and value. I will suggest this is not only overly simplistic, but that the seeds of the inevitable failure of this project are located in the nature of the technology. What Jonathan Zittrain notes about the jealous guarding of IP by technology companies takes on an even more sinister character when it comes to controlling the possibilities

of creativity in the digital space. As such, technological alternatives move from hardware to software to production itself. The volume and flexibility of the data will be the instrument through which computing will take on creativity. The very stuff we think of now as requiring human intervention, creative decision-making developed by working through a project, is turning into a transitional phase where analysis of the data, combined with computing power and distribution through Internet protocols, can credibly reduce the people involved to passive bystanders.

There is a relationship between this effort to rebrand economies and restructure them as 'creative' with the exploration of mythical gold mines for digital prospectors that we have discussed in Chapter 2, but the need to revisit this as an idea is linked not so much to those spurious economic models, based on little more than faith and boosterism, than to the direction and configuration of creativity as we might interpret it. As indicated above, the variety of terms used to define an age coming to grips with the transformation of its functions by computing power are of necessity approximate and partial. Seeded within them, and frequently cited as the best reason for us to accept a digital age in the shape determined by the technology, is a combination of a challenge to the imagination and the identification of a new frontier for knowledge and understanding. Given these are qualities that are highly prized in any age, such descriptions are invariably flattering. They are tempting for those who see themselves as potential contributors to an age defined by human creativity and intelligence, posited as the new capital required for successful business. But far from creativity by digital means as the saviour of now-defunct economies, the disposition of the technology industries will create a rude shock to these assumptions, the basis of which is already in play. By distorting and perverting the functions and operating strategies of creativity until they conform to a preferred vision of the businesses that operate in the digital domain, it is the creative community itself that is offering up the solutions for the direction in which these businesses will force their users and shape their outputs. Creativity may well have its day, but at this rate it will be short. Additionally, the very foundations of artificial intelligence, as formulated by Turing and his successors, are already indicating precisely how to keep this day as brief as possible. The unpredictable and expensive humans can be shunted aside for the replications of

Figure 5.1 A reconstructed version of Turing's Colossus at Bletchley Park

creativity the technology industry will prefer and can simulate by studying the craft of digital creatives. No doubt the weavers of the 18th century never believed a machine could do their jobs either. The key to understanding this lies in Turing's ideas about computational consciousness (Figure 5.1).

Turing for creativity

Every year there is a computing prize, known as the Loebner Prize for Artificial Intelligence. It is awarded along principles first articulated by Turing. Having rejected the possibility of reconstructing the myriad, unknowable processes of human thought, he posited the idea that if the responses from a computer were indistinguishable from that of a human then, logically speaking, the computer should be said to be thinking. This principle has since become known as the Turing Test, and defines at least a type of intelligence that computer scientists could realistically pursue. As such, it has appropriated the efforts of artificial intelligence developers ever since its first publication after the war, becoming the long-standing aim

of cybernetic research. As Turing himself put the challenge, 'May not machines carry out something which ought to be described as thinking but which is very different from what a man does?'[2]

Clearly, in Turing's view, there is no reason to attempt to reconstruct the complexities of the human brain if an efficient alternative could produce the same result, and the Loebner Prize encourages exactly this approach. For Turing, and for those who have followed him, the crucial feature of artificial intelligence was the credibility of the outputs of computation at mimicry, not the presence of actual thought, but something closely resembling it. Having begun with the challenging question of whether computers could one day think in the same way a person does, he shifts the ground to ask the more realistic question: 'Are there imaginable digital computers which would do well in the imitation game?', that is, the imitation of responses to the point of credibility. His own reframing of the question was designed to give the computers he foresaw at least a fighting chance in terms of what he understood would be their properties, and thus to explore their capacity for extremely large and fast computations of the zeros and ones in which they deal. He understood that the model of operation bequeathed to the future of computing was one that would cope with large numbers of equations at speeds far superior to those of his own time, and the problem of replicating human thought would be more demanding on subtle programming than sheer computational power. The trick to the imitation game was structuring responses to questions such that they were indistinguishable from the answers human beings might give. His 'Argument from Consciousness' refutes the objections that would have it that mimicry would not be enough, and he thinks the value of such sentiments are both misplaced and not provable given the impossibility of measuring or assessing reflexive consciousness. It is his case about this argument, that the solipsism on which it relies simply rules out too much of that which of necessity remains unproven, that has come to dominate the process of testing for machine intelligence. He hints, quite rightly, that the variation in prowess amongst humans for thinking in any case lowers the credibility threshold for many, and by association, the standard required of the credible response. His further discussion of 'Lady Lovelace's Objection', the observation by Babbage's assistant, the brilliant Ada Lovelace, that the analytical engine can do '*whatever we know how to order it*', picks up her use of italics about

this principle (rather similar to Idhe's objection to the superiority of Big Blue and its defeat of chess champion Garry Kasparov). This fixes on the ambiguity of her statement: does it imply the impossibility of such a thing, or the absence of evidence for it as a property? Turing was not trying to make an argument suggesting the primitive nature of the Babbage engine rules it out as an example: quite the contrary, that it contained in principle the same qualities of the computers of his own time (and ours) in this regard. It is in applying the prejudices we have when differentiating between computer and human that disadvantages the computer, and reduces computing expressions as derivative in a way that we do not apply to human creativity.

This argument begs a question about computing as it happens now and in the creative modes in which we increasingly use them. In our time of more powerful computers, is it in this guise of mimicry that the notion of creativity will ultimately find itself the province of machines rather than humans? If a computer can mimic human creative practice, do we dare say that it is being creative? How is something *originated* in any case?

Creative relativism: where's the threshold?

These questions are greatly problematic given the variations in intent and quality of the products of creative practice. In all forms of creativity there are conventions and standards, but frequently what challenges the internal culture of an art form are those examples of practice that refute or ignore these. Accepting gradations of intelligence is one thing, but the relativism of creative outputs is such that making a distinction between one field of work and another is fiercely difficult, and the question of judgement of prowess even more so. It takes a better definition of our anticipation of the creative response to an artistic challenge or a design brief that could do it. This reflects the way in which we, the human agents in the technology process, engage with a proposition in order to complete it. This process is exemplified by the chatbots that are entered for the Loebner Prize, in pursuit of passing the Turing Test.

Like so much of the technology we have, the Turing Test is exactly dependent on the credulousness of people engaging with it as a system, as Turing himself predicted. Can it produce a believable

representation of human thought? This, it would seem, depends as much on the human beings engaging with it as on the prowess of the programmers, as Christian's (2011) account of the experience of the Loebner Prize shows. This is not simply evident because the current crop of programmes designed to win the Loebner Prize are disappointing failures (they are), but because Turing's proposition is so dependent on a powerful ruse about what constitutes intelligence. The Turing Test has offered a long-term guide as to how to structure programmes to understand and respond to user behaviours. What he proffered was a sophisticated call and response system, the replication of patterns of speech now known as natural language processing. To Turing, this may well have seemed logical enough, but this is not without significant flaws. Whilst it is clearly only a partial solution to the 'Argument from Consciousness' that Turing was seeking to refute, the test itself has certainly proved an enduring, practical challenge.

The techniques that have evolved with the intentions of replicating intelligence are just as applicable to creativity in the digitised framework. When these are combined with the framework of IP rights, the argument that creativity will be the answer to economic challenges looks rather vulnerable. The complexities of human beings become, in themselves, a weakness when confronted by the brute force of computational power. Their limitations in expressing that complexity through the single channel of one body are a significant handicap when it comes to the multi-tasking possible for a standard modern laptop.

Some short experiences with the 'winners' of the Loebner Prize demonstrate the foolishness of mistaking speech or statements for intelligence, a phenomenon we habitually note in ordinary life when dealing with actual humans.[3] Turing's Test is too simple in its way, and it seems unlikely that a comprehensive winner will be found any time soon by the methods currently being pursued. The absence of context and the relativism required to define any particular conversation makes meeting the challenge too difficult. Intelligence is not simply made up of a matrix of responses, however sophisticated, and if it were possible in this fashion, the effort seems somewhat misguided. But what interests me more here is not Turing's assertion about what constitutes intelligence, nor even the extent to which the technologists involved seek to reduce a notion of intelligence in such an unintelligent way, but with the capacity of the imagination.

Whilst the focus of such competitions has been on the computer and how it functions, the real dilemma posed in making distinctions about intelligence is in managing the credulity of the human engaged with it. As noted above, Turing was well versed in understanding intelligence as manifested in human beings as immensely variable, but this did not apply solely to the output of a machine. The technology can exploit the creative mind seeking to make sense of the world, and thus confect a solution between them. A computer may not think on its own, but a user can imagine that this is possible. Does this difference matter?

To put Turing's question another way, can machines create? For Turing, it would seem, the answer to this variation on his original question would turn on whether we can accept what is produced as a credible proposal in the domain of creative practice. The inverse of this problem is the extent to which that perception is relative, and whether it is made by assessing a craft skill or an aesthetic proposition, or something that reflects taste or judgement. To create in this domain is to reflect on a history of creation, to shift consciousness from intellectual process to sensual response and to express an instinct as much as a rational formulation. It means making something consistent with the traditions of an art form and offering up something to progress our understanding of it. Issues of taste or popularity notwithstanding, we expect the artist to be as good as their word and to challenge us as well as to please us, to offer up the unexpected and to find something within a shared human experience that enlightens us about it. For autonomous creativity in the technological domain, it turns on whether a credible example within the traditions of art practice might qualify.

Like Turing's thoughts on intelligence, this seems to me in itself based on a fallacy, one designed to create some level of fear, but also to mark out and challenge something we believe is significant to the properties of humanity. This is important to the concept of creativity and its concomitant actions given the way in which speculations in this field are not dissimilar to those in the early debates about artificial intelligence. The focus on cognition, itself newly arisen as the dominant mode of psychological assessment since Turing's original paper, has elided the connection between intelligence and creativity, and I would assert here that they are by no means coterminous nor mutually exclusive. The clues as to how a proposition of this type

might be put are, however, already there. In the spirit of Turing, who having asked a controversial question and then looked to construct a viable answer, we can now see how the programmers of generations of software have learned from user behaviour. After all, Turing's proposition of the game of mimicry has determined the direction of programming for artificial intelligence and cybernetics. So what happens when creative practitioners begin to depend on the software to generate and complete their creative work?

The evolution of Creative Suite

Amongst the many problems in the early adoption of proprietary software for creative practice was the extent to which it undermined the craft practice, an issue we will discuss more directly in Chapter 6, but whose most famous instance we need to look at now. The example of choice is nearly always Photoshop (Knoll, Gutman and Brown, 1989–1990; Adobe, 1989–2013). It seems strange to recall now, but there was a point where those with long experience of wet photography as a painstaking craft were deeply suspicious of the image-manipulation possibilities of Photoshop. For such folk, it took photography to a level of sophisticated falsification that undermined the image as a representation of truth. It damaged the authenticity of the photograph. Many of my colleagues (and I worked in a graphics department at this time), whilst acknowledging its utility, felt instinctively that it was somehow cheating, that it contained the capacity for falsehood not located in habitual photographic practice, and thus presented an ethical as much as a technical dilemma. They also felt robbed when all those hard-won darkroom processing techniques were turned into icons, when decisions were no longer time consuming nor costly, both of which demanded reflection on whether to proceed or not, given that an approach to an image could be revised by pressing the undo button. The time and money, they argued, were part of the creative process itself, forcing new ideas into the heads of the creators as part of their occupational responsibilities, demanding planning before the photograph was made and decision-making informed by craft afterwards. Digital cameras were, they complained (with some justification at that time), inadequate for creating and working with high-definition images, in contrast to the 35mm format equipment to which they were accustomed. As they frequently

Figure 5.2 The first iteration of Photoshop, reapplying darkroom practice to the interface

Source: Image from creativebits.org, published under Creative Commons.

noted, camera technology hadn't substantially changed in 80 years. It was hard to see what was wrong with it. For them, this was what photography was and for them it worked (Figure 5.2).

As we now know, this approach was doomed, and took a fair few practitioners and established industrial companies (like Kodak) with it. But what the Photoshop example also shows is the capacity of software to replicate the processes of a craft within a given discipline. Long-standing workflow conventions or craft techniques become compressed in time and reduced to analogous buttons that refer to now forgotten practices in the physical world. Adobe in particular has proven a past master of this method, creating products from observation of the analogue profession, reformulated for digital treatment. Augmenting their image-manipulation software, they developed a package of programmes to replicate other creative processes, from video editing or drawing, to sound recording and screenwriting. This is nothing less than impressive, and Adobe dominates the market in products intended for creative content generation through iterative generations of projects marketed as Creative Suite, or CS. For a decade from 2003, at intervals of 18 months or so, the creative industries, especially those involved in graphics and advertising, would sigh at

the advent of a new version of the programmes. Because of the in-built functionality and interoperability of the programmes, and the gearing of much of their workflow to the possibilities of CS, most agencies simply shrugged and signed up to the next iteration, argu-ing that the cost in not doing so would leave them at a disadvantage, or make them look less cutting edge. New features available in the latest iteration of CS would quickly become ubiquitous in the visual landscape. Eventually, this culminated in a final version of the fixed software, CS6 in 2013. For Adobe, this was not the end of the CS story, but the beginning of a migration from creative practice as located on the user's computer to exercising users' creative efforts on Adobe's own servers, in the form of cloud computing. A shift in cre-ative ownership and dependence was finessed at every stage of this journey.

In much the same way as computing and Internet technologies evolved separately, and were only put together at a later stage in the development of either, so was there mutual distrust between the original programmers of CS and the distribution processes of the Internet. Their products were initially oriented to the print indus-tries, and thus intended and priced for standalone machines with specific functions in a professional publishing milieu. The Internet and its rampant populism was seen as a means by which the busi-ness model for companies like Adobe would be undermined, with free copies of their expensive software available via cracked codes and distributed on pirate websites. The graphics industries also con-tributed to this atmosphere of paranoia given their own morbid fears of potential theft of the creative content they developed themselves. Changes in the size and scope of the programmes and improve-ments in the hardware also changed the behaviour of Adobe's clients. They became more at ease with the Internet as a medium, and it began to take priority as the means by which their work was gen-erated, moderated and distributed. Reflecting the Internet's sharing ethos, users of Adobe's software would regularly suggest features for inclusion in future versions, and the Suite eventually bloated into the 16 separate programmes seen in CS6. The file formats empha-sised quality, echoing the original intentions of CS to be primarily for professional use in graphics and image making, extending into video and sound editing, to exploit the improved resolutions of new screens, more processing power and improved graphics cards,

made possible by larger hard drives supported by greater Internet bandwidth.

For Adobe and its customers, there would surely come a point where the regular updating of software and increasingly large file sizes would need to be dealt with in alternative ways. The result of this has been the recently released Creative Cloud or the CC version of the suite, a virtual licence for software that will update itself as new iterations become available, with the provision of online storage and working space for media professionals. CS morphs from a product into a service, and it is impossible not to be impressed with Adobe's approach to responsive design that the CC accommodates. The once reflective, problematic craft process, taking time and consideration to formulate viable alternatives, is made irrelevant by the task-resolving solutions of CC's programmers, like removing camera shake in its video editing programme Premiere, or enabling the export of photoshopped web pages directly into the web editor Dreamweaver, bypassing completely the coding processes that used to be done by experts at this both tedious and painstaking craft. In doing so, the software does not resolve the problems that used to be the subject of conjecture and reflection by small teams of creatives, but simply ignores them, removes them from the equation, and as such redefines the character of what gets produced. Expensive human intervention becomes less necessary. Problems like camera shake need not be resolved out on location any more but in post-production, and animated discussions between web designers and HTML coders no longer massage the desirable into the possible. The disappearance of such seemingly minor irritations isn't much of a cause to champion, but there is something within the processes as they shift to a web platform that ought to give pause for creative thought. This process has taken on more sinister overtones as the notion of responsive design moves from amendments driven by creative usage (and suggested to the makers as a result), to one where the software itself, in its web-enabled state, can report the patterns and styles of usage, can learn the ways in which designers and image makers choose to manipulate the material they have, and mould these into programmable amendments or conventions that the users never need be aware of. As the software automatically updates, the realisation that another process has been selected out is a gradual one. The 'creative capital' of users, as Florida likes to refer to it, is siphoned

off without their direct knowledge, except in an EULA so complex they won't have read it, or pitched as if the company is doing them a favour by collecting their use data if in the unlikely event they have actually ploughed through it.[4] In much the same way as the entrants to the Loebner Prize programme their software to learn from the interactions that take place, in a world of powerful computing, creative processes themselves become capable of an ersatz creativity, eventually indistinguishable enough from the 'real' thing, itself increasingly a product of its underlying technologies. We already see it when our images are automatically corrected for light, orientation, suggested cropping dimensions and tagging of our subjects. The authenticity of the image that drove my photography colleagues long ago, informed as it was by Barthes and their craft skills, seems a long way away, and creativity of the artistic kind transforms into that of the engineering version.

We see this effect already in work obviously machine driven: unfortunate word associations made by Google Ads, or incomprehensible computer-generated subtitling, but however stupid the existing entrants in the Loebner Prize may look today, their successor programmes, utilising large-scale computing power and cleverer algorithms, will be far more difficult to distinguish from the real thing. There is no technological reason why we can't do such a thing, and it remains the obvious endpoint to the trajectory on which our computing in the creative sector has been based. What we haven't understood are the implications of applying this same principle to the frontiers of human creativity, nor its consequences for who we will become as a result when our camera decides which is the best image and the optimal way of presenting it, publishing our creative content for us without a need for our intervention or reflecting our intentions. Google Glass is merely the first gesture in this direction.

The inevitable process by which we will progress to such a position is driven by the association between technology and business, accelerated by the spurious arguments about the importance of creativity to economy. Idhe's defence of the humanity of computers, by which I mean his nuanced argument derived from an analysis of whether a computer actually did defeat Garry Kasparov, offers a model of how computer scientists might rise to a creative challenge. He notes that the challenge was for Big Blue's designers rather than

Big Blue's to formulate, echoing the Lovelace Objection, and that the rule-based systems of chess lent themselves to the skilled marshalling of computational power by talented and creative software programmers. Beating Kasparov was the easy part. Deciding that it comprised a victory for computers over humanity is another matter, but differentiating between Kasparov's creative play, responding to the moves made with the reflective experience of a Grandmaster, and the calculating machine that beat him becomes irrelevant in judging who plays the better chess.

Learning models

As noted earlier, until recently, creativity was seen as a specialist and marginal attribute mostly found in the domain of the Arts. Educational curricula paid lip service to it as either culturally enhancing or therapeutically satisfying. So undesirable might it be to a well-functioning workforce that the structures and processes of Industrial Era education were organised in such a fashion as to beat the creativity out of pupils in the push for a compliant and obedient workforce. One of the reasons for inhibiting the minds of young people into the figures and tropes of industrial society through the school system was to set down parameters on what people could formulate as ideas. Literacy and numeracy were acceptable and measurable: expression and criticality more open to conjecture and less valued in the school experience of the 20th century. The process was required to be sufficiently brutalising to determine the limitations of pupils who might be spending a career on an assembly line. This had the virtue of encouraging creative individuals to identify their practice with a certain level of rebellion and to develop a virtuous circle of creativity linked to push the boundaries of acceptability within the context of their work. The relation to craft practice meant that creativity was not without discipline; more that such discipline was put to the service of individuation and personal taste, and then let loose into the world for wider dissemination and appraisal. With the colonisation of creativity by the corporate agenda, a new definition of creativity emerges, and with some support from the old creative practitioners who tend to view it as at least more benign and free than the working conditions of the Paleotechnic Era or as Taylorized labour in car factories. As a result there have been many more boosters for creativity as there

have been for the technology that stakes a claim to it, and the overlap has been considerable. In many cases (Florida, 2002, or Shirky, 2009 spring to mind), the association of creativity with technology takes the concepts as virtually coterminous, conflating distinctive practices in the search for larger conceptual shifts in our social organisation. In such approaches, there is no serious technological practice without creative explorations.

The trouble is the triviality in treatment of what passes for the creative. For Florida, virtually anyone with an education who has managed to steer clear of working in the burgeoning 'service class' of personal carers, clerical staff and customer service assistance, those who have avoided the fate of simply playing out the designs of others, becomes a member of the 'creative class', by assessing their autonomy and the relatively high economic value of the work they do. Whilst Florida includes those involved in what might be seen as creative activities without much quibble, the extension into professional classes like lawyers, doctors or accountants expands the population of this class without improving its creative credentials. This conflation of creativity with autonomy is achieved by claiming activities like problem-solving and values like individuality as core beliefs of the new class he identifies. Recognising 'every aspect and every manifestation of creativity – technological, cultural and economic – is interlinked and inseparable' (Florida, 2002: 8) becomes the means of identification rather than an assessment based on older occupational classifications. Florida's case for creativity is an economic one: modern economies require these professional classes to develop new opportunities, hence the ease with which they can be folded in together, despite having very little in common. They become the engine for the economy in this fashion, the very individuality Florida claims for them as definitive is lost in lumping them together as a class, and their creativity is not a manifestation of their originality so much as a means of furthering the value of the firms they work for. The new aim of human creativity under such circumstances looks rather bleak, reduced by the technological framework to instrumentalism.

On the other hand, Shirky (2009) isn't bothered about whether a creative manifestation is paid for or not. His argument is that the creative opportunity presented by the technology is an egalitarian social leveller, enabling the creative expression of those whose

voices have been hitherto unacknowledged by the traditions of the Arts. That this manifests itself in banality and triviality is part of his case: such expression has been repressed by the self-serving elite whose definition of art and creativity fails to reach larger swathes of the community than those who can genuinely claim connoisseurship of them. But whilst Wikipedia's basic reliability is uneven and untrustworthy, and *lolcat*,[5] the website devoted to anthropomorphising domestic pets with witty captions accompanying pictures of cats and dogs, is at best a silly diversion, his communitarian view uses the same rationale as Adobe: that the compilation of the large forces and data represented in Internet traffic create a consensus view of what is good. This populist approach, scorned by critics like Lanier as simply asking the wrong question about creativity, misses the point that creative practice is a slippery customer whose properties are difficult to predict, and whose starting point may not be so easily identifiable. Rather than releasing the creative energies of user agency, the technology looks simply reductive.

To my mind, both of these approaches suggest a confused idea of what creativity is and how it works. With Florida we are invited to define creativity through autonomy, and with Shirky it is shaped by popular reception that ignores former categories and context. For the Arts, the context is vital as a means of making value judgements, and whilst autonomy can be an important attribute for an artist's practice, it is the expression of this through creative work that validates the proposition, and this is definitive of such practice. Creativity is converted into systems and models developed out of potential the technology borrows from imagination solely for its moral force: such arguments would never be put without it. But the reassessment of a certain model of creativity as a virtue is very recent, and conditional on a certain type of creativity that reflects and is supported by the engineering model rather than the artistic one. That this does not inhibit the claim-making to creativity, as if these are indistinguishable, presents some serious problems in the domain of creativity in its cultural forms.

The link here is between some very large economic forces in play, all steadily progressing towards a goal held in common. The emergence of digital technology as a global economic opportunity was so confusing and surprising that, like many befuddled investors in the railways of the 19th century, speculators were horribly burned in

the so-called dot.com crash of 2001, having made exactly the same mistakes as their Victorian Era predecessors. For fear of being left behind, and without a complete idea or understanding of the technology and its potential, large sums were effectively wagered on ideas with, it turned out, rather limited economic potential and suspect business models. Given the novelty of e-commerce, businesses found themselves turning to new types of people for solutions to getting their products to their customers, and experimenting with new ways of connecting with customers and making money. All this gave rise to the idea that this feeling around in the dark was somehow 'creative', that websites and shopping portals required creative ideas to make them work. This was largely because such features initially didn't work: in the environment of the Internet, there were few established protocols or reliable methods for doing profitable business. To many, this looked like a business opportunity that could be shrouded in the mantle of creative entrepreneurship.[6] As I have argued, this is not the same as the cultural form of creativity with which it often becomes confused.

The 'Flickr' example

Somewhat worse, and more hazardous for creative practitioners of the old school, was the migration of processes from analogue methods of doing things, strips of film dangling into calico bags, film splicers, developing tanks and darkrooms, into scanners, digital cameras and editing software. The efficiencies and cost savings these 'dry' processes had over the traditional 'wet' ones were substantial, even if in their initial application the qualitative results were invariably poorer (following the engineering mania for workflow ahead of quality). As the processes matured, and software like Photoshop became ubiquitous, video cameras began coming with data cards or hard drives and still cameras began working at high resolutions; the once solely professional world of image manipulation became a commonplace for anyone with a decent computer and some time to learn the software (or to look up the tutorials on YouTube). These 'prosumers' as they were styled, initiated an explosion in the market for hardware and software that gave professional results unheard of for even well-invested professionals only a few years before. Such activity also gave rise to increasing demand for web space where the images

could be shown to the world. Into this environment the Flickr (2004) photo-sharing site started life. Originally a feature in an online game, it was only when users turned to its properties as an image dissemination system that its inventors (the husband and wife team Stewart Butterfield and Caterina Fake) realised there was more potential in turning images into social discourse than from embedding them in a gaming platform.

But Flickr and other so-called Web 2.0-style applications were not driven by replicating the models (either business ones or aesthetic propositions) of existing analogue experience. The potential within the technology to add significantly to a given image through allowing dynamic content, like tagging and algorithms to rate images automatically, gave new purpose to the vast quantities of pictures being generated by an increasing number of devices at increasingly good resolutions, at a time when web space cost real money. Flickr was hugely popular as a service started by some intelligent coders for a newly discovered market. There is no question this was one of the first really functional and novel contributions to creativity on the Internet.

The tech website Gizmodo (2012) confidently grants that for technology entrepreneurs, 'the exit is *always* the goal'. But their reflections on this are somewhat partial and reflect the rise of the business plan as a selling proposition. When a truly creative idea emerges, surely there can be more to its potential than a sell-out? Flickr was sold to Yahoo in 2005 for $35 million dollars, in a deal that included the company's founders staying on. In a commonplace turn of events, this arrangement didn't last long. The impact of standardised engineering that kills off creativity once the corporates arrive meant that further development of the site became focused on corporate goals.

'Integration', Gizmodo notes in their eulogy for the evolution of Flickr that might have been, 'is the enemy of innovation.'[7] In other words, for all the hype of an Internet-based creativity founded on low-cost processes, large-scale participation and an economic windfall in selling up to some uncool corporates, the result is standardisation rather than continuous invention and development.

The Flickr story is instructive given the extent of the emphasis in new corporate life on creativity and how it responds to the challenges of creativity by forcing it into structures acceptable to

corporate capitalism similar to the many stories told in Jenkins, Ford and Green (2013). This can also be noted in the literature of modern business or the demands for the incorporation of creativity into the technology-driven education system. The premise for encouraging creativity is profoundly misunderstood by working in this direction. These accounts of creativity, and the omnipresent link to financial value, are predicated on seeing it as simply another skill for application to industry-linked problems, rather than a textured landscape for the expression of humanity in many directions. It is a dismal and limited view. The accounts offered within the technology framework nearly always seek to reduce discussions of creativity to process and claim a kinship between the artistic work and the engineering one as a means of dignifying the latter. Of the many distinctions to be made between processes here, I would suggest the most prominent is the difference in focus from reliable system building, the preoccupation of technologists, and the instantiation so prized by artists. The value located for the artist in achieving synthesis is manifest in the absence of a system, or its uniqueness in method should one be apparent, in the long term across a body of work. The validity of technology is mostly tested in a different fashion: under what conditions does it reliably perform? These two aims are not reconcilable, and are often the basis for misunderstandings between artists and engineers when they collaborate.

A distinction in creativity

For creativity in a digital age, this is quite a struggle. Creating valid artistic work in the digital domain often takes a long detour around the reliability of systems themselves. Most of the time, it is the system that wins out, given that without it nothing may be expressed at all. This isn't the same attenuated argument often put by engineers that claim artistic processes to be engineering or somehow technology by other means (Arthur, 2009: 48). This is what Ellul referred to when noting the tendency of 'technique' to obliterate everything else in its assertion of its authority. Having no sentiment to inhibit its exercise, it disregards tradition and local practice, replacing it with technocratic paradigms understood as an extension of existing knowledge, and transferrable to any other location. It is this quality that he

denounces when he observes that 'every component of civilization is subject to the law that technique is itself civilization' (Ellul, 1964: 130). The ubiquity of technological paradigms invariably spells the sort of Photoshop doom suffered by my 'wet' photographers, who will only lose in the game given the unequal forces against which they are pitched.

We have already seen a hint of the kind of creativity that machines can generate in the examples above. The exploitation of large volumes of user data drawn from every aspect of use suggests that creative practice of the technological kind will look to aggregation and standardisation for validation through structure. This is already how machines are used in creative projects, albeit with humans currently initiating some of the steps. The capacity to learn from how those humans behave in their decision-making is one of the challenges set out by Turing when formulating his ideas about thinking machines. As noted above, the means by which the software can learn and aggregate the habits of its users improves with the shift to cloud-based solutions, reflecting the long-standing disposition of the technology industries to retain as much control as possible, whilst aggregating as much user behaviour data as possible. At the same time, it uses this control of the system as a means of informing the next generation of tech. The products of such an approach are likely to be as popular and banal as Shirky could imagine, formulaic in the same manner that all chatbots who are entrants of the Loebner Prize have been programmed to change the subject and to ask simple questions if the going gets rough.

The challenge as to whether machines can create is, as Ada Lovelace put it, ultimately whether they can *originate*. Turing's riposte to this was to note how difficult a thing that was for human beings, and he was not wrong. There seems no question, since they have been put to the service of creativity, that computers can replicate practice well enough in a workaday fashion to produce uncontroversial and acceptable results. In certain areas (like the advertising industry), they now so determine the world view of those working with them, in terms of both production and dissemination, that another step towards such an aim would seem logical and desirable. That this should be so reflects the narrow view of creativity taken by those who seek to fit what it is to be creative into a technological system. The

dominance of this system of the production and distribution process makes the human contribution more and more irrelevant, and the implications for culture as a whole are as serious as Ellul foretold. This is not only a question about creativity, but about humanity, and the models in which we would prefer to live in, noting that what were formerly disparate societies are increasingly homogenised by the impact of digital technology.

6
The Paradox of Creative Practice

Studio practice and creative imagination

With my small research team of composers, photographers, film makers, graphic designers and the odd choreographer, I began my forays into incorporating digital technology into creative practice several years ago. None of the people I worked with then (and this remains true of many I work with now) knew very much about computers themselves, but we instinctively felt there were opportunities to make new work that would be somehow different by working through the gauze of computing. We were attracted by their possibilities, and we suspected those that made them would only have a limited idea of what this could be. We started where our interest began, in the products of the technology industry itself. Quite often, it turned out the ones that caught our collective eye were designed by Jonathan Ive and were nestled in seductive packaging that turned unboxing them into a performance in itself.[1] Given the generous funding we had at the time, we might at certain points give out a groan when a newly acquired piece of kit was rendered immediately obsolete by a later release, but only for as much time as it took for us to get a quotation for the latest stuff and compose a justification for some further 'bleeding edge' technology. We used the products of the technology industries in various ways, not always according to the manufacturer's instructions: whiteboard technology tipped sideways made an excellent live 3D moving and drawing space; Wii controls reconfigured to operate our sound equipment made controlling less accurate, but more unpredictable; latency turned into a

creative advantage, and other suchlike repurposing took up much of our time. We understood the difference between software and hardware, but not a lot else. In our struggles, some shape to the process of turning these products into creative tools began to emerge, seeking alternative properties or uses and reimagining traditional practices as undertaken in our new domain. It was often frustrating and time consuming. The properties of the technologies in our hands as extensions of and challenges to the imagination eventually began to throw up some interesting and consistent results, the point at which understanding the work we were doing came more clearly into focus. In this final chapter, I want to discuss these understandings and how we began to identify the character of the technologies we were using, and what this means for establishing what I have called earlier 'the craft practices of computing'. The tensions between a technological system and a creative artistic practice might well be reconciled by taking such a route. This is an important step if we are to continue to feel sure about what we mean when we discuss a creative practice that bears some resemblance to our recent cultural past, and is not solely the creature of the technology industries and invoked only for its instrumentalism.

Technological systems and artistic risk

I mention this as I note very many of those interested in discussing the Arts as mediated by technology have been very swift to make claims for the properties of technology as assimilated into arts practice. Mostly, this approach is based on observations of the art works, picking out a feature and asserting its significance as a reshaping or redefinition of approaches to making work. In some cases, it is purely an intellectual gambit.[2] Mediocre art work becomes significant because it is being offered as evidence for a wider thesis that fixes on assertions about a changed locus for practice or some perceived shift in what is possible in a previously stable domain. Its symbolism becomes more important than its cultural worth. The art work itself is often arbitrary, rarely emerges in a specific or repeatable form, and is posited as the object of discussion based on a speculation that this new form is somehow problematic, rather than because of an interpretation of its aesthetic values. Telematics, to give one example, is greatly overhyped in this approach, with enthusiastic speculators

positing newly accessible video links as something extraordinary, given the mundane possibility of combining the Internet with screen technologies. 3D projection is another, simply cascading technological capacity into the hands of artists who could not imagine the possibility of working with this only a few years ago. On closer inspection, works that supposedly relocate the performers in space or present them remotely in 3D suffer greatly from exactly the same compromises and frustrations that video conferencing businessmen have experienced for a very long time. Using such platforms as the means of combining the artistry of dislocated performers remains of purely intellectual interest, given the poverty of the creative results. What an audience actually experiences does not alter if the performer is in the next room or across the Atlantic: only the technical framework is challenged, not the creative one. The difficulties for interaction remain the same in either case, and we have not yet seen choreographers or directors trained to exploit such problems as a virtue. Should the technology emerge to enable this at a viable cost, it is more likely to do so via heavy investment by the tech industries, not as a response to the needs of artists.

The attempts to provide taxonomies of digital performance or installation art suffer from this problem as well (Dixon, 2007, is a good example, or Paul, 2008). Such categories emerge only as a result of revaluing work for its usefulness in making a point, and are constructed in this way to make the difficulties of producing work that would be valued for expression in its own right as tangential to studying their manifestations. Forms are borrowed from traditional practices like painting or sculpture, or emerge as a subset of web content formats that supposedly reveal the artist's intention in digitised form. The tendency of technology to make available individual interactions or unique experiences has likewise been reinterpreted through models and propositions rather than specifics, picking up the essential contingency of the work created and its dependence on technological context. The technology's ability to replicate the presence and finish of broadcast television (dependent as this impression is on framing by screens developed for just this use) gives rise to the disorienting experience of television broadcasting made for micro-audiences, the telecast as personal gift, but definable artistic qualities remain abstracted rather than located in a definable work. The positing of internalised experience as sensed through technology as a new

frontier of art (Kozel, 2007) is offered as a rich alternative, yet seem to have located within it some of the darker sides of science fiction. All of these, whilst arguing up the claims of the technology, especially where it might be seen to relocate or displace agreed conventions of meaning, seem unable to identify why this should be so specifically acute in a technological environment. How it differs to the analogue world in which artists in most areas are still trained, remains opaque. An Internet art work, or a digital one, is still defined by a 20th-century technique that does not expect the forms in which the work emerges to be the contingent products of technology. By focusing on the alteration in meaning wrought by technological mediation, the resulting work becomes about technology itself. Given the rapid shift in its functional capacity, even the most refined technological set-up is rendered obsolete or left unsupported by the technologists who have initially created it. They are rarely at hand for creative artists (though there are some noble exceptions to this, like the work of the UK theatre company Blast Theory and their relationship with the Mixed Reality Lab at Nottingham University).

These attempts at crystallising an essence of digital arts practice are, first and foremost, representative, rather than indicative or exemplary. The ease of such systematisation is telling us something about the substance of the art work, and not just its immaturity as art practice. There is something in these accounts of artists grappling with the potential of the technology that reveals the essential character of technologies of art. In particular, the reshaping of creative potential and its reorienting is determined by technological platforms that fulfil Ellul's prognostications about how inadequate art will be as a human response in the face of the application of technology. The premise of a human-based creativity that challenges or defies the technological seems impossible to formulate from within a technology-based practice, given the powerful forces in play over which the artist has no control.

As suggested above, there are some characteristics of the work that is created that can guide us in understanding how to work with technology in better ways. The first is the contingent form practice in the technological frame takes. Ever since Stockhausen sought to exploit the ability to splice taped sounds, artists have had to deal with the potential shift by the technology platform away from their intentions. In many cases, work is lost because of the redundancy of

the technology that supports it, especially where it borrows heavily from the character of technology in the first place. This is fine in circumstances where the technology is relatively stable, though this is by no means guaranteed (think of my disappointed 35mm photographers we met in the previous chapter, or Lanier's frustrations with MIDI). It is also rarely where the first enquiry of artists will take them.

Technology surprise packets

The second great lesson of the technology is in its unpredictability. Even Stockhausen was astonished by the results of his splicing and rerecording in making *Etude* (1952), in an echo of Turing's assertion about the capacity of machines to surprise. Given our limited understanding of computers, the unplanned often emerges through a faulty patch, a loose connection, an underpowered computer or an upgrade to the software, as well as our own lack of diligence in thinking about the consequences. The results can be significantly at odds with the intention, and may be the best you will get. Because of this lack of stability, it can be a risky proposition to invite an audience, who may not quite get what was intended, or might go away disappointed when it doesn't work. Whilst the technology has a predictable response to input, the wetware sometimes proves inattentive or neglectful of the possibilities that might occur in the face of such logical processing, given that artists usually work with people who can receive an idea with the empathy currently left out of machines.

All this is a precursor to something more fundamental about how expression emerges through technology. The enrichment of meaning sought by desperate analyses of technologically enhanced art work is framed as an extension of the means for the form to express. Overplaying the technological brings into sharp relief the limitations of the work to begin with, but also the confusion about how meaning is developed and how it relates to expression. The significance of the digital intervention can be measured by the extent to which it stretches the boundary of a form. This is perfectly well and good, but misses the real opportunity, and the real question for creative practitioners encountering the digital. How does the artist working with digital technology create expression? This, at least it seemed to me when wrestling with technology not quite designed to do what I wanted nor myself with the skills that might reshape it to my

desires, was the crucial question: we know the properties of paint, have seen these examined and redefined through the centuries by Michelangelo, Van Gogh or de Kooning. We know the body and its expressive powers well enough through Nijinsky or Cunningham; we understand the evolution of materials through architectural practice in the hands of Frank Lloyd Wright or Mies Van der Rohe. How, at the level of art, does digital technology inform or extend or transform our expressive powers as artists?

I have argued in this book that, given the contingency of the technology and the capricious will of the industry that supports it, we cannot yet fully know, that our engagement is too immature and thus far superficial. Furthermore, the processes of the business plan and the corporatising of the intentions of engineers will invariably focus on using the technology for the best return on investment, seeking the widest application rather than the best. But my experience with my own group of creatives suggests there are some directions that can inform us more fruitfully than others. Indeed, the qualities that are inherent in the engineering process that produces the raw materials for a new type of creative practice seem obvious to me now. Some of them are challenges that emerge precisely because of the way technology finds itself in our hands. The processes that bring it to life are not always those that complement the imagination and are often antithetical to it. But our explorations and experiments were attempts to come to terms with these qualities, not to fight the technology, nor to surrender to it, but to understand the power of the transformative force of our time. For artists, this cannot be said often enough: we can live up to the lofty social obligations we arrogate to ourselves only if we will encounter the technology on these terms, committing ourselves to our role as the means by which society can better understand itself. Today, society resorts to technology for communication or definition; it comes to us in the form of something that keeps us occupied on the bus as we tweet our feelings or Instagram a selfie. As such, it is natural for artists to gravitate in the direction of technology, to understand the hold it has taken on us. By extension, for artists this means understanding technology as well, not just its functions, but its provenance, disposition and potential in that most human of all activities: imaginative creative practice. In much the same way that electricity once seemed an unknowable enigma, so does digital technology today.

Given the prominence of this moment of the technological, it is both logical and necessary for artists to turn to it as substance and to attempt to shape it in their hands. Without seeing this as compulsory, such a practice is also increasingly antithetical to the nature of the technology in their possession.

One of the difficulties facing our understanding of the future of creative practice is the extent to which the technology has made its past redundant. Our current arrangements rely on an understanding made obsolete by the assault of technology on the craft skills of creativity that had developed and endured through the 20th century. The software developed to resolve the problems of video editing or image processing was undertaken knowingly. Programmers understood the craft they were seeking to replicate and the techniques for which they were creating shortcuts. Their initial users also required this knowledge in order to properly master the new methods of making, but their successors do not. Making a cut is no longer a question of a splicing machine, but of an icon with a razorblade on it. The tacit knowledge that enabled a previous generation to make the link is unnecessary as the understanding shifts to the abstraction of the buttons. It seems perfectly consistent with the history of craft to make a claim that most of these skills will survive, but it will be in an artisanal form rather than as standard knowledge.

This transformation of the creative experience challenges the organising principles of culture. These still assume the necessity of a basis in 20th-century craft practice, the analogue, as a precursor to creative mastery. That the basis of a creative proposition remains within the known figures and tropes of the analogue world, and that there is something inseparable about the physical craft practice, means that without it the prospect of creativity is apparently remote. These values reflect something of the conservatism of those whose creative clothes are in the process of being stolen by the developments of the software and a certain level of denial of a world that has moved on. The validity of this position may be asserted but, as acknowledged above, the use of IT promotes learning about IT and little else. Software-trained editors no longer require an understanding of the analogue practices hinted at by the icons once they have learned the impact of pressing the buttons and of seeing how easily their mistakes can be rectified. At this point, the logic of a progression from the analogue, of mark-making or wet processing, to the

technological practice of software manipulation or workflow organisation looks rather a stretch. Because of the apparent similarity of outcomes – images, videos, soundscapes – the analogue homes for these (photography, illustration, film making or music) have been expected to carry on these traditions into the Digital Age. They have invariably done so with the same expectations about craft practice and creative results that characterised their history, aiming to engage the same themes or issues with significantly different processes. The assumption has been that the technology offers the ability to continue the same process by other means, that it is merely a delivery system rather than a means of expression in itself. As we can see, with the development of Vine Video or Instagram selfies, with practices as diverse as music videos, computer games or Pinterest boards, as the possibility of technological interventions into creative propositions expands, this assumption looks rather shaky. The properties of the technology begins to assert itself, with a far wider community of users resorting to a broader range of strategies to propose their creative acts for a far wider audience than might have been available for such domestic-level creativity only a generation ago. The trick is to resist the tech industries attempts to domesticate and dominate the practical output through interventions into their own products, and to allow the character of the technologies to play out in inventing what might take the place of the old certainties of the atelier.

Digital technology has qualities that cry out for such treatment: the flexibility of data, the sheer volume of information it can produce, the impressive resolutions it supports, its interoperability across devices, with an infrastructure fuelled by a super-competitive industry that tries to out-perform its members on this or that minor principle, and regularly succeeds in doing so. The insatiable restlessness of technology that would seek to satisfy in ever more seductive ways requires an examination by the artist if they are to be true to their word about their social and cultural role.

The cultural power of digital technology is devastating, and looks so certain to dominate our social as well as economic lives that parts of all the creative industries have been prepared to set their traditional practices aside in order to accommodate its demands, and play hopeful games to preserve or defend from the onslaught of a technological revolution led by the qualities I have identified as business-driven and process defining. This accommodation with

technological platforms seems at odds with historical versions of arts practice in the face of technological advances: photography did, after all, make painters more painterly, more concerned with the substance of paint and its effects, and more profoundly determined to present their visions as reflecting their subjectivity in contrast to the perceived impartiality of the camera. But then, digital technology has emerged at a time when the Arts and creativity have also come to see themselves as an industry, feel confident enough to accommodate corporate power, to adopt its styles and to make claims to economic contributions, dismissed as dubious a generation ago, and have them treated seriously by governments, the media and corporations.

What sometimes appears as the autonomy of technology (and is sometimes expressed as such by technologists) is not so much how it fulfils human desires or replaces decisions, but how it expresses the imperatives of accumulating systems. Regardless of how technology is perceived, as a positive or negative force on society or individuals, this holds true for all those who examine the technology at a conceptual level, whether they are Kevin Kelly or Jacques Ellul. This method of accumulating processes is well expressed by those with considerable distance in their views about the benefits of technology. Mumford (1934) describes this as the 'technical complex', noting that all inventions have one foot in the past and another in the future. In his account, it was the Renaissance man Francis Bacon that first gave us a structure for the institutions of science (in Bacon's case through the Royal Society), one that promoted a diffusion of scientific understanding through technology that accumulated over time and resulted in practical exploitation of the principles proven in the laboratory (Mumford, 1970: 120–122). Arthur refers to this process as 'standard engineering' (2009: 90) and part of the combinatorial evolutionary process of technology. This is not to be confused with standardised engineering: as Arthur shows, there is plenty of innovation demanded in standard engineering paradigms, and these are essentially an accumulation of processes within systems. Additional complexities arise because the engineering challenges diversify, or a solution fails, or an idea is ported from one field to another. The process layers a new solution upon an existing one, builds up new conventions and establishes further domains of engineering practice. Thus, a base principle embarks upon a path of development. The application of principles to real-world problems is led by the

structure, interpretation and solution of previous problems, themselves reflecting a value system and a series of conventions built out of the various traditions of engineering practice. This, as Mumford pointed out, is inherently corporate in disposition, and replaces a level of human creativity with an 'automation of automation', reflecting the conflict between the technological world and the human one that he is so determined for us to reclaim as a kind of antidote to the gigantism of the technical (1970: 182).

Because of this, and to balance the account, there are some observations to be made about the nature of technology to be exploited by the artist. As discussed above, whatever the conventions of form or technique developed in the Arts in the 19th century, the 20th century saw them turned on their heads and rejected as insufficient to express the ideas and images that emerged from the Machine Age.

For Ellul, Stravinsky and Picasso embody this opposition. Modernism was as much determined by new materials and the forms into which they could be manipulated as it was by changes in social experience wrought by new technologies, and Mumford's differential treatment of art as the 'domain of the person' is based on its ability to contrive 'internal transformations' (1952: 16–17). The flaw here is that it presupposes a way of seeing art that has not survived the onslaught of post-modernism. For artists, it seems not only important to engage with the defining forces of their time, in whatever form they may present themselves. The difficulties presented by technology are also an unavoidable encounter in asserting the human, or in finding the humanity in the digital. The challenge to the imagination is driven by finding ways in which an art can be extracted from the material of the present. The blithely stated argument that art will flourish as technology dehumanises us is not consistent with the one that says the technology also makes and defines our lives and world view, without marginalising art as a fringe practice. By this reckoning, the artist is put in the impossible (though sometimes self-styled) position of claiming unique insight through holding both positions at once. Just not liking the art made from the stuff around us ducks the question of how artistic practice operates in a world of zeros and ones. To recommend artists should ignore the technology, or demonstrate their capacity without it, is to be blind to one of the fundamental features of art as a practice and artists as participating citizens. This sets tasks of varying complexity for artists in depth and breadth: how

much do you need to know about the technology, and when is that enough?

In my own group's work, we quickly learned to give up our pretensions to our analogue art forms. Having begun from the perspective and disposition of a specific way of expressing, we all found ourselves shedding this former creative identity in the encounter with digital technology. One principle became clear rather early on: the better one understood the deeper structures of the technology, the more one was able to exploit its structural foundations to make something interesting. There was, as ever, a sting in the tail: what arose with depressing frequency were moments where, having been sucked into the vortex of technological complexity, it was difficult to identify the moment of art, to remain focused on the point of the investigations and the consequences of reshaping a world view now determined by the lens of technology. This frequently led to long diversions into coding, or frustrating examinations in search of the component at the wrong setting, or an obscure checkbox left unticked that derailed a whole chain of technologies and subjected us to fairly regular public failure: indeed, I formulated a law that recognised the potential for technological failure was proportionately inverse to the importance of the occasion.

We were also aware of the prejudice in the Arts against computing as a vehicle for creative practice, especially so given we were working in an art school at that time. Some of our new colleagues, as they watched the endless procession of G5s, data projectors, miles of cabling and big screens making their way upstairs into our new lab, made it clear to us that anything involving computers could not, by definition, be linked to creative outcomes. Art was not possible with these machines. This reflected that long-standing loyalty to craft practice as an antidote to the industrial process, an idea that goes back more than a century to when Morris and his pre-Raphaelites posited handicraft as the counter-narrative of the machines of the Industrial Revolution, the notion that as an extension of the human maker, the hand was the definitive tool of the artist and artisan. We noted the ease with which other machines were accepted in creative terms: neither bronze-casting nor printmaking machines were seen as problematic, though the artists using these processes would often remain aloof from them, relying on technicians to realise their work without getting their hands dirty.

Photoshop revisited

This was by no means all of our initial discoveries. We noticed some principles at work from the designers of our toys, and very clever they were, too. One of the first we have already discussed was the evolution of Photoshop, from a clunky, ham-fisted editing tool for scanned pictures into a process so ubiquitous for the treatment of images that it got its own verb.[3] In early iterations, it provided simple ways to replicate the effects of image manipulation that one might have found in the darkroom, which was, after all, the only model known at that time. The process depended on scanning technology, as digital cameras, such as existed in 1990, were experimental and could not replicate the quality of photographs that had been scanned, and available in the early, if ill-fated, Kodak Photo CD system.[4] Simple filters and cropping tools moved photo processing for the first time from wet to dry, even if the results looked rather amateurish in the hands of the untrained. Given that we were all fairly untrained in the potential of the software (a rather blunt instrument when compared to later iterations), this meant it was easy to distinguish a 'photoshopped' image from a processed one. Indeed, many of the first experiments with Photoshop tended to foreground the manipulation process to make it clear the image had been edited on a computer. This annoyed photographers a lot, but gave Adobe plenty to work with as they began the process of perfecting the interface. Its evolution gave rise to a broad range of Photoshop-based practices, jokey visual montages inserting the incongruous in the same picture, or games like Photoshop tennis where participants make comic additions or subtractions to images.[5] The popularity of Photoshop expanded in tandem with its development as image software, with Adobe learning along the way how to improve its product through observations of its use. In the process, it did for the manual skills of airbrushing, the physical practices of image editing that Photoshop replaced. These found posterity by being represented in the interface as icons, the pictorial depiction of which would eventually baffle those who had never worked in a wet-processing photography studio. But the chief cultural contribution of Photoshop was not the extension of the expertise and opportunity for photo manipulation to a wider public. It achieved this for sure, but in the spirit of technological change it turned the professional tricks and hard-won

skills of photographers into filters available at the touch of a button: what Photoshop ultimately demonstrated was the unreliability of the image as a factual representation. That this was known to photographers and aestheticians long before mattered for little. By putting the capacity to misrepresent into the hands of innumerable image makers, it undermined the authority of the image in a way that once required a Barthes or a Sontag to point out. Photoshop gave millions a direct experience of the manipulation process, and made us all instinctively distrust the persuasive image as too good to be true.

There is another crucial lesson to be learned from Photoshop that took a little longer to work out. As the versions of the programme developed ('improved'), it incorporated increasing amounts of redundancy. Early attempts at Photoshop encouraged the broad use of all its tools, with the resulting images looking unmistakably over-shopped, given the enthusiasm of its adherents. Later versions confronted the user with so many options they needed to show discretion or be humiliated when their technique was found lacking in the online environments in which such images were distributed, given these often came with opportunities for commentary. More importantly for the creative process, it also developed specialist users in their own right, none of whom might ever use every possibility or combination Photoshop presented them with, but who nonetheless could only be described as 'expert users' of the software. The later iterations also added the essential element that changed its working processes: the ability to use layers. This feature (introduced in its 3.0 iteration) was probably the key to its domination of the image-manipulation software market. Our work with it made us think more carefully about the way it changed our acquisition of original photographs, and what we imagined we could do afterwards with the software.

Two important changes took place: the first was to rename photographs as images, itself an acknowledgement of the change in the way we conceived of the material derived from pointing a camera at a subject. We noticed that we all just started doing this around 2005, without being quite aware of why, or who did it first. By doing so, we abandoned the camera as the recording device and began to see it as part of a wider process. No image need ever be thought of as complete as it could now be forever reworked. The second important insight we made was exactly that the image-making process

itself had begun to be determined by what we could or could not do in Photoshop. Our regular encounter with the software had begun to define our approach to image making from the point of capture, knowing that there need not be an endpoint in the evolution of the image itself or a definitive iteration of it. We no longer had to be quite so fussy about light or framing, knowing we could do something about it afterwards, with relative ease and at no cost. We had begun to create our images in the framework provided for us by the system in the software, to see the world through the filter of Photoshop which, for all it has enabled the multiplication of images, has permanently altered the process of making them, as well as undermining their authority. It now defines how we can be creative with photographs through the tools it supplies to refine or reshape them.

I mention Photoshop as a useful way of understanding what became apparent to me as a problem in dealing with much of the hardware and software available to us. It seems the most obvious and broadly representative example, especially given that with each iteration it provides further tools and possibilities for treating our images. It did not do this alone of course: a generation of digital cameras with ever higher resolutions helped, more so when thrown in with the mobile phone, whose exposures cost nothing more than battery power, and do not even require paper to examine. It is a specific example of how the technology imposes a system upon us that changes our behaviour, even those of us who see ourselves as rebelliously creative. Whatever the nostalgia for high-quality photographs produced in the wet processes of the darkroom (and we note the return of this practice as a handicraft), Photoshop now defines how we make and look at images in much the same way as the Box Brownie did for an earlier generation. We no longer believe in images as objective records given that we perceive them as photoshopped from the outset of a process that may have no definable end.

If this was a cautionary tale about the domination of the creative process by proprietary software, the world of hardware was even more daunting. My own work in this area was focused on motion-capture systems, much vaunted as a solution to translating movement into data visualisations. I worked with a number of well-known systems, noting that none of them were the complete article despite their promotion as systemic solutions by zealous salesmen. My intention is

not to criticise the need for sales to fund R&D of the next generation of kit, but to demonstrate how a value system can distort the results of experimental processes into pursuing the aims of the technologist, who in turn imposes those solutions on their customer. That this can happen without concern for the interests of the creative practitioner seems a commonplace, and reflects the ethos of technology development in a significant way. Hardware development happens within the framing of achievable parameters, usually defined by the shortcomings of the previous iterations of the technology. In the case of motion capture, this happens to be determined by verisimilitude and measurable gradations of it related to the accurate reproduction of exactly the movement that has been recorded. The focus of the industry on this aim perverts the potential and possibility of the technology, geared as it is around a standard not required for myself and my colleagues in the studio, or most users outside of animation or clinical environments. Our interest was in working with data streams in real time and turning motion into an engagement process, and this did not require such close calibration. By defining the problem in these terms, most of the products we used were incredibly accurate if astronomically expensive. Given the complexity of the problem, huge amounts of data were generated and it was necessary to use expensive post-production processes to correct the data once it was acquired.[6] In other words, the engineers of the systems were looking for the right answer, as if there were such a thing, and sought to impose that answer on all their customers, including us. This never occurred to us until we began to use the systems, and then we were quickly inducted into the technological complex developed by motion-capture companies to resolve what they defined as the problem of motion capture, measured by their various calibrations of accuracy.

It is perfectly possible to suggest myself and my colleagues were not exactly the target market for machines designed to develop computer games or to speed up the painstaking processes of animation, but neither were most of the systems we used capable of doing such a thing without very serious additional investment, and much of that in the aforementioned post-processing phase. In the motion-capture industry, the competing claims cluster around such achievable values as accuracy and transmutability. The capacity to record a moving body with a high degree of accuracy and where the data can be easily exported into a flexible file format has defined the approach of all

hardware manufacturers in this field. This reflects its emergence as an industry from clinical practice, the gait analysis required to inform treatment of children with cerebral palsy, for example, for which much of the hardware was fashioned in the first place. Its application to creative practice is made more difficult by this *deus ex machina*, given that it represents a value of little concern in much of the work using human motion as a creative inspiration. The accuracy or not of the model of movement was less useful in our applications than the capacity for interaction between movement and machine, but this idea was not one considered in the visually biased world of motion capture. This was because a further prejudice was easily identifiable in this process, one shared by many approaches to experience in the digital world: the resolution of movement was not into data, or directed towards transmogrifying it in any way, but into the production of accurate 3D visual representations. The purpose of motion-capture systems as we experienced them was to convert the physical into the visual, leaving behind all the other things that could be done with data collected from the body. This *ocularcentrism* was a repeated feature of our engagement with technology, a subtle, overarching aim that continues to define the application of technology to the fields we were experimenting with, as observed earlier by the phenomenologist of technology, Don Idhe (2007). Within the framework of technological fantasy, all he can see are imaging technologies that restrict the potential to be creative by dominating our experience with their visuality (2010: 11–15).

I want to avoid suggesting that we were superior in approach or understanding to our engineering counterparts, though I suspect we were more thoughtful about it than most. In fact, as our experiences moved away from proprietary systems and towards building our own bespoke technology, we encountered the same problems that beset the technology we would often complain about. Setting aside the challenges to hack most of the hardware we acquired, and to use what in music might be called 'extended techniques' in our manipulation of the software, there was something we found our products had in common with the outputs of corporate technologists. I pose it here as the most serious creative problem facing those who seek to use digital technology as a creative platform, tool or environment. There is, I would suggest, something inherent in the zeros and ones, and in the evolution of the technological processes that mean we

have what we have at this exciting moment in technological and creative history. It seemed to us the very point where accumulated engineering met creative stasis. Our substantive objection to much of the technology we used was its systemising disposition, the obligations presented by the tech of a system that insisted we go about our business in specific ways. The solutions posited by the technology were forced on us as users by the systems themselves, reflecting as they did the very latest in accumulated understanding from the engineering point of view. This produced an ever-tightening framing of our speculative adventures, restricting them to the parameters permitted by the engineering. The manifestation of this coercion was in the shape of the system itself. There was no escaping it, and whatever clever work-around we might employ, we would be drawn inexorably back into a system that required a system mentality to understand and create within it. In itself, this is as far as the engineering will ever get you. We felt it as a legacy of the engineering process, where collaborative contributions accrue, sometimes over long periods of time and quite anonymously, into the systematised conventions that had accumulated to force us into a model. The opportunity to improvise was increasingly engineered out.

As Jaron Lanier (2010, 2013) has pointed out, this is because of a difference in values between the engineer and the creative artist. The engineer needs, wants, is trained to produce technologies that will be *interoperable*, that will work with others, and to do this they often require the establishment of a standard. For creative artists, we substitute this value for *fidelity*, to an idea, a sound, a process or an image, rather than the development of a system or a principle. But the domination of these functions by engineers leaves us, as Lanier says, with technologies like MIDI, or reductive interfaces like the protocols that allow the Web to work. After all, TCP/IP, the protocol that allows computers to talk to one another, was invented before computers had anything interesting to say. I would go a step further and suggest that the creative practitioner struggles to accept this as a working method, a framework directly imposed by the platform they use, given the importance in art of the ideals of originality and authenticity. Even if we could set aside the issues of craft, the art processes remain faithful to these ideals. To what extent can the practitioner achieve either in the dilemma posed by the systemic processes of CS products, or of sensors that will code all signals as off or

on? Even where this becomes a hugely complex chain firing off at extremely fast speeds, we still find ourselves improvising within the system only as it allows us.

This, in the end, was our own discovery, and a significant impediment to how we genuinely develop the creative potential of the technology. The experience of experimenting with technologies of many kinds gave rise to some interesting results, but on closer examination, all of these began to gravitate towards the same end: whether it was with hardware or software, we too found ourselves adept at making systems. We noticed the same thing as Ada Lovelace had noticed: computers don't originate.

The challenge for a creative practice of technology is its ability to express more than the product of a systemic process, more than an environment in which practitioners are restricted to improvising within the structure, and something akin to the loose framing experienced in analogue art forms.

The domination of the output by the technology is only part of the process: it provides a stimulating new opportunity, and thus far we, as creative practitioners, are seduced into focusing on it as the defining influence on our productions. This is quite provably true, given the strength with which it frames the potential for us to act within it. It appears as a property of the digital environment, and we are left without the means to express except through the systems we create. It is this that a new creative practice through technology must acknowledge and seek to address as our creative contribution to the potential of the zeros and ones.

The importance of culture in the Digital Age

In this book, I have sought to explain my own perceptions and experiences of technology in the creative space, drawing on ideas about technology and investigations into what drives it. My enquiry emerged from dissatisfaction with the glib gestures towards creative possibilities that can be cited from many directions. Whether it was in the practical disappointments of using unreliable or unstable tech, or the prognostications in the media about the links between the digital and the creative, and how they would together resolve the economic challenges of our time, there was too much that did not ring true to my experience. I found myself noting the switch

to belief in bits ahead of things, and that the imaginations of too many were quite carried away with their potential. This seemed to have an historical resonance, as a number of other commentators have noted, with the unimpeded development of technologies in the 18th century that became the Industrial Revolution by the 1870s. It seems vital to me now that we, as a society and in the various organisational structures in which we operate, question this role of technology as the deliverer of humankind, and to note the desolation it leaves in its wake. This is not simply physical. As the products of corporate industrialism have moved from the environmentally damaging, inefficient industrial processes decried by Geddes or Ellul in the 20th century to the ethereal, virtualised experiences of the 21st, the immediate impact of technology has shifted from the physical to the virtual, together with their own apologists. The steam engines that changed production in the 19th century changed the people of that time as well. When we now have technologies that are entirely focused on individual desire and on capturing their experience as part of someone else's business plan, we need an alternative viewpoint about the benefits of such a thing. To pretend this is a scientific advance is to intentionally mislead. Science in these processes is cited because of what Mumford described as its role as 'the spiritual arm of technology' (1970: 110). It covers the technological in a mantle of intellectually pure disinterestedness. This impression is an important distraction for the venality of technology, which, as I have argued, has far more in common with business than it has with science.

In the realm of the creative, this creates much confusion. Artists appreciate both the social status of science and its claims to truth, which it shares, even where its truth is derived from entirely different authority. For this reason, as well as others that are well embedded in the history of the Arts, it seems natural to see the processes of science as another form of creativity. This, as we have seen, is perfectly reasonable until we get to the products of technology and note the ways in which they are organised, adopted and sold on to us. Technology adoption is essentially the process of marketing, where the most convincing case for adoption secures the market, and seeks to control that market. This is not the same as a meritocratic and dispassionate assessment of the efficacy of a given method to produce a result, nor does it share much with the scientism that is defined as a search for knowledge. To offer technology as a creative destination in itself in

this manner is to misunderstand creative process as it manifests in either science or art. It is defined far more readily by the ownership of IP and the capacity to promote it in a marketplace.

This is where we can first find the distinction at least between the types of technology encountered in the technological sphere and that within the Arts. The cumulative process of ideas that characterises technological development has a fundamentally different trajectory to that which artists seek. As I have discussed above, this changes our perception of art at the highest level. As digital technology produces creative practice in abundance, it often does so in forms we would never have thought of as artistic, and we are often happy to reject the idea that we should take, say, computer games, seriously as art. More importantly, there is a challenge to what it is to be creative once the opportunities of creativity meet enthusiastic users who reject a complex understanding of arty nuances for the convenience of the buttons and filters that will enhance their productions and distribute their work. This may not impact very much on someone editing their images in Photoshop before posting them to their Tumblr blog. But the claims for the technology are far greater than this, given its billing as both an immediate economic saviour, a force capable of resolving the physical problems our earlier Paleotechnic phase endowed us with, and ultimately the home of our collective consciousness in the vision of a Kurzweill or a Moravec.

What we do know about technology is that it proves difficult to predict its long-term impact. Its association with creativity has become a central theme in adjusting society to its demands, seen as the trade-off for its invasive and ubiquitous domination of working lives now permanently tethered to email. It seems rather pointless to demand a rolling back of its advances, and more modest and useful to encourage an understanding of its processes and its impact on us. In the creative sphere it represents a significant threat to creativity as a human expression, in ways that are sufficiently subtle enough for us not to mind too much. When our messy craft skills are taken off our hands, we turn to the conceptual art that has defined much 20th- and 21st-century art practice. The assertion of creativity in this framework has shifted the emphasis from the construction of things, the mark-making and physical forming of our recent past, to the less tangible and more malleable bit, a virtual switch whose flickering now determines so much in our existence. Creative practice cannot

possibly be reduced to the ability to operate the software. Sometimes, the purpose of creativity is not the instrumental exploitation of principles so beloved of our creative technology industries, but an end in itself. In an instrumental age, this is ridiculed, but the looming threat to our individuality from technology that aggregates and compiles is somehow buried in its claims to liberate and democratise.

I have attempted to make parallels between the unforeseen disasters of immoderate applications of technology and the experience of the many affected by it, and to disengage disinterested science from self-interested technology as a means of examining more closely the forces that define the rapidly changing society around me. I have questioned the validity of claims to creativity by corporations who abuse it as a concept with the intention to mislead about their motivations, but I have also attempted to give the machine its due. Can it be creative, by which I mean, is it possible to imagine that computers can also originate creative propositions? Might that then leave us as partners with our computers, as we are in so many other domains? By our current trajectories, it well might, and it requires nothing by way of philosophical interpretation to understand that, in certain ways, it already does. But inherent in this opportunity is the necessity for rethinking our creative destiny, to use the very capacity of computing to distribute and customise, noting its limitations and enhancing them with our capacity to originate. Without such attention, creativity may become as redundant as the spinning jenny: the means to shift to a new age, without being a part of it.

Notes

Introduction: The Conference

1. Moore's Law, for the uninitiated, was electronic engineer Gordon Moore's 1965 observation that the number of transistors on a chip doubles roughly every two years. Despite its increasing irrelevance to computing power, and the consensus that it may no longer hold true, no conference is complete without a citation of it.
2. This is so regular that I have named it Sporton's Law of Technology Demonstration, which can be simply stated as noting that the potential for technological failure is proportionately inverse to the importance of the occasion.
3. Indeed, Kevin Kelly's (2010) book about these matters is called *What Technology Wants*.

1 The Social Narrative of Technology

1. See https://fbcdn-dragon-a.akamaihd.net/hphotos-ak-ash3/851575_2287 94233937224_51579300_n.pdf for Facebook founder Mark Zuckerberg's personal crusade on this topic.
2. Home taping was a relatively short-lived phenomenon. The broadcasters, depending on the laziness of viewers, eventually understood that their programmes and movies could have a second life by releasing them on tape, and thus reasserting their proprietary rights over the material. But the capacity remained, and evolved into new forms like TiVo. These manoeuvrings over control of cultural content will be discussed in Chapter 3.
3. As Allen (2009) points out, the lesson of this has never been lost on vice chancellors and presidents of universities, who frequently point out the difference between the sort of discovery or 'blue skies' science and eventual opportunities to exploit the ideas in economic forms.
4. This is the origin of Schumpeter's phrase 'creative destruction' that unfettered capitalism invariably produces, with the processes of redundancy creating a vacuum to be filled by the next phase of economic activity.
5. This finds a corollary in the technology industry in the heavy discounting of hardware as a catalyst for exciting demand elsewhere for services that provide a regular income from those hooked on them.

2 Science with a Business Plan

1. According to Tann and Breckin (1978: 552), despite (or perhaps because of) their entrepreneurial instincts, Boulton and Watt refused to sell Watt engines where they judged them to be impractical.

2. Crump (2010) indicates the range and type of these goods, watches or pens becoming everyday household objects, for instance.

3. One of the noble exceptions to this was 'What's App', a very popular smartphone application that users pay for up front. Their attitude towards advertising was both refreshing and frank (see http://blog.whatsapp.com/index.php/2012/06/why-we-dont-sell-ads/). This endured only until their idiosyncratic but highly popular app was bought up from them by Facebook for $19 billion US dollars, together with the usual blandishments about retaining the start-ups founders.

4. India launches Aakash computer priced at $35, *BBC News*, 5 October 2011, http://www.bbc.co.uk/news/world-south-asia-15180831.

5. E-OK is the acronym for the Russian 'Электронный образованный комплекс' or 'Electronic Education System'.

6. Silver, J., 'The Classroom Disruptor', *Wired Magazine* (UK Edition), March 2012, 106.

7. It was at MIT that Hollerith conducted his first serious experiments into resolving the problems of large quantities of raw data, and turning Billings' suggestion into a workable apparatus.

8. Hollerith agreed to be charged $10 a day for machines not functioning, but such was the quality of the firm he used for manufacture, and the meticulous nature of his design and oversight of the process, he was never penalised.

9. Pugh (1995: 27) notes that after the Charles Flint merger of Hollerith's company with two others, the new Computing-Tabulating-Recording Company was valued by Flint at $17.5 million, of which only $1 million was in tangible assets.

10. Leaving aside government interest in the data generated by users in the form of PRISM-style surveillance.

11. See Dillon and Thomas (2006) or Grodinskyand Tavani (2005) for commentary on this.

12. The consequences of this tendency are noted in Mayer-Shonberger (2009), where ancient minor convictions, for example, return to haunt the unwary when accessed by officious bureaucrats decades later. It has also given rise to the new practice of cyberhoarding, noting that somewhere the data is never lost.

13. The 1943 quotation attributed to Thomas Watson, 'I think there is a world market for maybe five computers', is generally thought apocryphal, but there is some conjecture about whether it applied to the market for a specific IBM product developed a decade later, for which only the largest industrial concerns in the US could be considered potential customers.

3 Technology Adoption as Ideology

1. We can note some cod-Darwinism in his approach, reflecting the values of today's technology businesses, aligned to the scare story that those who fail to innovate in technological terms condemn not just themselves but their species to extinction.

2. Like the accounts found in Brockman (2011).

4 Technological Systems and Creative Actions

1. See http://www.careyyoung.com/past/productrecall.html for further details of this work.
2. Young, C., On Cildo Meireles, *Tate Etc. Magazine*, Issue 14, autumn, 2008.
3. Toffler, A. 1981. *The Third Wave*. New York: Bantam Books, p.29.
4. Frayling (2011) includes an excellent example of these suspicions drawn from Grayson Perry's experience as a potter making a claim to art, contrasted with Damien Hirst's cool observations about the banality of craft.
5. It turns out Heidegger used a reservoir ink pen, rather than the quill, according to the photographs in Adam Sharr's book *Heidegger's Hut* (2006), though it is noted that his Black Forest retreat is an incredibly simple building with few comforts.
6. See Thompson (1991) for an account of the frustrations of employers whose errant workforce would often observe 'St. Monday' by not attending work on the first day of the working week.

5 Can Machines Create?

1. As suggested by various sources, but see http://www.geek.com/chips/chips-to-augment-intelligence-549165/ at geek.com to gauge the enthusiasm for this.
2. Turing, A. M. 1950. "Computing Machinery and Intelligence." *Mind*, no. 59 (236): 435.
3. Interestingly, one area where this is far more ambiguous is poetry. The website botpoet.com hosts a large range of human- and computer-generated poetry, together with statistics indicating the scores of humans incorrectly distinguishing human creativity from a chatbot.
4. Adobe Creative Cloud's EULA is 15 pages long and is available in many languages (the website points you to the one in your computer's nominated language: http://wwwimages.adobe.com/content/dam/Adobe/en/legal/licenses-terms/pdf/CC_EULA_Gen_WWCombined-MULTI-20121017_1230.pdf), and there is a General Terms of Use document (http://www.adobe.com/legal/general-terms.html) that goes with it. The products cannot be activated unless users agree to these conditions.
5. See http://icanhas.cheezburger.com for these delights.
6. For some, like Amazon founder Jeff Bezos, it was, though it is noted that Amazon has yet to turn a profit on a business model that focuses on expansion and investment, with all the characteristics of a Victorian manufactory to boot. See Stone (2013: 190–192) for an approach that Wedgewood would definitely have approved of.
7. Honan, M. 2012. How Yahoo Killed Flickr and Lost the Internet, *Gizmodo*, http://gizmodo.com/5910223/how-yahoo-killed-flickr-and-lost-the-internet.

6 The Paradox of Creative Practice

1. This hitherto unappreciated facet of technology marketing has given rise to the plethora of 'unboxing' videos found on YouTube or Vimeo.
2. See Birringer (2009) for an excellent example of this.
3. There is a useful chronology of the changes in Photoshop available on the blog creativebits: http://creativebits.org/the_first_version_of_photoshop.
4. The system ran from 1992 until being phased out between 2001 and 2004. Despite Kodak's destruction by digital photography, the camera giant produced excellent products in this field. A summary of their corporate graveyard can be seen in abbreviated form at http://www.kodak.com/ek/US/en/Our_Company/History_of_Kodak/Milestones_-_chronology/Milestones_chronology.htm.
5. See http://www.flickr.com/groups/pstennis for a sample.
6. This problem was so consistent in our experience that one of my colleagues, the brilliant young composer Jonathan Green, invented what became known in our lab as 'Green's Syllogism'. 'As complexity increases, so does power consumption. As cost increases, so does complexity. Therefore cost increases demand for higher power consumption.'

Bibliography

Allen, R. C. 2009. *The British Industrial Revolution in Global Perspective*. Cambridge, MA: Cambridge University Press.

Arthur, W. B. 2009. *The Nature of Technology*. London: Penguin Books.

Baker, S. 2009. *They've Got Your Number*. London: Vintage Books.

Barthes, R. 1957. *Mythologies*. Translated by A. Lavers. 1972 ed. London: Jonathan Cape. Original edition, Paris: Editions du Seuil.

Bauerlein, M. 2008. *The Dumbest Generation: How the Digital Age Stupefies Young Americans and Jeopardizes Our Future (or, Don't Trust Anyone Under 30)*. New York: Penguin.

Beal, B. & Bohlen, J. 2012. *The Diffusion Process* (reprinted November 1981). Iowa State University of Science and Technology 1957 [cited 05/03/2012 2012]. Available from http://www.soc.iastate.edu/extension/presentations/publications/comm/Diffusion%20Process.pdf.

Bijker, W., Hughes, T. P. & Pinch, T. 1987, 2012. *Anniversary Edition*. Cambridge, MA; London: MIT Press.

Birringer, J. 2009. *Performance, Technology & Science*. New York: PAJ Publications.

Broadhurst, S. & Machon, J. 2009. *Sensualities/Textualities and Technologies*. Houndsmills, UK: Palgrave Macmillan.

———. 2012. *Identity, Performance and Technology*. Houndsmills, UK: Palgrave Macmillan.

Brockman, J. (ed.). 2011. *How Is the Internet Changing the Way You Think?* London: Atlantic Books.

Carr, N. 2011. *The Shallows: What the Internet Is Doing to Our Brain*. New York: W.W. Norton & Company.

Children's Employment Commission. 1842. Appendix to the Second Report of the Commissioners.

Christian, B. 2011. *The Most Human Human*. London: Viking Books.

Coleman, B. 2011. *Hello Avatar: Rise of the Networked Generation*. Cambridge, MA: The MIT Press.

Commission, Children's Employment. 1842. Appendix to the Second Report of the Commissioners.

Crump, T. 2010. *How the Industrial Revolution Changed the World*. London: Robinson Books.

Davis, E. 1998. *TechGnosis*. New York: Harmony Books.

Dillon, T. W. & Thomas, D. S. 2006. "Knowledge of Privacy, Personal Use, and Administrative Oversight of Office Computers and E-mail in the Workplace." *Information Technology Learning and Performance Journal* no. 24 (2): 23–34.

Dixon, S. 2007. *Digital Performance*. Cambridge, MA; London: MIT Press.

Dyson, G. 2012. *Turing's Cathedral*. London: Allen Lane.

Ellul, J. 1964. *The Technological Society*. New York: Vintage Books.

Florida, R. 2002. *The Rise of the Creative Class*. New York: Basic Books.

Foucault, M. 1977. *Discipline and Punish*. New York: Knopf Doubleday Publishing.

Frayling, C. 2011. *On Craftsmanship: Towards a New Bauhaus*. London: Oberon Books.

Geddes, P. 1915. *Cities in Evolution*. 1997 ed. London: Williams & Norgate.

Gilmore, M. 1952. The World of Humanism 1453–1517. New York: Harper Torchbooks.

Gladwell, M. 2009. *Outliers*. London: Penguin.

Gleick, J. 2011. *The Information: A History, a Theory, a Flood*. London: Fourth Estate.

Graham, P. 2004. *Hackers and Painters*. Sebastopol, CA: O'Reilly Media Inc.

Griffin, E. 2010. *A Short History of the British Industrial Revolution*. London: Palgrave Macmillan.

Grodinsky, F. and Tavani, H. "P2P networks and the Verizon v. RIAA case: Implications for personal privacy and intellectual property." *Ethics and Information Technology* no. 7: 243–250.

Heidegger, M. 1978. *Basic Writings*. Edited by D. Farrell-Krell. 2011 ed. London & New York: Routledge.

———. 1998. *Parmenides*. Paperback ed. Bloomington, IN: Indian University Press. Original edition, 1982.

Honan, M. 2012. How Yahoo Killed Flickr and Lost the Internet. *Gizmodo*, http://gizmodo.com/5910223/how-yahoo-killed-flickr-and-lost-the-internet.

Hutton, W. 2010. *Them and Us: Changing Britain – Why We Need a Fairer Society*. London: Little, Brown.

Idhe, D. 2007. *Listening and Voice: Phenomenologies of Sound*. Albany, NY: State University of New York Press, from http://www.bbc.co.uk/news/world-south-asia-15180831.

———. 2010. *Embodied Technics*. Copenhagen: Automatic Press.

India launches Aakash tablet computer priced at $35. *BBC News*, 5 October 2011. Available from http://www.bbc.co.uk/news/world-south-asia-15180831.

Jackson, M. 2008. *Distracted: The Erosion of Attention and the Coming Dark Age*. New York: Prometheus Books.

Jenkins, H. 2008. *Convergence Culture*. New York: New York University Press.

Jenkins, H., Ford, S. & Green, J. 2013. *Spreadable Media: Creating Value and Meaning in a Networked Culture*. London & New York: New York University Press.

Keen, A .J. 2012. *Digital Vertigo*. London: Constable & Robinson.

Kelly, K. 2010. *What Technology Wants*. London: Penguin Books.

Kozel, S. 2007. *Closer: Performance Technologies, Phenomenology*. Cambridge, MA: MIT Press.

Kuhn, T. S. 1962. *The Structure of Scientific Revolutions*. Chicago: University of Chicago Press.

Kumar, K. 1978. *Prophecy and Progress*. Harmondsworth: Penguin Books.

Kurzweil, R. 2006. *The Singularity Is Near*. New York: Penguin Books.

Lanier, J. 2010. *You Are Not a Gadget*. London & New York: Allen Lane.

——. 2013. *Who Owns the Future?* London: Allen Lane.

Leavitt, D. 2007. *The Man Who Knew Too Much: Alan Turing and the Invention of the Computer*. London: Phoenix Books.

Lessig, L. 2004. *Free Culture: The Nature and Future of Creativity*. New York: Penguin.

Lewandowsky, S., Oberauer, K. & Gignac, G. E. 2013. "NASA Faked the Moon Landing—Therefore, (Climate) Science Is a Hoax: An Anatomy of the Motivation Rejection of Science." *Psychological Science* no. 24 (5): 622–633.

Lim, K. G. 2002. "The IT Way of Loafing on the Job: Cyberloafing, Neutralizing and Organizational Justice." *Journal of Organizational Behaviour* no. 23 (5): 19.

MacCormick, J. 2012. *9 Algorithms That Changed the World*. Princeton & Oxford: Princeton University Press.

Manovitch, L. 2001. *The Language of New Media*. Cambridge, MA, London: MIT Press.

Mason, M. 2008. *The Pirate's Dilemma*. New York: Allen Lane.

Mayer-Shonberger, V. 2009. *Delete: The Virtue of Forgetting in the Digital Age*. Princeton and Oxford: Princeton University Press.

Moore, G. 1991. *Crossing the Chasm*. New York: HarperCollins Publisher Inc.

Moravec, H. 1999. *Robot: Mere Machine to Transcendent Mind*. Oxford: Oxford University Press.

Morozov, E. 2013. *To Save Everything, Click Here*. London: Allen Lane.

Morris, I. 2010. *Why the West Rules – For Now*. London: Profile Books.

Mumford, L. 1934. *Technics & Civilization*. Chicago & London: Chicago University Press.

——. 1952, 2000. *Art and Technics*. New York: Columbia University Press.

——. 1970. *The Myth of the Machine: The Pentagon of Power*. New York: Harcourt Brace & Jovanich.

Naughton, J. 1999. *A Brief History of the Future: The Origins of the Internet*. London: Weidenfeld & Nicholson.

——. 2012. *What You Really Need to Know about the Internet: From Gutenberg to Zuckerberg*. London: Quercus.

Negroponte, N. 1996. *Being Digital*. New York: Vintage Books.

Norman, Donald A. 1998. *The Invisible Computer*. Cambridge, MA; London: The MIT Press.

Nye, D. 2006. *Technology Matters: Questions to Deal With*. Cambridge, MA: MIT Press.

Page, M. 2012. The Internet Economy in the United Kingdom. In *Issue Papers and Perspectives*. London: A.T. Kearney Inc.

Palfrey, J. & Gasser, U. 2008. *Born Digital*. New York: Basic Books.

Paul, C. 2008. *Digital Art*. 2nd ed., *World of Art*. London: Thames & Hudson.

Prensky, M. 2001. "Digital Natives, Digital Immigrants." *On the Horizon* no. 9 (5): 1–6.

Pruett, M. L. 1984. *Art and the Computer*. New York: McGraw-Hill Book Company.

Pugh, E. W. 1995. *Building IBM: Shaping an Industry and Its Technology*. Cambridge, MA: MIT Press.

Randall, A. 1991. *Before the Luddites: Custom, Community and Machinery in the English Woollen Industry, 1776–1809*. Cambridge, MA: Cambridge University Press.

Reichart, J. 1971. *The Computer in Art*. London: Studio Vista.

Rogers, E. M. 1983. *Diffusion of Innovation*. Third Edition. New York: The Free Press. Original edition, 1962.

Robinson, K. 2009. *The Element: How Finding Your Passion Changes Everything*. London: Allen Lane.

Rush, M. 2005. *New Media in Art*. 2nd ed., *World of Art*. London: Thames & Hudson.

Sennett, R. 1977, 1986. *The Fall of Public Man*. London: Faber & Faber.

——. 1998. *The Corrosion of Character: Personal Consequences of Work in the New Capitalism*. New York: W.W. Norton, Inc.

Sharr, A. 2006. *Heidegger's Hut*. Cambridge, MA: MIT Press.

Shirky, C. 2009. *Here Comes Everybody*. London: Penguin.

——. 2010. *Cognitive Surplus*. London: Allen Lane.

Shumpeter, J. A. 1943/2010. *Capitalism, Socialism and Democracy*. Abingdon, Oxon: Routledge Classics.

Siegel, L. 2009. *Against the Machine*. New York: Spiegel & Grau.

Silver, J. 2012. The Classroom Disruptor. *Wired*, 105–111.

Sowell, T. 1998. *Conquests and Cultures*. New York: Basic Books.

Stallabrass, J. 2003. *The Online Clash of Culture and Commerce*. London: Tate Publishing.

Steil, B., Victor, D. & Nelson, R. (eds). 2002. *Technological Innovation and Economic Performance*. Princeton, NJ: Princeton University Press.

Stone, B. 2013. *The Everything Store: Jeff Bezos and the Age of Amazon*. London: Bantam Press.

Tann, J. & Brecklin, M. J. 1978. "The International Diffusion of the Watt Engine, 1775–1825." *The Economic History Review* no. 31 (4): 541–564.

Thompson, E. P. 1967. "Time, Work-discipline, and Industrial Capitalism." *Past & Present* no. 38 (1): 56–97.

——. 1991. *The Making of the English Working Class*. London: Penguin. Original edition, 1963.

Toffler, A. 1970. *Future Shock*. New York: Random House.

Turing, A. M. 1950. "Computing, Machinery and Intelligence." *Mind* no. LIX (236): 433–460.

The Turner Prize 1995, 1995. Exhibition Brochure. London: Tate Gallery.

Wallinger, M. 1994. *A Real Work of Art*. London: Wallinger.

Williams, R. 1974. *Television: Technology and Cultural Form*. London: Fontana.
Willis, P. 1990. *Common Culture*. Milton Keynes: Open University Press.
Young, C. 2007. Product Recall. New York: Paula Cooper Gallery.
——. 2008. "Playing the System". *Tate Etc. Magazine*, Issue 14, Autumn.
Zittrain, J. 2008. *The Future of the Internet*. London: Allen Lane.

Index

CPSIA information can be obtained
at www.ICGtesting.com
Printed in the USA
LVOW08*0418100117

520324LV00008B/249/P